DALÍ

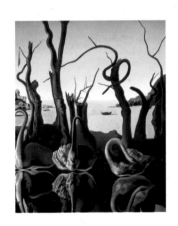

Publisher & Creative Director: Nick Wells
Senior Editor: Sarah Goulding
Picture Research & Development: Melinda Revesz
Designer: Mike Spender

Special thanks to: Hilary Bird and Helen Tovey

FLAME TREE PUBLISHING
Crabtree Hall, Crabtree Lane
Fulham, London, SW6 6TY
United Kingdom

www.flametreepublishing.com

Flame Tree is part of the Foundry Creative Media Company Limited

First published 2006

Every effort has been made to contact copyright holders. We apologize in advance for any omissions
and would be pleased to insert the appropriate acknowledgements in subsequent editions of this publication.

While every endeavour has been made to ensure the accuracy of the reproduction of the images in this book,
we would be grateful to receive any comments or suggestions for inclusion in future reprints.

Printed in China

DALÍ

Authors: Elizabeth Keevill & Kevin Eyres Foreword: Michael Robinson

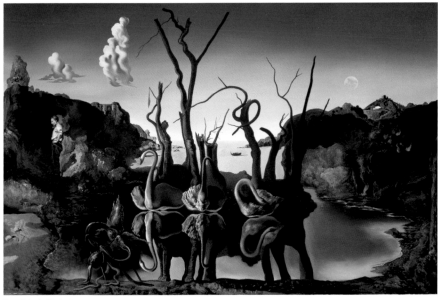

Swans Reflecting Elephants

**FLAME TREE
PUBLISHING**

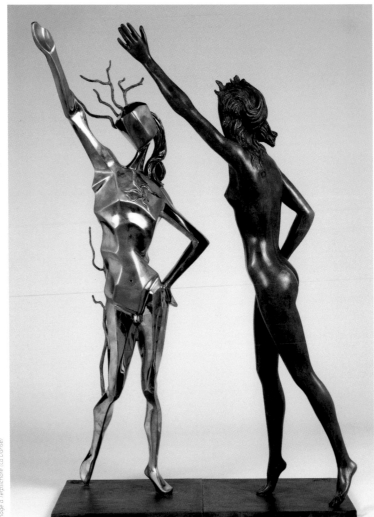

Hommage à Terpsichore (La Danse)

Contents

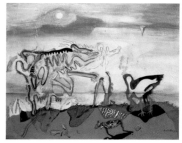 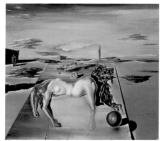

The Spectral Cow; Dormeuse Cheval Lion Invisibles; Gala's Foot

Portrait of Gala Balancing Two Lamb Chops on Her Shoulder; Still from Un Chien Andalou; Sans Titre

Places .. 144

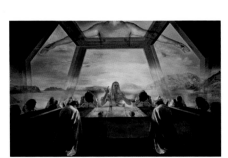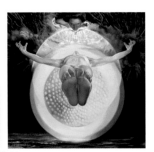

View of the Church and Abbey of Vilabertràn; Santa Creus Festival in Figueras – The Circus; Woman at the Window in Figueras

Influences .. 204

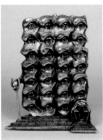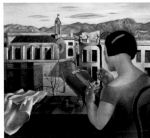

The Sacrament of The Last Supper; Yeux Surréalistes; L'Ascension de Christ (Pietà)

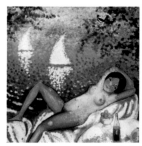 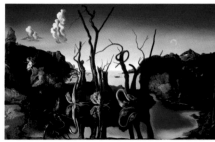 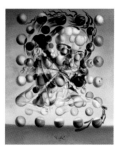

The Smiling Venus or Nude in a Landscape; Swans Reflecting Elephants; Galatea of the Spheres

How To Use This Book

The reader is encouraged to use this book in a variety of ways, each of which caters for a range of interests, knowledge and uses.

- The book is organized into five sections: **Life**, **Society**, **Places**, **Influences** and **Styles & Techniques**.
- **Life** provides a broad look at all of Dali's work, beginning with some of his earliest works in 1918 and continuing up to the 1980s.
- **Society** shows how Dali's work was both informed by and reflected the times in which he lived.
- **Places** looks at the work Dali did in Spain, France, Italy and the US, and how these places affected his painting.
- **Influences** reveals who and what influenced this unique artist and touches on his own long-lasting legacy.
- **Styles & Techniques** delves into the myriad techniques employed by Dali, from oils, gouache and watercolours to bronze, wool, nails and unusual sculptures.
- The text provides the reader with a brief background to the work, and gives greater insight into how and why it was created.

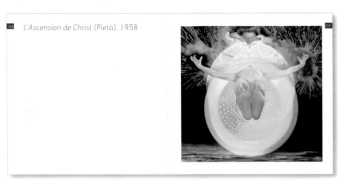

L'Ascension de Christ (Pietà), 1958

1. Title of work

2. Date of work (if known)

3. Information about the work and the context within which it was created

9. Picture credit

8. Place in which the work was created (if known)

7. Medium in which the work was created (if known)

6. Period in which the work was created (if known)

5. Related work to the one pictured

4. Artists name, date of birth and death, and place of birth features at the beginning of each chapter

74

Portrait of Luis Buñuel, 1924

Courtesy of The Art Archive/Luis Buñuel Collection Mexico/Dalí Dmitri Salvador Dalí, Gala, Salvador Dalí Foundation, DACS, London 2003

This portrait of Dalí's friend and collaborator Luis Buñuel (1900–83) was the first work of Dalí's to be shown outside Catalunya. When it was first exhibited in 1925 at the Primera Exposición de la Sociedad de Artistas Ibéricos, in Madrid, critics described it as a work both 'serious and calm'. Indeed the style is plainly influenced by the new 'Classical' style that swept Europe after the First World War and found its expression in Spain in the 'Noucentisme' movement.

Buñuel was a dominant figure among Dalí's contemporaries in Madrid. He was a powerful macho figure and a keen sportsman, and something of his power comes out in this portrait. Using a very limited range of sombre colours, Dalí accentuates the thoughtful, almost melancholy, look on Buñuel's face, giving him a sense of gravitas. In collaboration with Dalí, Buñuel went on to produce the two defining films of the Surrealist movement, Un Chien Andalou (1929) and L'Age d'Or (1930). The clouds in the background of the portrait, taken from a painting Dalí saw in the Prado, appear at the beginning of Un Chien Andalou.

CREATED
Spain

MEDIUM
Oil on canvas

PERIOD
Early

RELATED WORK
Cristian School, Sonja, 1928

Salvador Dalí Born 1904 Catalunya, Spain

Died 1989

Foreword

Today, in this media-orientated world preoccupied with the cult of celebrity, we are used to seeing 'personalities' whose perceived value to society is not balanced by their contribution to it. Apart from television, this truism is perhaps most obvious in the art world, where a quest for the 'filthy lucre' is perhaps most evident in artists seeking to exploit the potential visual imagery within popular culture. Art history tends to suggest that such exploitation began in the 1960s with cult celebrity artists such as Andy Warhol, who famously proclaimed that 'being good in business is the most fascinating kind of art'. However that would be to ignore the prior cult status of Salvador Dali, probably the father of 'the artist as cult celebrity'.

From the beginning of his career, Dali had a sense of his own artistic destiny and an insatiable appetite for unashamed megalomania, culminating in his 1964 autobiographical work *Diary of a Genius*. Such precociousness was, however, well justified. Before joining the Surrealist Movement in 1929, he was painting to very exacting standards of craftsmanship using his very fertile imagination as motif. His works such as *Figure on the Rocks (Sleeping Woman)* from 1925, painted when he was still only twenty-one, demonstrate that he had already mastered the skills of draughtsmanship and foreshortening, as well as possessing a comprehensive understanding of colour and composition. His work before the Second World War continued to show a development of those skills in which the absence of 'the mark' in his meticulously detailed paintings became Dali's trademark.

Notwithstanding his considerable achievements in painting and furthering the aspirations of the Surrealist aesthetic at this time through the development of his 'paranoid-critical' paintings, the leader of the Surrealist movement, André Breton (1896–1966), expelled Dali from the official movement in Paris for non-compliance with their political agenda. Equally, Breton felt that Dali was now overshadowing his importance as the leader of the movement, and was later to use the anagrammatic epithet 'Avida Dollars' to describe Salvador Dali and his own megalomaniacal and financially rapacious self interests.

As if to realize this prophesy, Dali and his even more rapacious wife, Gala, set off for America to live in exile in 1940, where he published his *Declaration of the Independence of the Imagination and the Rights of Man to His Own*

Madness, declaring that 'the difference between me and a madman, is that I am not mad.' While there he used his idiosyncratic persona as the 'bad boy' of painting, prostituting his talents to advertising agencies and Hollywood. Using existing images from his portfolio of work to date, he would apply them to corporate and product commercials, or meticulously paint corporate images such as the Coca-Cola bottle, predating Andy Warhol's predilection for corporate imagery and self-promotion by twenty years. Dalí dressed shop windows in his own inimitable style, and created backcloths for a Hitchcock movie. He was also commissioned to paint portraits of wealthy society women, again in his own inimitable and often unflattering style. Thus the birth of 'Avida Dollars' was complete and culminated in the publication in America of Dalí's first self-promoting book, *The Secret Life of Salvador Dalí*, in 1942.

It has been suggested that Dalí was later hoodwinked into signing blank sheets of paper, enabling publishers to later overprint his images at their own behest. Equally plausible is that Dalí, at least initially, knew perfectly well what he was doing, in furtherance of his aspiration 'to be Salvador Dalí – I have no greater wish.' His aspirations may well have got out of hand, leading as it has to controversies as to the authenticity of his later works.

Despite these controversies, Dalí's stature as one of the great artists of the twentieth century is assured. He has left a legacy of ideas that continue to be exploited by an extensive network of merchandising opportunities around the world controlled by the Gala-Salvador Dalí Foundation, which the artist set up in 1983. Such is the enduring appeal of Dalí and his work, that there exist today a number of specialized Dalí museums around the globe.

The difference between Dalí and most of the aspirant 'artistic celebrities' of today is that his reputation was built on a strong foundation of talent – not just ideas but the consummate skills of craftsmanship to execute them. Celebrating the centenary of Dalí's birth in 2004, the critic Robert Hughes refers to post-modern artists such as 'the blandly decadent' Jeff Koons, who hasn't 'one twentieth of his talent' and asks, 'why dump on Dalí for his greed today?'.

Why indeed.

Michael Robinson, *2005*

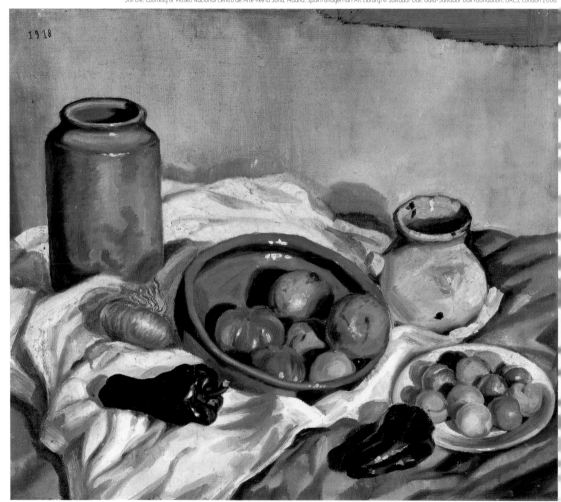

Introduction

'Painting is an infinitely minute part of my personality.'

Salvador Dali was the most complex and possibly the most controversial artist of the twentieth century. Although his popularity with the public at large has never been in question, the attitude of the art world towards this giant of twentieth-century art has often been much more ambivalent. Reasons for this apparent mismatch between public and academic reactions to Dali's work can be traced to the artist's life and the huge body of work that his prodigious creativity and boundless energy produced.

Dali spent his whole life constructing the image he wanted the public to have of himself and his art. He was a consummate showman, an impresario and an international celebrity. In many ways he created the template for the personality-led career of Andy Warhol in the 1960s, and for late twentieth-century artists such as Damien Hirst and Tracy Emin who live their lives deliberately in the glare of the media spotlight.

What was worse for many members of the art establishment, Dali seemed to be obsessed with money. In America he painted portraits of the rich and famous, produced murals for their homes, never turned down a commission from the advertising agencies on Madison Avenue, decorated Fifth Avenue shop windows and even had a hand in designing hair styles. Driven by the fierce ambition and single-mindedness of Gala, his lover, wife, muse and business manager, he even arranged the sale of his own work, upsetting the profitable financial arrangements between artists' agents, dealers and galleries.

In the twenty-first century, Dali's behaviour would pass almost without comment, but in the middle of the twentieth century he managed, at one time or another, to offend almost every part of the art world. No wonder its opinion of Dali has been a little hesitant at times. What many critics seem unable to do is divorce 'Dali the constructed identity' from the work he produced as a consummate artist. There seems to be at times an unwillingness to accept that although much of his work was done for commercial motives, it never compromised or interfered with his serious work, which comprises, across its breadth and depth, some of the truly great achievements in western art.

Of course none of these things concern the public at large, with whom Dalí's work clearly connects. Ultimately, given the choice of the unilateral approval of the art establishment for his work or the popularity of the public, Dalí may well have chosen the latter.

Dalí led a complex life, moving between countries and continents, but he never forgot his Catalan roots. He was born on 11 May 1904 in Figueras, a busy market town in the Spanish province of Catalunya, the second child of a reasonably prosperous family. His elder brother had died tragically little more than nine months before Salvador's birth, a fact that was to haunt Dalí all his life.

Catalunya was, and still is, a region of Spain fiercely protective of its own distinct culture and language. Dalí was brought up in a society that was essentially liberal-minded, cosmopolitan, sceptical of the church and broadly socialist in outlook. Throughout his childhood, Dalí's interest in art and his obvious talent as a painter were encouraged both by his own family and by the Pichots, friends of his family and part of an extended 'clan' of talented Catalan artists.

Dalí spent his childhood summers immersed in his painting and studying the works of the great artists. Every summer he stayed in the little fishing village of Cadaqués, where his family had a small house. Cadaqués, some 40 km (25 miles) from Figueras, was something of artists' retreat at the time and the Pichots, who had a modest estate there, entertained many famous artists including, in 1910, Pablo Picasso (1881–1973).

Something of a child prodigy, Dalí was publicly exhibiting his work to critical acclaim in Figueras as early as 1918 when he was just fourteen. Following the heartbreaking death of his adoring mother in 1921, he left Figueras to continue his studies at the Academy of Fine Arts in Madrid where he met and befriended the great Spanish poet Federico Garcia Lorca (1898–1936) and the Surrealist film maker Luis Buñuel (1900–83). These two talented young Spaniards were the first of a remarkable group of Europe's leading artists that Dalí collaborated with over the subsequent decade.

Although originally a shy, retiring child, Dalí had by now developed sufficient confidence in his growing abilities as an artist to be openly critical of his tutors and the quality of their lectures. This led to his temporary expulsion from the college in 1923, when he was charged with inciting his fellow students to riot. In the following year, Dalí was jailed for five weeks, ostensibly for campaigning against the Spanish dictator Primo de Rivera (1870–1930). Then in 1925 he held his first one-man show at the Dalmau Gallery in Barcelona. Dalí's life had already become the constant tumult of activity that it was to continue to be virtually until his death.

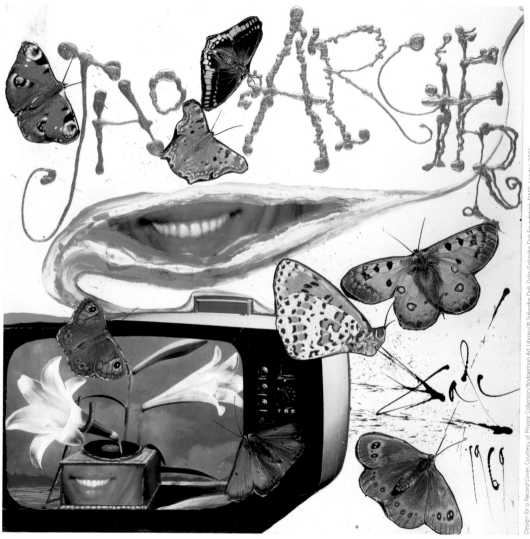

Over the next five years, Dali took his place at the very heart of contemporary European art. He was friends, or at least acquainted with, all of the major modern artists working in Europe at the time and moved in a circle that included Joan Miró (1893–1983), André Breton (1896–1966), René Magritte (1898–1967), Juan Gris (1887–1927), Picasso, Marc Chagall (1887–1985), Lorca and Buñuel. By the age of twenty-five Dali had arrived.

In the summer of 1929 a group of artists, including René Magritte, the French poet Paul Eluard and their wives, visited Dali at Cadaqués. Dali had achieved heightened international fame and public notoriety that year with the release in Paris of *Un Chien Andalou*, the Surrealist film that he had produced with his friend and collaborator Buñuel.

As soon as Dali saw Eluard's wife, the Russian émigré 'Gala' (her real name was Helena Dimitrievna Diakonova Eluard), he began what was to become a lifelong fixation with her. Gala's marriage to Eluard was a fairly dissolute one and when he left at the end of the summer visit, Gala remained with Dali. It would be difficult to exaggerate the effect that Gala had on Dali and the influence she exerted over him throughout their life together. Gala was at once his lover, his muse, his advisor and, most controversially for the rest of the art world, his business manager.

His affair with Gala, a married woman, was profoundly shocking for his family. It shattered the vestiges of the relationship Dali had with his father, who categorically refused to accept Gala under any circumstances, although years later Dali's father was grudgingly prepared to acknowledge her role in his son's success.

In 1930 Dali bought the small fisherman's cabin in Port Lligat that he and Gala were to add to extensively over the years, finally converting it into their home and studio complex. The house at Port Lligat, a tiny fishing community adjoining Cadaqués, was to become Dali's base for the rest of his life and no matter how much he travelled it was always to here that he returned. He was to say of it, 'I am home only here; elsewhere I am camping out'.

During 1930, the same year he bought the cabin at Port Lligat, Dali officially joined the Surrealist movement, which had been founded by André Breton in 1922. However, no sooner had he joined the Surrealists than he started to upset them and eventually, in 1939, after a number of temporary rifts, he finally broke with them completely. An enduring influence on Dali, which outlasted his membership of the Surrealist movement, was the work of Sigmund Freud. Dali made a serious study of Freud's work and met him in London in 1938.

The 1930s are referred to as Dali's Surrealist period and it was during this decade that he created many of his best-known works. In 1934 he and Gala visited America for the first time and America welcomed Dali with open arms. The media loved him and American high society treated him with an affection he found lacking in Europe. Dali and Gala returned to Europe briefly, but in 1940 they moved to America and made it their home for the next nine years, not returning to Europe again until 1949.

America gave Dali's wide-ranging creativity the free rein that Europe had denied it. As well as painting and drawing, he wrote extensively, produced storyboards for film sequences for

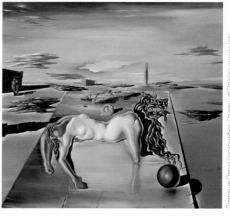

Alfred Hitchcock, Walt Disney and Fritz Lang, and designed haute couture clothing and jewellery. He also produced the artwork for numerous advertising campaigns and designed stage sets, shop-window displays and exhibition stands. Dali even produced his own range of perfumes and cosmetics. His life was a torrent of creativity and he was seldom out of the media's attention, appearing not only in magazine features and television programmes, but starring in advertisements for products as unlikely as Alka-Seltzer.

During this period, Dali and Gala were busy developing the Dali 'brand'. They had an apparently inexhaustible appetite for money and to satisfy this Dali was prepared to embrace the world of commercial art with his usual energy and enthusiasm. However, he was still producing 'serious' art, turning from Surrealism to a more measured style, influenced in part by the old masters of the Renaissance and in part by the new developments in atomic and nuclear physics.

Dali and Gala returned to Europe in 1949 and were now major international celebrities. For the next thirty years they travelled around the world mixing with world leaders, film stars, musicians and, on two occasions, were even granted audiences with the Pope. Such was Dali's fame at this time that he could publish a successful book based entirely on photographs of his moustache. Whenever possible Dali and Gala returned to their home at Port Lligat where Dali continued to produce masterful paintings and artefacts alongside his more commercial activities.

Gala died in 1982, and Dali painted his last picture, *The Swallow's Tail*, the following year. Heartbroken by the death of Gala, Dali died on 23 January 1989 after a long and painful decline.

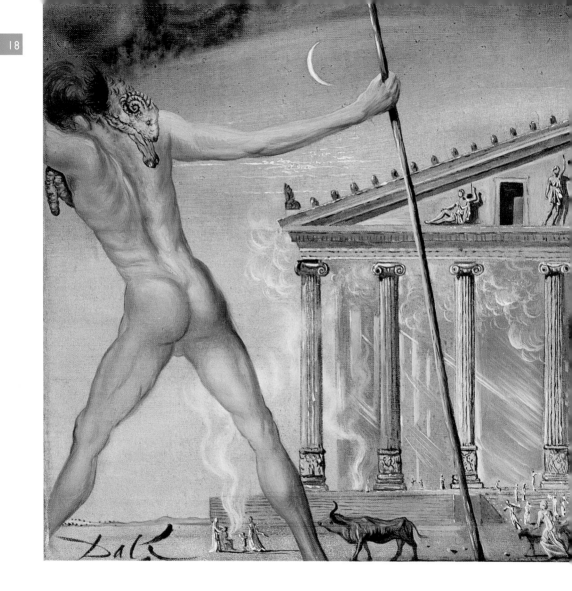

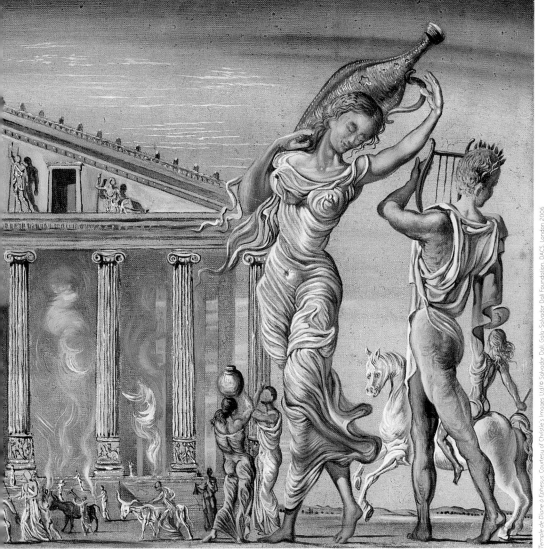

Dalí

Life

Still Life, 1918

In 1918, although only 15, Dali was already immersed in the world of art. His father had enrolled him at the Municipal School of Drawing in Figueras, where he was tutored by its principal, Juan Nunez. Dali had also fallen under the influence of the Pichots, friends of his father and part of an extended family of talented Catalan artists.

Still Life (1918) is a work that shows Dali's precocious skill as a painter. Although he did not produce a great many still lifes, it was a genre that always fascinated Dali. In his early years, when he was still absorbing the works of the great artists and trying to find his own distinctive 'voice', he experimented with a wide variety of styles ranging from the works of the Renaissance and seventeenth-century Spanish artists, such as Diego Velázquez (1599–1660) and Francisco de Zurbarán (1598–1664), to the much more modern work of the Impressionists, Purists and Cubists, who were especially preoccupied with the 'still life' genre. This traditional still life, with its Mediterranean fruit and vegetables arranged with rustic Spanish crockery, is an evocation of Dali's Catalan roots and shows much of the influence of the Post-Impressionist Paul Cezanne (1839–1906) and gives no clue of what was to follow.

CREATED

Spain

MEDIUM

Oil on canvas

PERIOD

Early

RELATED WORK

Paul Cézanne, *Still-life with Green Pot and Pewter Jug, c.* 1869

Salvador Dali *Born* 1904 Catalonia, Spain

Died 1989

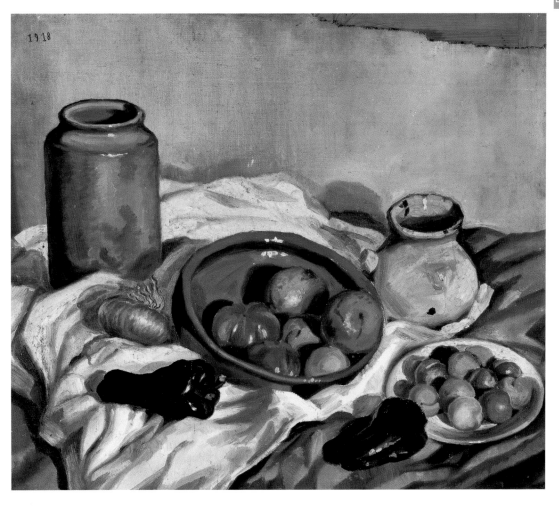

The Tartan 'El Son', 1919

The year Dali painted *The Tartan 'El Son'*, 1919, was a significant one for the young artist. At the start of the year, the first official exhibition of his work was held in his home town, Figueras. Of the several artists showing their work, Dali was singled out by the local newspaper *Emporda Federal*, its review finishing with the words, 'We salute the new artist in the firm hope that in time our words will become a prophesy: Salvador Dali will become a great painter'. Later in the same year he was to sell his first paintings.

The Tartan 'El Son', painted in oil on card, is subtitled 'The Artist at the Rudder of the *El Son*'. Dali shows the little tartan (a traditional Mediterranean sailing boat) scudding over the waves, its single triangular lanteen sail catching the wind. The boldly applied broad brushstrokes in this painting show the huge impact the French Impressionists, such as Edouard Manet (1832–83), Claude Monet (1840–1926) and Auguste Renoir (1841–1919), had on Dali at this point in his artistic development. The influence of the Catalan Impressionist artist and family friend Ramon Pichot (1872–1925), whose works the Dalis had in their home, also cannot be overemphasized. The setting for *The Tartan 'El Son'* is the bay of Cadaqués where the Dali family spent their summers.

CREATED

Spain

MEDIUM

Oil on cardboard

PERIOD

Early

RELATED WORK

Claude Monet, *The Green Wave*, 1865

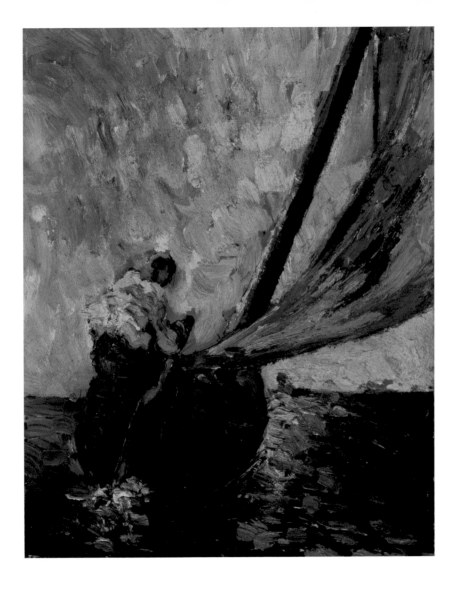

Self Portrait with L'Humanité, 1923

At the time of this painting, Dalí was studying at the Royal Academy of Fine Arts in Madrid. Throughout this period he experimented with the numerous styles of painting he encountered in his studies. *Self Portrait with L'Humanité* catches Dalí in a transitional period. His choice of French workman's clothes and the face lacking a mouth, point to an artist still unsure of himself and looking for his own distinct style. In this work there is clear evidence of the influence of Georges Braque (1882–1963) and Pablo Picasso (1881–1973), who were both working in the Cubist style. The use of collage and the angular, minimal details are typical of the Cubists' work at the time.

Dalí, who professed to have no interest in politics in his later life, chose to include in this work part of the front page of *L'Humanité*, a French Communist paper that he subscribed to at that time. Even at this early, formative point in his career, Dalí was attempting to create not just works of art, but a distinct image for himself as an artist.

CREATED

Spain

MEDIUM

Oil, gouache and collage on cardboard

PERIOD

Early

RELATED WORK

Pablo Picasso, *Guitar, Newspaper, Glass and Bottle*, 1913

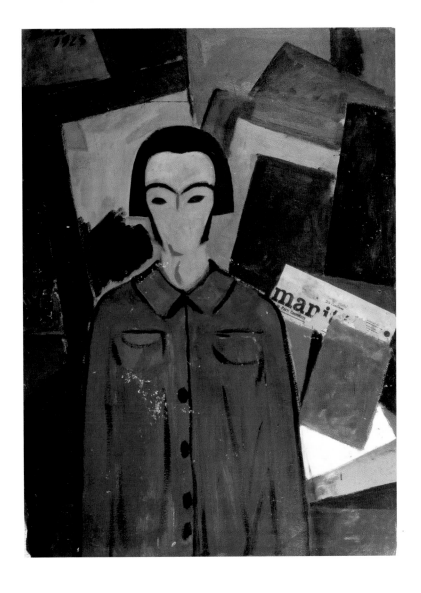

Portrait of My Father, 1925

Dalí had a problematic relationship with his father, a successful notary and supporter of Catalan independence. He felt that his father saw him as a less-favoured replacement for the son, also called Salvador, who had died little more than nine months before Salvador Dalí's birth. Much of Dalí's later imagery and writing is concerned with his quest to fulfil Freud's dictum that the hero is a man who resists his father's authority and overcomes it.

Portrait of My Father, painted in 1925, was one of several pictures of his father that Dalí produced in the early part of his artistic career. It depicts his father, seated, holding a rather phallic pipe, his face seen in three-quarter view and apparently scrutinizing the viewer. After the First World War there was a move away from avant-garde art movements, such as Cubism, to Classical Realism, also known as 'The Return to Order', whose monumental quality is clearly informing Dalí's style here.

Although the muted tones make the painting appear almost monochrome, there is a warmth in the portrait that a contemporary critic compared to the work of the great French Post-Impressionist Paul Cézanne (1839–1906).

CREATED

Spain

MEDIUM

Oil on canvas

PERIOD

Early

RELATED WORK

Pablo Picasso, *The Reading of the Letter*, 1921

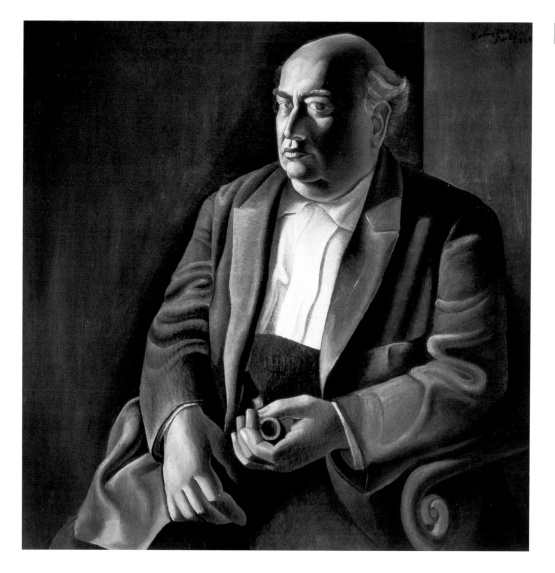

The Spectral Cow, 1928

By 1928, when he painted *The Spectral Cow*, Dali's attraction to Surrealism was exerting an increasingly strong influence on his work, although he was not to join the Surrealist movement officially until the following year.

By creating images that suggested the dreamlike, unconscious and irrational, the Surrealists wanted to challenge the viewer's perception that there was only one 'fixed' reality. André Breton (1896–1966) was the leader of the Surrealists and *The Spectral Cow* is a pictorial representation of one of his poems from the collection *Claire de Terre* ('Light of the Earth') written in 1923. The poem describes a dream in which a bird is shot while flying over the sea, but when the waves bring the body to the shore it has transformed into a cow.

As in a dream, the viewer is invited to create his own reality. Both the bird and the cow are only hinted at by vague outline and ghostly image. The air of putrefaction and the decomposing donkey prefigure the death and decay that played a major part in Dali and Luis Buñuel's (1900–83) film *Un Chien Andalou* (1929) that caused such a sensation the following year.

CREATED

Spain

MEDIUM

Oil on plywood

PERIOD

Transitional

RELATED WORK

Max Ernst, *La Belle Saison*, 1925

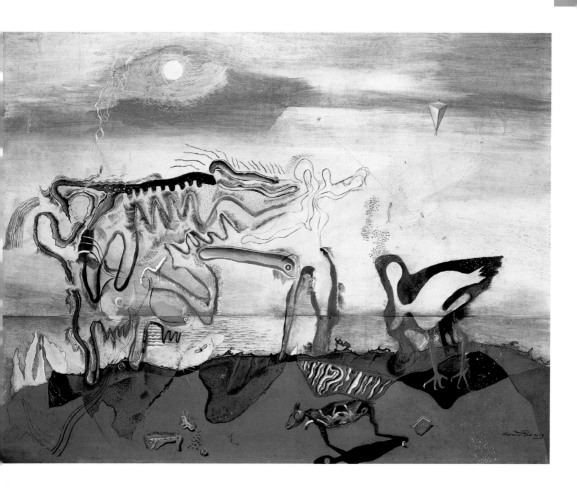

Dormeuse Cheval Lion Invisibles ('Invisible Sleeper, Horse, Lion'), 1930

Courtesy of Christie's Images Ltd/© Salvador Dali, Gala-Salvador Dali Foundation, DACS, London 2006

Almost as soon as he joined the Surrealist movement, Dali began to exert his influence over their artistic direction. In doing this he began a struggle with Breton that was to result in Dali's final expulsion from the movement in 1939.

Dali devised a technique that he called 'Paranoiac Critical Interpretation'. By using this method, Dali believed he could experience the visions of delirium that a mad person might experience. However, he also famously stated that, 'the only difference between me and a madman is that I am not mad'. In paranoiac-critical images, an object might suggest a number of seemingly unrelated things; indeed it could 'become' an apparently unrelated thing.

In this painting, Dali transforms the body of a reclining Dalisque (a female slave or concubine), into both a lion and a horse. In this early work the transition is rather clumsily handled. In Dali's later works his technique was to be much more convincing. The painting is one of a series of similarly named compositions, each containing the same central image, but in slightly different contexts.

MEDIUM

Oil on canvas

PERIOD

Surrealist

RELATED WORK

Giorgio de Chirico, *The Seeker*, c. 1930s

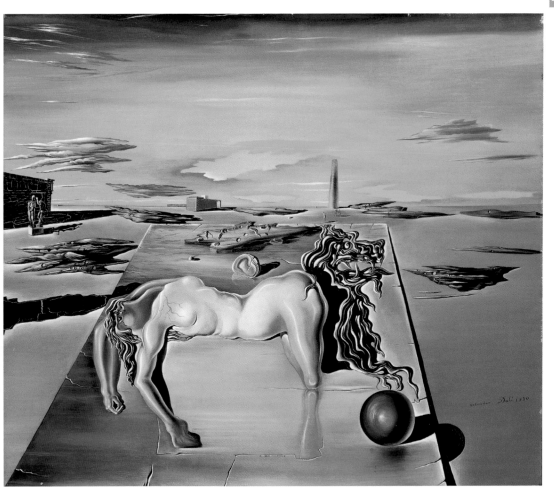

Buste Rétrospectif de Femme ('Retrospective Bust of a Woman'), 1933, 1977

Objets trouvés ('found objects'), commonly associated with the Surrealist movement, are an attempt to subvert or redefine the meaning of everyday objects, either by placing them in a new context or by grouping unrelated objects together to form a new artefact.

Buste Rétrospectif de Femme, which Dali exhibited at the Pierre Colle Gallery in 1932, is one of the seminal Surrealist artefacts of the period and is connected to Jean François Millet's (1814–75) *The Angelus* (1859), a work Dali was to return to again and again. *The Angelus* features a peasant couple facing each other in a field, remembering the death of their child. This would have obvious resonance with Dali's family life, his elder brother having died in childhood. Dali discovered an inkwell that featured images from Millet's *The Angelus* and formed a hat from it using a loaf of bread as its brim. In doing this he claimed he transformed the bread from something 'completely useful' into something 'useless and aesthetic'. He placed the hat on a porcelain bust of a woman overcome by ants, which Dali saw as a symbol of decay. He adds corncobs as plaits of hair and a celluloid cartoon strip as a choker.

As with many Surrealist *objets trouvés*, the original no longer exists and what we see here is a reconstruction made under the supervision of Dali in 1977 as part of an edition of eight with each one slightly different.

MEDIUM

Painted and gilded bronze, feathered cap, beads, plastic strip, two ink pens and glass

PERIOD

Surrealist

RELATED WORK

Wilhelm Freddie, *Sex-paralysappeal, c.* 1936

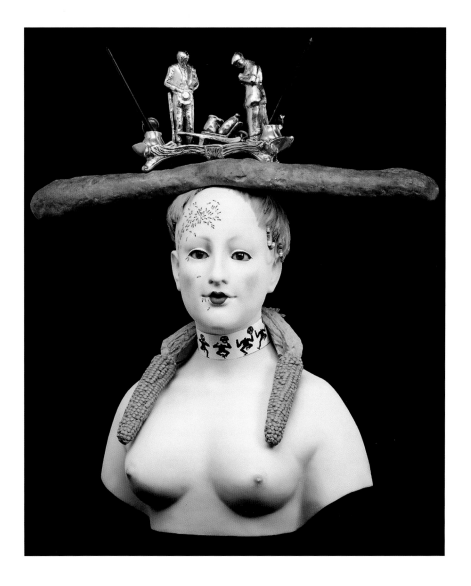

Paranoiac Face, 1935

Part of Dali's paranoid-critical reasoning was concerned with seeing images in such a way that they could transform visually into something completely different. Coming across a postcard image of an African hut surrounded by villagers, Dali mistook it for a new work by Picasso because he viewed it from the wrong angle. When he showed the same image to Breton, he said he saw it as the Marquis de Sade (1740–1814), in whom Breton was interested.

Paranoiac Face is, on the one hand, a representation of African villagers surrounding a hut similar to the original photograph. However, on the other hand, Dali has subtly altered the piece to make it appear like a head, especially when the image is turned through 90 degrees. When viewed as a head, the navel of the lying figure becomes the right eye. The same figure's legs and a pot become the nose, while the red figure and two pots become the lips, and the trees in the background form the hair.

Dali's conclusion from the incident that inspired *Paranoiac Face* was that people have a propensity to interpret images both as they are and in terms of their own specific interests.

MEDIUM

Oil on panel

PERIOD

Surrealist

RELATED WORK

Man Ray, *Portrait of the Marquis de Sade*, 1938

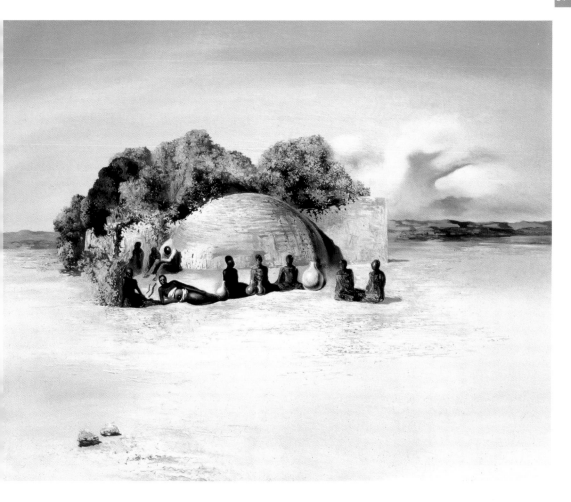

Téléphone – Homard
('The Lobster Telephone'), *c.* 1936

Courtesy of Christie's Images Ltd/© Salvador Dalí, Gala-Salvador Dalí Foundation, DACS, London 2006

Surrealist artefacts are often at their most effective when they are simple. The arbitrary placing of objects together to create bizarre juxtapositions was something that Dalí excelled at. Perhaps the most successful, best known and iconic of these works is *Téléphone – Homard*.

Dalí claimed the inspiration for the piece arose when he and his patron Edward James, the English millionaire and Surrealist poet, were eating lobster. At some point in the meal they began tossing the shells away and one landed on a telephone. Whether this is true or not, Dalí claimed to see lobster claws and telephone mouthpieces as interchangeable, making the typically surreal comment that he did not understand why, 'when I ask for grilled lobster I am never served with a cooked telephone'. Certainly the lobster, considered by some as an aphrodisiac, had sexual associations for Dalí, who created several images, including photographs, where lobsters were positioned over women's genitalia.

The actual fabrication of *Téléphone – Homard* was a collaboration between Dalí, James and the interior designer Syrie Maugham, wife of the writer Somerset Maugham. Ten versions were originally made, some using black phones and others using white phones with white lobsters.

MEDIUM

Telephone and plaster model of a lobster

PERIOD

Surrealist

RELATED WORK

Meret Oppenheim, *Fur Breakfast*, 1936

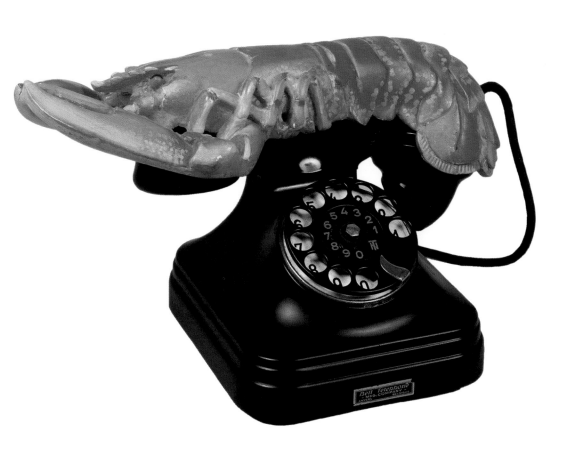

Le Calm Blanc ('White Calm'), 1936

Dalí's incredibly fertile creativity led him continually to experiment with both new and old forms of artistic expression. *Le Calm Blanc*, a photorealistic scene painted by Dalí at the height of his Surrealist period, perfectly anticipates the snapshot aesthetic of images from the Pop Art movement of the 1960s.

Dalí based this eerily placid scene on an old postcard showing a view of Bay of Port Lligat near Cadaqués. Minutely drawn characters, so realistic that they might almost be expected to move, stare out at the viewer against a rather cold, grey backdrop. The female bather and the small swimmer in the distance share the scene with a rustic individual standing on a rock to the left. He is similar to a character from the French Realist Jean François Millet's *The Angelus* (1859), a painting that exerted a huge influence on Dalí throughout his life.

In the foreground is the broken remnant of an amphora, a large storage jar used in the ancient world, which alludes to the many Greco-Roman remains discovered on the coastal plain of Catalunya, notably at Ampurias, just south of Cadaqués.

MEDIUM

Oil on panel

PERIOD

Surrealist

RELATED WORK

Richard Hamilton, *My Marilyn (Paste Up)*, 1965

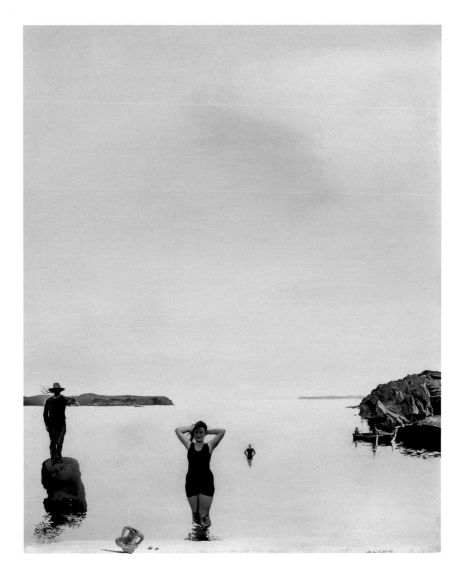

Untitled – Woman with a Flower Head, 1937

Dali had an enduring fascination with the world of *haute couture* and in the late 1930s worked with the great French couturière Elsa Schiaparelli, most notably on her remarkable 1938 Circus Collection inspired by the great Exposition Internationale du Surréalisme that took place in Paris in the same year.

In this image, the central figure, a voluptuous woman, glides across the vast featureless plain in a flowing ball gown. Whether her head is depicted as being no more than a ball of flowers or she is wearing a fantastic hat and possibly looking behind her at the supplicant figure, is not clear, but Dali did produce several images at this time in which flowers replace the head. The kneeling figure behind the woman appears to be gathering one of the bones that litter the beach while in the distance a young girl, lost in a world of her own, skips across the sand.

In this essentially monochrome ink and gouache work, the controlled explosion of colour that Dali uses to describe the woman's head immediately draws the viewer's eye into the centre of the work.

MEDIUM

Gouache, pen, brush and black ink on light-brown paper

PERIOD

Surrealist

RELATED WORK

René Magritte, *The Great War*, 1964

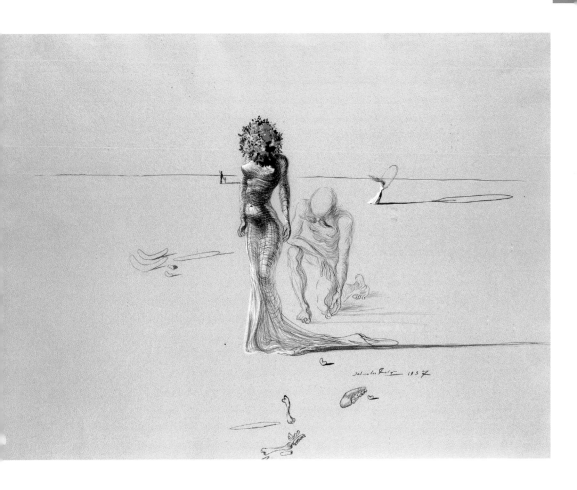

The Invisible Afghan with Apparition on the Beach, of the Face of Garcia Lorca in the Form of a Fruit Dish with Three Figures, 1938

In 1938 Dali painted three very similar works, *The Invisible Afghan with Apparition . . .*, *Apparition of Face and Fruit Dish on a Beach* and *The Endless Enigma*, which were exhibited to great acclaim in New York the following year.

The Invisible Afghan with Apparition . . . is a far smaller work than the other two. It concentrates on the illusion that Dali has created by arranging a collection of objects in such a way that when seen together they appear to become other, unrelated forms. Here Dali creates not one but three further images from what initially appear to be three figures sitting on a beach.

The face is that of Dali's friend the Spanish dramatist and poet Federico Garcia Lorca (1898–1936), who was brutally assassinated by the Fascist forces in 1936. The second image is that of a bowl containing three pears. The final image is that of a shadowy Afghan hound whose legs can just about be made out standing on the beach and whose body is formed from clouds.

MEDIUM

Oil on panel

PERIOD

Surrealist

RELATED WORK

René Magritte, *The Domain of Arnheim*, 1938

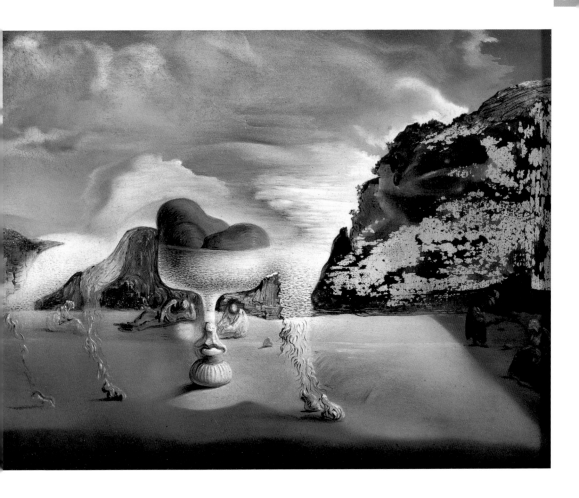

Mountain Lake, 1938

Just as he claimed to have had premonitions of the outbreak of the Spanish Civil War, Dali also maintained he experienced forebodings of the Second World War. In 1937 he painted *The Enigma of Hitler*, alluding to the failed peace negotiations between Hilter and the English prime minister Neville Chamberlain. In 1938 he produced *Mountain Lake* in which, as in *The Enigma of Hitler*, the central image is a telephone receiver.

Mountain Lake is a more enigmatic work. The lake is almost certainly based on Lake Resquerses, a place of pilgrimage situated north of Figueras in the foothills of the Pyrenees. Dali tells how his father took his mother there after the death of their first child and, overcome with the beauty of the place, his mother wept. The telephone receiver, and the crutch that supports it, have snails crawling over them, and the telephone cable is very obviously unconnected. Rather than referring specifically to the conversations of Hitler and Chamberlain, *Mountain Lake* can be seen as a comment on the fragility of all communication.

Mountain Lake is a particularly sombre example of Dali's multi-image pieces. The lake itself can be seen as a fish, the ripples in the water suggesting its scales.

MEDIUM

Oil on canvas

PERIOD

Surrealist

RELATED WORK

René Magritte, *Heraclitus's Bridge*, 1935

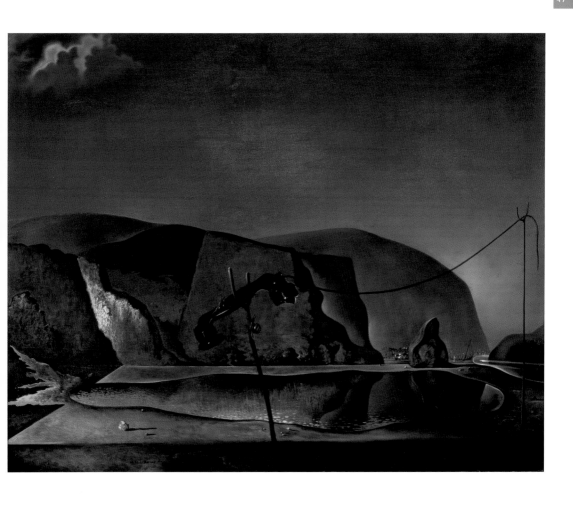

La Famille des Centaures Marsupiaux ('Family of Marsupial Centaurs'), 1940

Courtesy of Christie's Images Ltd/© Salvador Dali, Gala-Salvador Dali Foundation, DACS, London 2006

Dalí often claimed that his first memories were from his time in the womb, 'the maternal uterine paradise'. He became interested in the theories of Dr Otto Frank (1842–1939) whose book *The Trauma of Birth* suggested that birth complications were the cause of almost all subsequent neurosis. Frank was originally a close friend of Freud, but was later to become one of his fiercest critics.

Dalí liked the idea that children could be born and then return to their mother's womb whenever they liked. In *La Famille des Centaures Marsupiaux* he visualizes this happening not to humans, but to centaurs, mythical creatures from Greek legend with the head and torso of a human but the lower body of a horse. Both in its content and its technique, the painting is a return to the Neo-Classical style with which Dalí experimented in the 1920s.

Although Dalí painted this work in America, the centaurs appear above a rocky coastline similar to the area around Cadaqués in Spain. The same coastline appears four years later in *Dream Caused By The Flight Of A Bee Around A Pomegranate One Second Before Waking* (1944, see page 52).

MEDIUM

Oil on canvas

PERIOD

Classic

RELATED WORK

Max Ernst, *Fireside Angel*, 1937

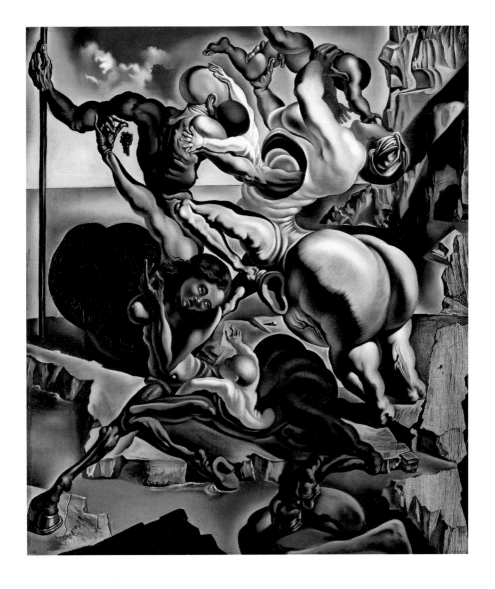

Soft Self Portrait with Fried Bacon, 1941

Dali's stated intention with *Soft Self Portrait with Fried Bacon* was to produce what he called an anti-psychological self-portrait: 'Instead of painting the soul, the inside, I wanted to paint solely the outside, the envelope, the glove of myself.' All this is a far cry from Dali's obsession with examining the many facets of an object that the mind can create either consciously or subconsciously.

In this remarkable work, Dali represents himself simply as a flexible mask of his face, melting in a way that suggests his earlier famous melting clocks. The face appears on a Classical plinth with the title inscribed in English, and is supported by nine crutches of the type that appear in so many of his works. The major supporting crutch is being eaten away, suggesting perhaps that the whole structure may soon collapse.

Dali places a piece of fried bacon on the plinth, a reference to his fetish for food and oral pleasure. He wants the viewer to think of the taste and smell of food, to think of this 'glove' of himself as 'edible, and even a little gamey'.

CREATED

America

MEDIUM

Oil on canvas

PERIOD

Surrealist

RELATED WORK

René Magritte, *The Philosophical Lamp*, 1936

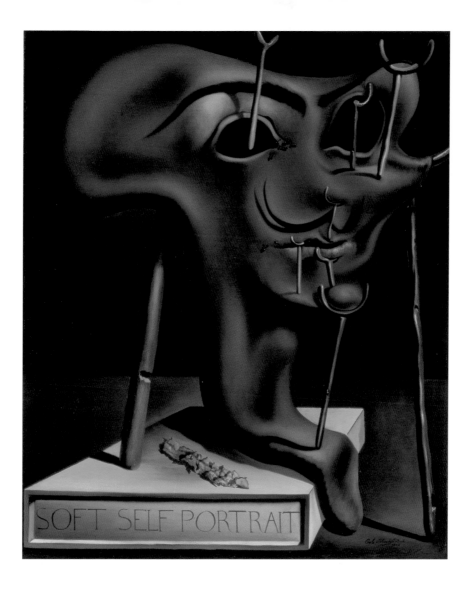

Dream Caused by the Flight of a Bee Around a Pomegranate One Second Before Waking, 1944

Courtesy of Thyssen-Bornemisza Collection, Madrid, Spain, Lauros / Giraudon/Bridgeman Art Library/© Salvador Dali, Gala-Salvador Dali Foundation, DACS, London 2006

In 1944 Dali and Gala were established in America. *Dream Caused by the Flight of a Bee* ... certainly has a glossy, almost photorealistic style that shows the influence of American consumer society much more markedly than Dali's Catalan roots. Indeed the work can be seen as part of Dali's quest at this time to work as closely as possible to 'hand-done colour photography of the images of concrete irrationality'.

The inspiration for *Dream Caused by the Flight of a Bee* ... was a dream that Gala recounted to Dali. The dreamer's state of suspended animation had resonance for Dali, both with the works of Freud and with the discoveries concerning particle physics that were being made at the time.

Although the bee and the pomegranate of Gala's dream appear in the foreground, it is the more threatening presence of two fierce tigers leaping from a fish that has in turn erupted from another much larger pomegranate that dominate the work. It is the bayonet piercing Gala's upper arm, not the bee's sting, which is destined to wake her.

CREATED

America

MEDIUM

Oil on panel

PERIOD

Classic

RELATED WORK

René Magritte, *The Reckless Sleeper*, 1928

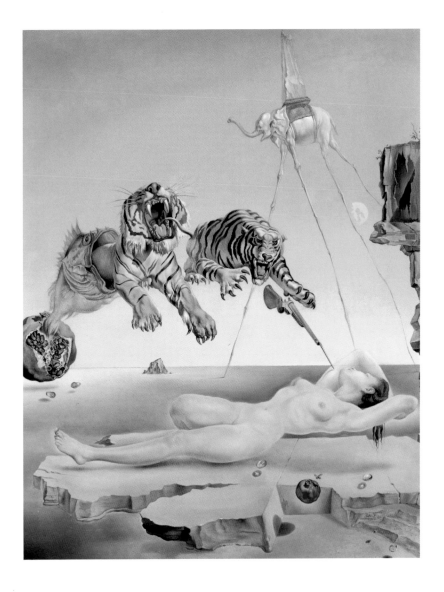

Giant Flying Mocha Cup with an Inexplicable Five Metre Appendage, c. 1946

Courtesy of Private Collection, Peter Willi/Bridgeman Art Library/© Salvador Dali, Gala-Salvador Dali Foundation, DACS, London 2006

In the 1930s, Dali became interested in a painting by the Swiss Symbolist, Arnold Böcklin (1827–1901), entitled *Island of the Dead* (1880), which Böcklin described as, 'a painting to dream over'. Dali claimed that The *True Painting of the Isle of the Dead by Arnold Böcklin at the Hour of the Angelus* (1932, see page 228) was inspired by the Böcklin painting although there is not a great deal of visual evidence.

Giant Flying Mocha Cup with an Inexplicable Five Metre Appendage, which Dali painted around 1946, is, in effect, a reworking of the 1932 work, to which it bears a striking similarity. On a featureless golden beach an enigmatic swathed figure, holding but not using a crutch, walks towards a block of stone with marble inlaid circles and a Medusa's head. Above the stone floats a coffee cup from which extends the 'inexplicable five metre appendage'. In Freud's interpretation of dreams, receptacles represent the female genitals, while rods are regarded as phallic. To the right floats a pomegranate, the symbol of resurrection, fertility and chastity, which appears in many of Dali's works at this time.

CREATED

America

MEDIUM

Oil on canvas

PERIOD

Nuclear Mystic

RELATED WORK

Paul Nash, *Landscape from a Dream*, 1936–38

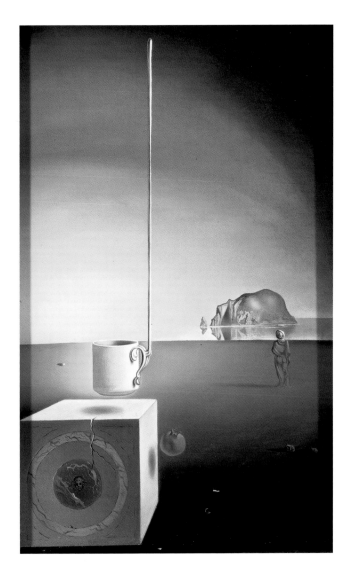

Dalí Atomicus, 1948

Philippe Halsman (1906–79) was a celebrated French photographer who shot over a hundred covers for *Life* magazine. He and Dali collaborated on many projects right up to Halsman's death in 1979. In 1954 they produced a humorous book called *Dali's Moustache, A Photographic Interview*, consisting of a series of beautifully lit and photographed portraits of Dali's trademark moustache. Among other images, the moustache is used as a graph illustrating the ups and downs of his career, as a paintbrush and forming a dollar sign. Some of the ideas for the photographs were Dali's, and some Halsman's.

To achieve spectacular results from this earlier sitting, in 1948, Dali first suggested inserting dynamite into live ducks. Fortunately Halsman demurred, and instead they devised a scenario to suspend furniture on wires and throw cats and water into the air while Dali jumped into the mix. The shot required twenty-six 'takes' before Halsman was satisfied with the result. The wires were then retouched out and Dali painted cats legs and water onto the canvas to match the composition of the photograph.

MEDIUM

Gelatin silver print

PERIOD

Nuclear Mystic

RELATED WORK

Irving Penn, *Optician's Window, New York, c.* 1939

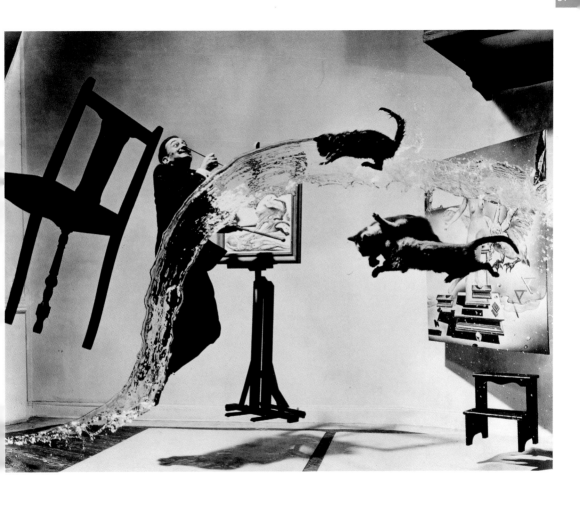

Salvador Dalí in His Studio at Port Lligat, Catalonia, 1956

On long childhood holidays Dali fell in love with the area around Cadaqués, fascinated by the wonderful Mediterranean light and the unusual rock formations particularly at Cap de Creus. He clearly felt more attached to the small fishing village than his home in Figueras some 40 km (25 miles) away.

In 1930, at the start of their lifelong relationship, Dali and Gala purchased a small run-down fisherman's cabin at Port Lligat. Over the next forty years they bought several more cabins and remodelled them into a remarkable labyrinthine home and studio complex where Dali could work, entertain and store his works.

Dali returned to Port Lligat whenever possible, saying of his house and studio, 'I am home only here; elsewhere I am camping out'. In the photograph, taken in 1956, when most of the major enlargements had been completed, Dali can be seen working in the studio where he painted many of his greatest works. The house at Port Lligat is now part of the Gala-Salvador Dali Foundation and is now one of the three major Dali museums that the foundation runs in Catalunya.

CREATED

Spain

MEDIUM

Black and white photograph

PERIOD

Nuclear Mystic

RELATED WORK

Irving Penn, *Salvador and Gala Dali*, 1936

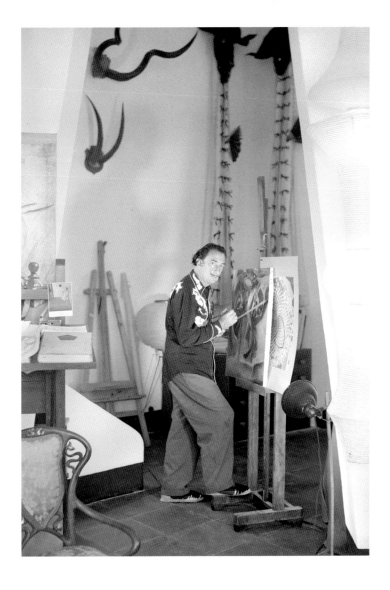

Chevauchée Céleste ('Celestial Ride'), 1957

In the 1950s, Dali produced a series of almost photorealistic paintings that incorporated images from his earlier Surrealist period combined with more contemporary features. In *Chevauchée Céleste*, a faceless virgin brandishing a crutch, rides a rhinoceros, symbol of virility. The rhinoceros totters on impossibly spindly stilt-like legs, recalling Dali's images of elephants from the previous decade, and reversing everything we understand about the solidness and bulk of these huge beasts. Dali's enduring fear of impotence has become strength. Indeed he later remarked in an interview that, 'all the great people who realize sensational achievements are impotent'.

The Catalan plains and beaches of Dali's earlier works have become a landscape that resembles the fairway of a golf course overlooked by a phallic skyscraper wreathed in clouds. However, the familiar small figures appear isolated in the landscape while to the left stands a segmented Classical female form. In the bottom left of the picture a 'soft watch' is draped over a rock, an image that had first appeared twenty-five years earlier, while inset in the rhinoceros's side a baseball game plays on a giant television screen.

MEDIUM

Oil on canvas

PERIOD

Nuclear Mystic

RELATED WORK

Max Ernst, *Celeste*, 1921

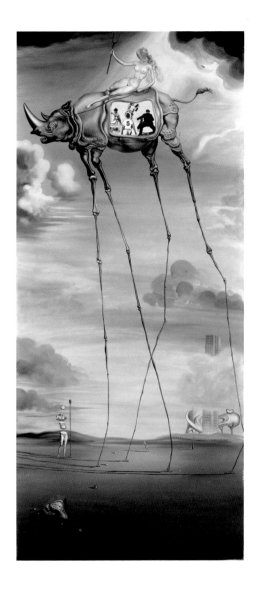

Chocolat, c. 1966

Food is a major recurring theme in Dali's work. Images of bread, seafood, eggs, bacon and meat are scattered throughout his work and here an apple and chocolate dominate the scene. As well as taking great pleasure in eating, Dali used images of food to signify oral pleasure, the earthy realm of the physical, and in some cases an offering to distract the carnivorous hunter.

On a vast flat plain, a woman shaped like a jug dribbles chocolate into a mug balanced on her stomach. The mug overflows spilling on her clothes and on to an apple below, while to her left a kneeling male figure appears to be worshipping her. The jug-shaped woman is a theme that appears in several paintings. Freud interpreted the appearance of a jug or vessel in a dream as signifying a woman 'waiting to be filled'. For Dali the symbol had the added suggestion of fear of the act of sexual intercourse.

Dali gives chocolate, considered an aphrodisiac and greatest of all 'comfort' foods, an unpleasant twist by showing the woman spitting it out and making it look disturbingly blood-like.

MEDIUM

Watercolour and ballpoint pen on paper

PERIOD

Late

RELATED WORK

Victor Brauner, *Cup of Doubt*, 1946

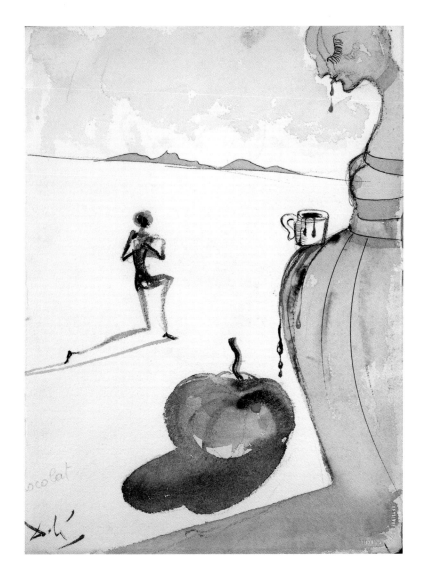

Gala's Foot, 1973

Even at the age of 70, Dali remained fascinated by scientific advances and how these discoveries might be applied to his work. In his book *Ten Recipes for Immortality* (1973), Dali discusses the concept of stereoscopic vision and how it could be used to produce pairs of paintings, which, when viewed together, would produce a three-dimensional image.

Gala's Foot shown here is the left-hand component of a stereoscopic work. To create a three-dimensional effect, the left- and right-hand works were designed to be viewed together using a special floor-standing viewer. Dali's 'stereographic' work was based on photographs that he took with a stereoscopic camera and then used to create pairs of similar, but not identical, photorealistic paintings. For example, in the left-hand image of *Gala's Foot* Dali's jacket is blue and Gala's trousers white, whereas in the right-hand image the jacket is red and the trousers blue.

When the left- and right-hand components of the work are viewed correctly Gala's foreshortened foot, to which Dali is pointing, appears to emerge from the three-dimensional image.

MEDIUM

Oil on canvas

PERIOD

Late

RELATED WORK

Jan Vermeer, *The Art of Painting*, c. 1666–73

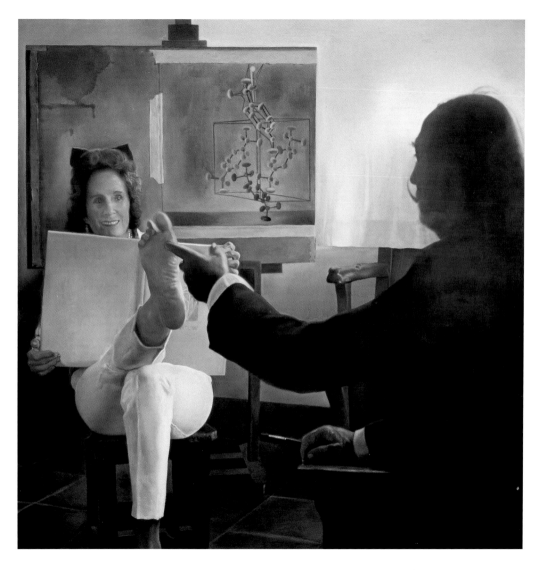

The Angel of Alchemy, 1974

In a gesture of youthful bravado, while at the Madrid Academy of Arts, Dali claimed that he could win an award for a painting without even applying his brush to the surface. He further claimed even to have won an award for splashing paint at the canvas.

In Dali's later life, possibly inspired by the work of Abstract Expressionists such as Jackson Pollock (1912–56), he returned to the concept of splashing paint. In an earlier work *La Char d' Or* ('The Golden Chariot', 1971) Dali imposed a structure on the random splashes he produced. However, in *The Angel of Alchemy*, the image is more abstract and the addition of the skull-like head to produce an angel is more arbitrary.

The reference to alchemy, the medieval quest to turn base metal into gold, can be explained by Dali's use of gold paint, or more subtly perhaps by the artist's ability to produce a work of art, representing gold, out of apparently random splashes of paint, representing base metal.

MEDIUM

Gouache and gold paint on paper

PERIOD

Late

RELATED WORK

Willem de Kooning, *Woman I*, 1950–52

Gala Bouquet, 1979

By 1979 when he painted *Gala Bouquet* Dali's health was failing and his relationship with Gala had deteriorated to the point where they were living apart. It has even been suggested that Dali had to obtain written permission from Gala to visit her during this period.

Gala Bouquet, which from its title is clearly dedicated to her, shows nothing of the meticulous craftsmanship of his major works where even brushstrokes are hard to identify. Here there is evidence of scraping, scratching and even paint thrown at the surface. The almost feverish blending of oil and watercolour and the deliberate blurring into each other of the colours combine to produce an unusually visceral work, very different from the lightness of his *Vase de Fleurs* ('Vase of Flowers') painted in 1959.

In this small work we can glimpse another more personal aspect of Dali's later work. It is as though in producing this bouquet for his lifelong companion he is struck simultaneously by tenderness and anger.

MEDIUM

Watercolour and oil on card

PERIOD

Late

RELATED WORK

Emil Nolde, *Iris*, undated

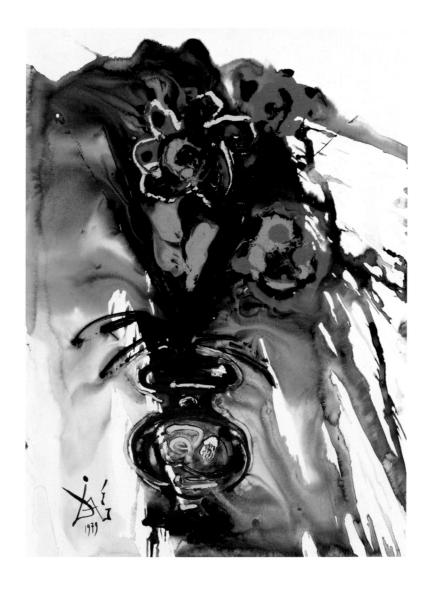

The Anthropomorphic Cabinet, 1982

The year Dali produced the bronze *The Anthropomorphic Cabinet* was the year that Gala, the great and enduring love of his life, died. Although Dali was shattered by her death and his health was clearly failing, he continued to create works of art and initiate new projects.

Anthropomorphism is defined as the attribution of human form or characteristics to nonhuman things. However, in Dali's work the process becomes two-way, with nonhuman forms and characteristics also attributed to humans. In *The Anthropomorphic Cabinet* the figure of a reclining nude, her hair covering her face, appears to be struggling to get up, held down by the weight of the drawers emerging from her chest. 'Chest of drawers' was an English phrase that Dali found endlessly amusing when he first heard it in the 1930s.

Strictly speaking, *The Anthropomorphic Cabinet* is little more than a faithful three-dimensional representation in bronze of the painting of the same name that Dali produced forty-six years earlier in 1936 and can be compared to the statue *Venus de Milo With Drawers* (see page 214) from the same year.

MEDIUM

Bronze

PERIOD

Surrealist

RELATED WORK

Giovanni Battista Bracelli, *Bizarre de Varie Figure*, 1624

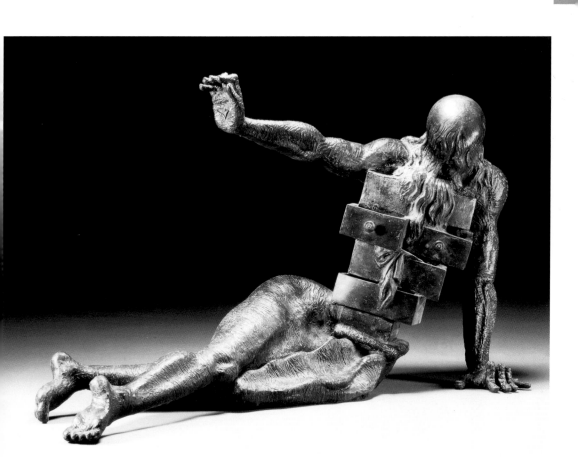

Dalí

Society

Portrait of Luis Buñuel, 1924

This portrait of Dali's friend and collaborator Luis Buñuel (1900–83) was the first work of Dali's to be shown outside Catalunya. When it was first exhibited in 1925 at the Primera Exposicion de la Sociedad de Artisas Ibéricos in Madrid, critics described it as a work both 'serious and calm'. Indeed the style is plainly influenced by the new 'Classical' style that swept Europe after the First World War and found its expression in Spain in the 'Noucentisme' movement.

Buñuel was a dominant figure among Dali's contemporaries in Madrid. He was a powerful macho figure and a keen sportsman, and something of his power comes out in this portrait. Using a very limited range of sombre colours Dali accentuates the thoughtful, almost melancholy, look on Buñuel's face giving him a sense of gravitas. In collaboration with Dali, Buñuel went on to produce the two defining films of the Surrealist movement, *Un Chien Andalou* (1929) and *L'Age d'Or* (1930). The clouds in the background of the portrait, taken from a painting Dali saw in the Prado, appear at the beginning of *Un Chien Andalou*.

CREATED

Spain

MEDIUM

Oil on canvas

PERIOD

Early

RELATED WORK

Christian Schad, *Sonja*, 1928

Salvador Dalí *Born* 1904 Catalonia, Spain

Died 1989

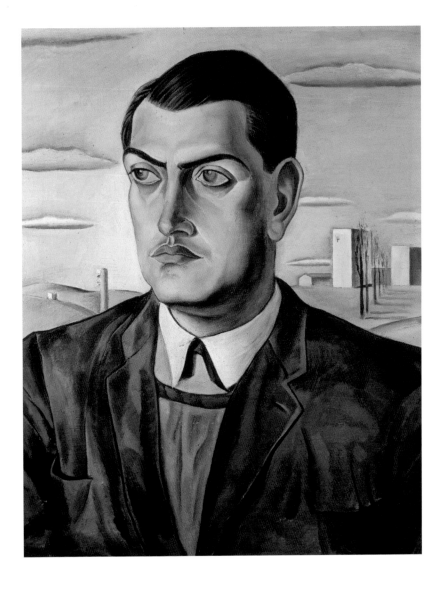

Portrait of Paul Eluard, 1929

In the summer of 1929 a group of Surrealists including Luis Buñuel (1900–83), René Magritte (1898–1967), and Paul Eluard (1895–1952) visited Dali at his studio in Cadaqués. Flattered by the presence of Eluard, a poet and one of the founders of the Surrealist movement, Dali started work on an allegorical portrait of him. It was during this visit that Dali met Gala, Eluard's wife, and was immediately consumed with desire for her. From the moment of their first meeting, Dali's relationship with Gala was to have a profound effect on everything he did.

The finished portrait of Eluard, painted while Dali was embarking on an affair with the sitter's wife, contains many of the symbols that Dali used during this period. The lion's head symbolizes his fear both of his father and of sexual intercourse, and the grasshopper represents hysteria and disgust. These are especially relevant when one considers that Dali claimed to be a virgin at the time of his meeting with Gala, and that his father, upon hearing of the relationship, irrevocably disowned him.

MEDIUM

Oil on board

PERIOD

Surrealist

RELATED WORK

Max Ernst, *The Meeting of Friends*, 1922

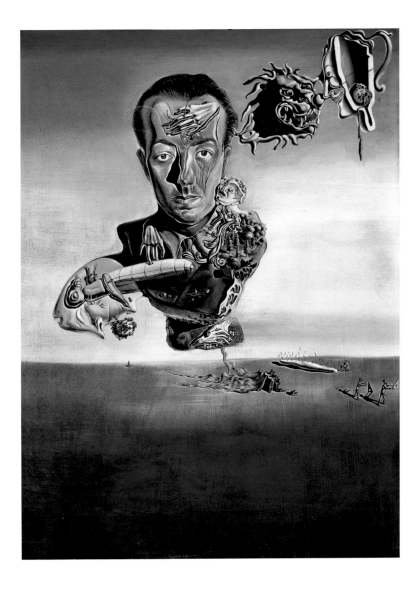

Partial Hallucinations: Six Apparitions of Lenin on a Piano, 1931

Courtesy of Musée National d'Art Moderne, Centre Pompidou, Paris, France, Peter Willi/Bridgeman Art Library/© Salvador Dali, Gala-Salvador Dali Foundation, DACS, London 2006

One of the central tenets of the Surrealists was support for the Communist Party and admiration for the achievements of the revolutionary Russian leader Vladimir Lenin (1870–1924). Dali on the other hand considered that 'Marxism was no more important than a fart, except that a fart relieves me and inspires me'. His trivialization of Lenin's image here, as recurring glowing heads on a piano keyboard, hastened his expulsion from the Surrealist movement.

Dali described the work as a 'hypnagogic' image, one seen when conscious rather than experienced in a dream. He explained the presence of Lenin in the painting thus: 'At sunset I saw the bluish shiny keyboard of a piano where the perspective exposed to my view a series in miniature of little yellow phosphorescent halos surrounding Lenin's visage'. He explained that the image related to a childhood incident, in which he was locked in a dark room as punishment for pushing a child off a bridge. While Dali was in the room he claimed to have found a bowl of cherries. In a gesture typical of Dali, the notes on the sheet music on the piano have been transformed into ants.

MEDIUM

Oil on canvas

PERIOD

Surrealist

RELATED WORK

René Magritte, *La Réponse Imprévue*, 1933

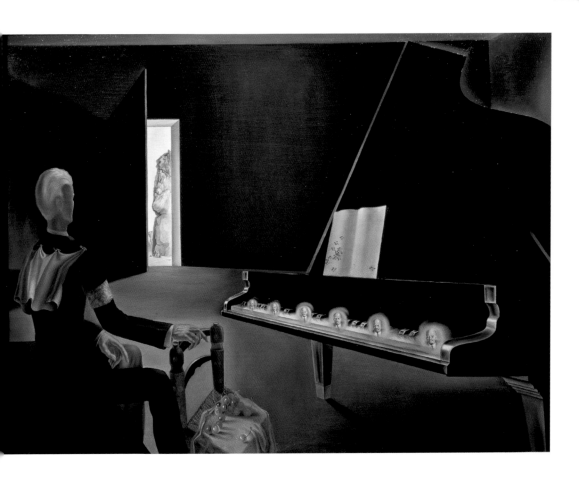

Reconstruction of the Image Known as 'Mae West's Face Which Can Be Used as an Apartment', 1934–35

Courtesy of Museo Dali, Figueras, Spain/Bridgeman Art Library/© Salvador Dali, Gala-Salvador Dali Foundation, DACS, London 2006

Much of the work of the Surrealists was based on subverting the accepted version of reality. One way they did this was to combine apparently unrelated objects to make what they described as a Surrealist object: the lobster telephone (see page 38) is a famous example. Another method they used was anthropomorphism, where nonhuman objects are given human characteristics. Dali developed this further, giving humans nonhuman characteristics.

Working from a photograph of the film star Mae West, Dali deconstructs her face and reconstructs it as a series of anthropomorphic objects. Her eyes become framed paintings, her nose is replaced by a mantelpiece on which a clock sits, her hair is formed by a pair of curtains and most famously her lips are transformed into a rather luscious sofa. Although Dali has added a wooden floor, deep red wall and a circular set of stairs, he still manages to retain the essence of Mae West's appearance in the original photograph. Against apparent logic the enduring image of the piece is not of the Surrealist apartment but of her head.

Dali produced several life-size versions of the sofa, but never created the apartment full size.

MEDIUM

Mixed media

PERIOD

Surrealist

RELATED WORK

René Magritte, *La Rêponse Imprévue*, 1933

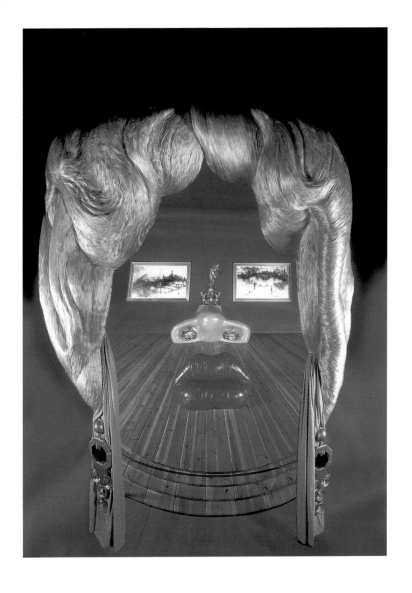

Portrait of Gala Balancing Two Lamb Chops on Her Shoulder, 1933

Part of Dali's technical genius as a painter was his ability to produce photorealistic paintings. Indeed in many of his mature works the brushstrokes are virtually invisible. Throughout his career Dali often used photographs as his principal source, and in this he was little different from the artists, including his hero Jan Vermeer (1632–75), who used optical instruments such as the camera obscura to aid them.

This portrait of Gala is based on a reversed version of a photograph taken at Port Lligat, the couple's recently converted house and studio just outside Cadaqués. In it we see a sleeping Gala, smiling sweetly among the renovations at Port Lligat. The most enigmatic part of the work is a pair of raw lamb chops that Dali has painted on Gala's shoulder.

In Dali's work food is often shown as an offering to distract a cannibalistic outburst, either by Dali or by a father figure, and here it takes the form of sacrificial lamb. Mischievously, however, when explaining the work to the American press, he said that he liked his wife and he liked lamb chops so he didn't see why he shouldn't combine the two.

MEDIUM

Oil on canvas

PERIOD

Surrealist

RELATED WORK

Roland Penrose, *Winged Domino: Portrait of Valentine*, 1938

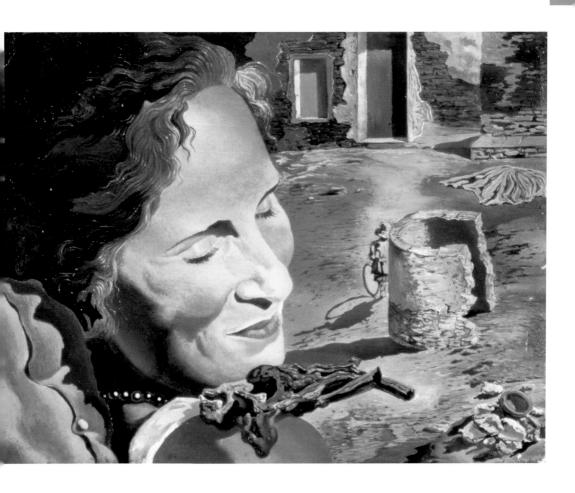

Portrait of Mrs Reeves, 1954

Like many great artists, Dali painted portraits both of himself and others throughout his long career. Some of these works were part of his exploration of his art, others were examinations of his relationship to his friends and family, and others still were works that he produced commercially, to commission.

Portrait of Mrs Reeves is an example of Dali's skill as a society portrait painter. Many of these portraits of wealthy socialites contained predominant elements of the surreal imagery associated with Dali, but this example is, in many ways, a portrait in the traditional genre. The imposing Mrs Reeves stands slightly to the left of centre dressed in a flowing brown ball gown with a shawl draped over her arm and holds, like many of the subjects of Dali's portraits, a red carnation, symbolizing mortality. Her whole appearance and demeanour is that of the successful society hostess.

Formal as Mrs Reeves appears, she stands in a vaguely Dalinian environment. In the distance a prancing white horse crosses a desert plain passing in front of a domed temple-like building, which is probably a reference to the building in Raphael's *The Marriage of the Virgin* (1504).

MEDIUM

Oil on canvas

PERIOD

Nuclear Mystic

RELATED WORK

Cecil Beaton, *Her Majesty the Queen*, 1955

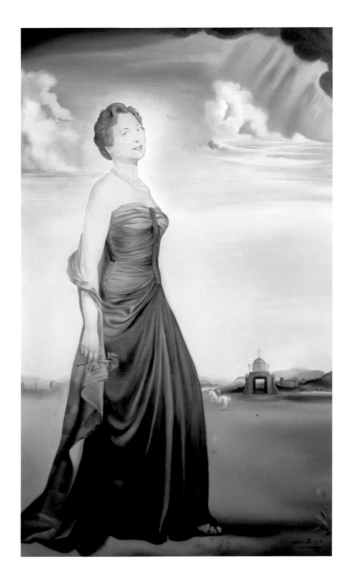

Portrait of Mrs Jack Warner, 1945

In 1945 Dali was living in California and becoming increasingly involved with the commercial film world in Hollywood. He was working with Alfred Hitchcock and Walt Disney, and was clearly at home with the all-powerful studio system that dominated Hollywood at the time.

Mrs Jack Warner, the subject of this unconventional portrait, was the wife of Jack Warner, one of the four founding brothers of Warner Bros Studios, and its boss. The slightly dishevelled Mrs Warner, her Medusa-like hair mirrored in the shape of the bizarre cloud formations above her, sits to the left of the work, her arm resting on what appears to be a Classical sarcophagus. She gazes into the middle distance, clearly oblivious of the strange landscape in which she finds herself. To her right, a strange conglomeration of Classical buildings rise from a flat barren plain with a ruined bridge that appears to have no purpose.

The notoriously cantankerous Jack Warner was so delighted with the portrait of his wife that he commissioned one of himself. He famously described the resulting work as, 'an excellent portrait of my dog'.

MEDIUM

Oil on canvas

PERIOD

Classic

RELATED WORK

Leonor Fini, *The Ends of the Earth*, 1949

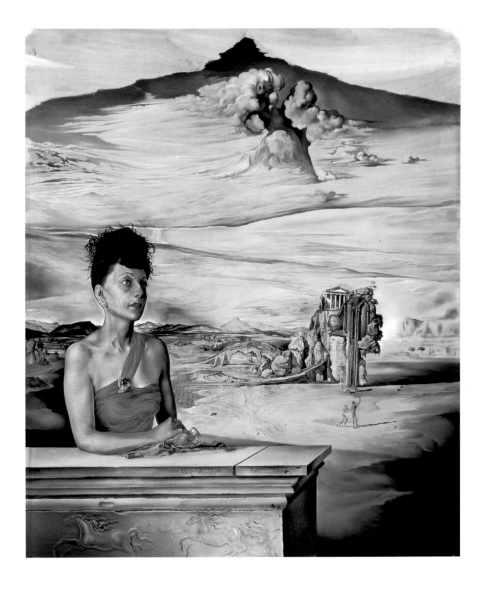

Portrait of My Dead Brother, 1963

Less than ten months before Dali's birth, his brother, also called Salvador, died. Despite the fact Dali never met him, his dead brother was to have a profound influence on him throughout his life. Dali felt that he was little more than a replacement for this child.

The image of a boy rendered in enlarged half-tone dots hovers over a typical Dali landscape. The boy's hair suggests the shape of a crow with outstretched wings, a common symbol of death. To the right stands a group of conquistadores, symbolizing Dali's battle to vanquish the spectre of his brother. To the left is a reworking of Jean François Millet's (1814–75) *The Angelus*, a work that Dali returned to constantly throughout his life. The newspaper image that Dali chose for his brother's face is too old, and looks nothing like the first Salvador.

The use of dots to produce images similar to enlarged newspaper photographs was a popular technique in the 1960s and was used by Andy Warhol. Fellow American painter Roy Lichtenstein (1923–97) produced images that appear to be greatly magnified comic strips using Benday dots, which give a similar, but cruder, half-tone effect.

MEDIUM

Oil on canvas

PERIOD

Late

RELATED WORK

Andy Warhol, *Most Wanted Man No 10, Louis M*, 1963

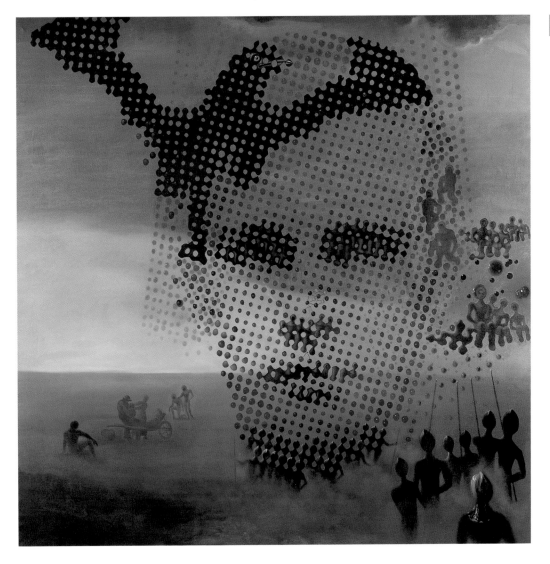

Portrait of Picasso, 1947

When Dali was six, Pablo Picasso (1881–1973) visited the home of the Pichots in Cadaqués. Dali was certainly staying in Cadaqués at the time and was aware of the visit. In 1926, seventeen years later, he visited Picasso at his home in Paris, where the great artist gave encouragement to his young fellow Spaniard. Dalí's work throughout the 1920s shows the influence of Picasso, and Dali clearly held him in high esteem.

After the Spanish Civil War, during which time Picasso was vehemently anti-Fascist, the relationship between the two artists cooled. Dali's portrait of Picasso shows how much his opinion of Picasso had changed by the 1940s. Dali places the bust of Picasso on a Classical plinth, signifying Picasso's status and importance. However, Dali transforms the actual likeness of Picasso into a series of less-than flattering symbols. Picasso's brain has extended into a chameleon-like tongue indiscriminately shovelling up inspiration for his work. The lute in the spoon-like tip is the symbol of the lover.

Dali felt Picasso was responsible for much that was wrong with modern art and symbolizes this by placing a rock above Picasso's head.

CREATED

America

MEDIUM

Oil on canvas

PERIOD

Classic

RELATED WORK

Pablo Picasso, *Woman with Hat Seated in an Armchair*, 1941

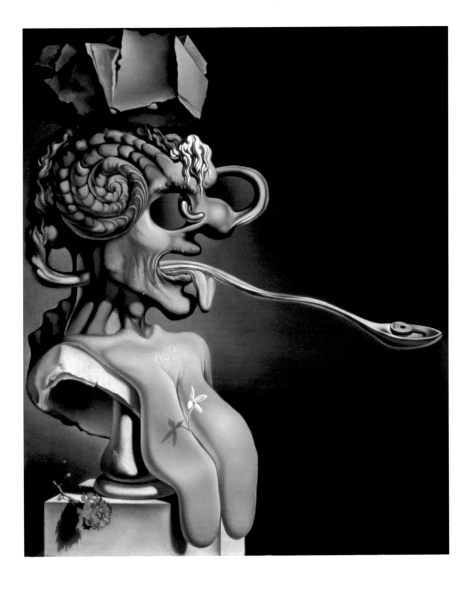

Still from *Un Chien Andalou*, 1929

While he was studying in Madrid, Dali met and befriended Luis Buñuel (1900–83). In January 1929 they began working together on the script for a film that Buñuel was going to shoot in Paris in April, financed by Buñuel's wealthy mother. The film was to have no obvious narrative but was to consist of a number of deliberately disturbing scenes based on Buñuel's and Dali's dreams.

On 6 June 1929 the short 17-minute film, *Un Chien Andalou*, was premiered in Paris in the presence of the Surrealist group and what Buñuel described as 'the fine flower' of Parisian society. The two collaborators' ambition was clearly to shock. Bizarre, unnerving scenes unfolded with no apparent logic, cut together to make a thoroughly unsettling montage. A severed hand appears with ants crawling from a hole in its centre, two dead donkeys are seen putrefying on grand pianos, and, most shockingly, a woman's eye appears to be sliced by a razor.

The venerable and respected *Cahiers d'Art* commented that this one razor slash had 'destroyed the pretensions of all those for whom art was but a matter of pleasant sensations'.

CREATED

France

MEDIUM

Film still

PERIOD

Surrealist

RELATED WORK

Man Ray, *Anatomies*, 1929

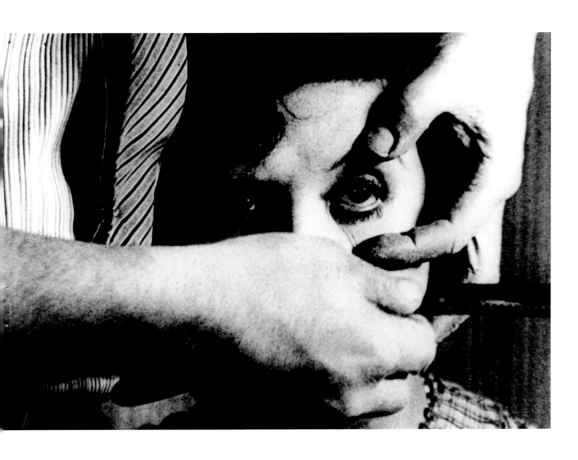

The Enigma of Desire or My Mother, My Mother, My Mother, 1929

Dali's mother Felipa died suddenly of cancer of the uterus in February 1921 when Dali was just 16. Her death was a huge blow to Dali. She had showered Dali with unconditional love, recognizing only his strengths and, unlike his father, was blind to Dali's faults.

The Enigma of Desire, originally called *The Image of Desire*, appears to be a homage to his mother. On a characterless beach with a precisely defined horizon sits an enormous rock that merges into the sleeping head of Dali. In niches in the rock is inscribed repeatedly the phrase *ma mère* ('my mother'). To the left of the rock is a strange composite creature and through a womb-like hole in the rock can be seen a woman's torso framed by a hole in another rock.

This is not a comfortable painting. Disturbing Freudian images, the severed hand with a dagger, the jug-shaped woman and the violently slashed breasts of the distant torso, are combined with Dali's familiar images of death, decay and the fear of sexual inadequacy.

MEDIUM

Oil on canvas

PERIOD

Surrealist

RELATED WORK

Max Ernst, *Forest*, 1927

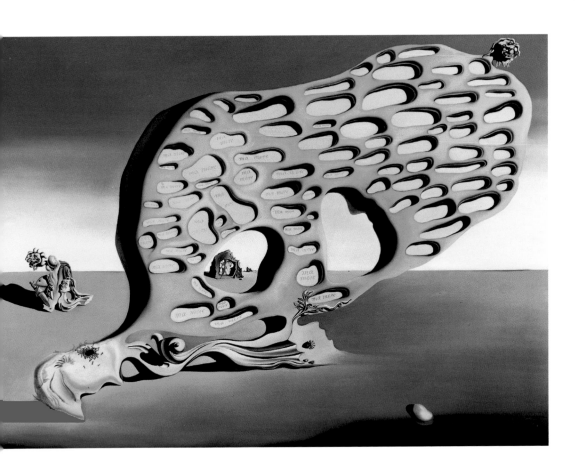

Necrophiliac Fountain Flowing from a Grand Piano, 1933

Ramon Pichot, who lived in the coastal village of Cadaqués, was a friend of Dali's father and part of an extended family of gifted artists. He is credited with inspiring Dali to become an artist. At their seaside estate, the Pichot family gave impromptu open-air concerts, sometimes around a grand piano, which the young Dali would attend.

Between 1932 and 1934 Dali painted a number of small pictures containing grand pianos. In Dali's paintings, however, the piano is not the source of pleasant childhood reminiscence. Works such as *Skull With a Lyric Appendage*, *Chemist Lifting With Extreme Caution the Cuticle of a Grand Piano*, and *Atmospheric Skull Sodomising a Grand Piano*, all painted in 1934, show a more neurotic attitude to the instrument.

In *Necrophiliac Fountain...* the piano has assumed the shape of a stone sarcophagus, the cypress tree on the lid referring both to the tree's association with graveyards and the cypress trees on the Pichot estate. A stream flows out of the tomb-like piano into a piano-lid-shaped pool beneath it. The water flowing from a 'dead' place into the ground gives the spring its necrophiliac quality.

MEDIUM

Oil on canvas

PERIOD

Surrealist

RELATED WORK

Giorgio de Chirico, *Ariadne*, 1913

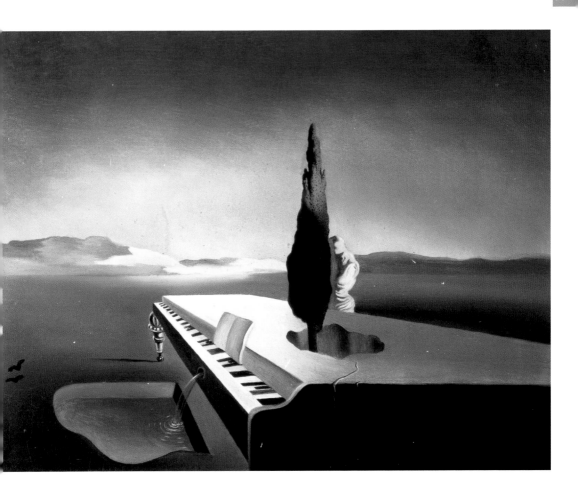

The Great Masturbator, 1929

Throughout his life Dalí was never afraid to confront and illustrate his sexual neuroses in graphic detail. Until his meeting with Gala he professed to be a virgin and Dalí certainly had a fear of heterosexual sex at this time.

What is clear is that Dalí had a guilty preoccupation with masturbation and an accompanying fear of castration as punishment. All of his sexual fears, guilt and desires are enunciated in this great painting, which was to foreshadow so much of his later work. Dalí painted it in the momentous summer of 1929, soon after his first meeting with Gala.

The complex central image, containing many of Dalí's recurring symbols, stands on a typically vast empty plain. The form, like so many in Dalí's work, is based on the strange rock formations he saw as a child at Cap de Creus, Cadaqués. To the right Dalí's head can be seen, its nose resting on the ground, but in place of his mouth is a giant grasshopper. To the right meanwhile a woman's head emerges with her mouth close to the genitals of the lower torso of a male form.

MEDIUM

Oil on canvas

PERIOD

Surrealist

RELATED WORK

Max Ernst, *Men Shall Know Nothing of This*, 1923

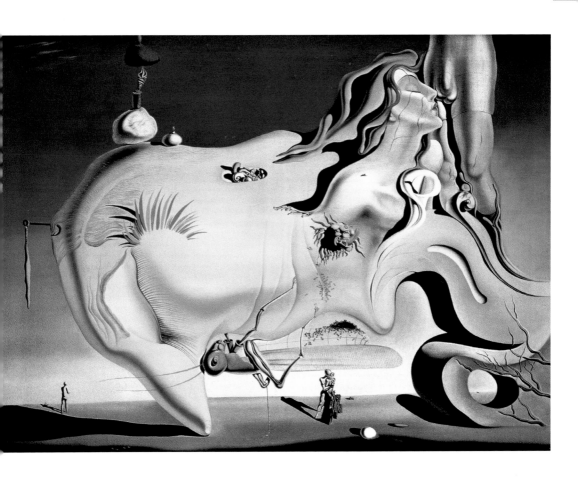

The Birth of Liquid Desires, 1932

Gala worked tirelessly promoting Dali and his work during their life together, and advising him on the direction his career should take. *The Birth of Liquid Desires* was personally sold by Gala to Peggy Guggenheim in 1940 and now hangs in the Venice Guggenheim Museum.

The work brings together many of the complex images that Dali used in the early 1930s. For example, the central image of a large rock is one of Dali's recurring references to the rock formations around Cap de Creus, although here the rock appears to float on the sea rather than rest on the beach. In the upper right-hand corner water flows from a chest of drawers, an allusion to the works of Freud and the repression of inner fears. The cypress trees below the chest signify death and happy childhood memories of the Pichot estate in Cadaqués. They also refer to a public fountain set among cypresses near his home in Figueras.

In the same year, 1932, Dali painted a companion piece, *The Birth of Liquid Fears*, a more minimal work featuring a single cypress tree.

MEDIUM

Oil on canvas

PERIOD

Surrealist

RELATED WORK

Max Ernst, *The Eye of Silence*, 1943–44

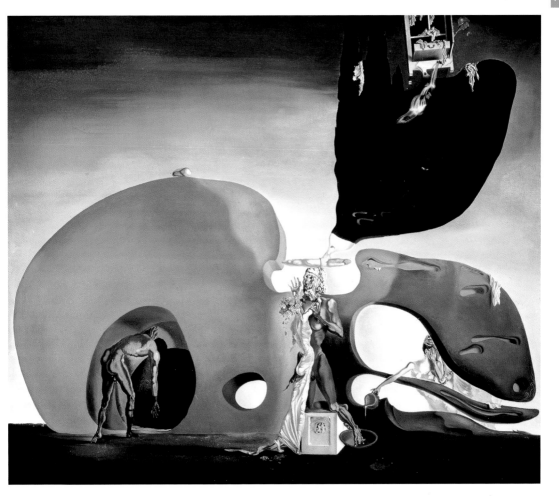

The Spectre of Sex Appeal, 1934

Dali's view of sexual matters was influenced by the many sexual neuroses he accumulated as a child and a young man. Rather than hide or repress these difficult feelings and emotions, Dali cultivated them and used them as the basis of much of his work.

The Spectre of Sex Appeal, which Dali also called 'The Spectre of Libido' is a tiny (18 cm x 14 cm/7 in x 5.5 in) work, but within its highly detailed composition are laid out many of Dali's fears relating to the sexual nature of women. In a cove remembered from his childhood stands a quizzical young Dali, the picture of innocence in his sailor's suit and cap, yet he holds Freudian male and female symbols of a bone and hoop. Unafraid, the child looks up at a monstrous headless apparition supported by two Dalinian crutches.

The form is clearly female but parts of her anatomy are missing and others are mere stumps. Her womb and breasts have become rough sacks bursting free from a rudimentary bathing costume. These sacks are a direct reference to Jean François Millet's *The Angelus*, elements of which appear in Dali's work throughout his career.

MEDIUM

Oil on panel

PERIOD

Surrealist

RELATED WORK

Paul Delvaux, *The Visit*, 1939

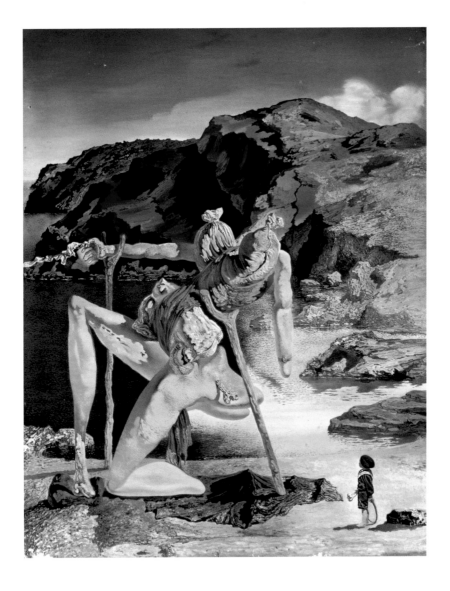

Ensorcellement – Les Sept Arts ('Bewitchment – The Seven Arts'), 1957

This is one of a series of paintings produced by Dali in 1957 to depict each of the seven arts, including dance, opera and music. In 1944, Dali had produced an earlier set of seven, based on the same set of subjects, for impresario Billy Rose's Ziegfeld Theatre in New York. Unfortunately these images were destroyed in a fire at Billy Rose's home, so Dali produced this second series for him as a replacement.

This image represents sorcery and shows the sorcerer or magician as having a long, reptilian neck and the body of a jewelled tortoise. The sorcerer's hat is elongated and supported on a Dalinian crutch, resting on a smaller tortoise. The weeping face on the hat contrasts dramatically with the grinning face of the sorcerer, suggesting that magic is all about deception. The spectre holding a candle links sorcery to the 'dark arts'. In the earlier version, destroyed in the fire, the image is more complex and the sorcerer's face more grotesque.

MEDIUM

Oil on canvas

PERIOD

Nuclear Mystic

RELATED WORK

Reuben Mednikoff, *Two Children and a Monster*, 1938

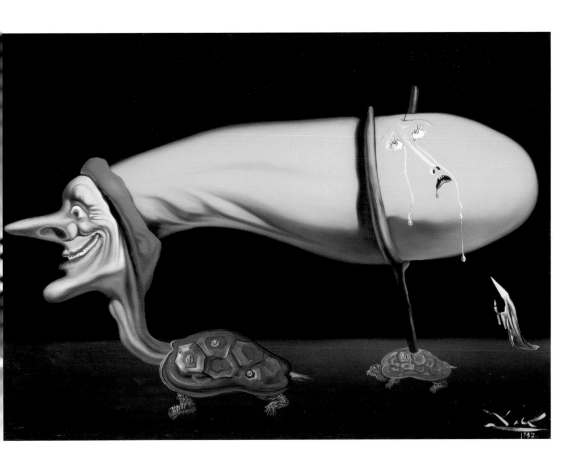

La Danse (The Seven Arts – Rock 'n' Roll), 1957

Courtesy of Christie's Images Ltd/© Salvador Dali, Gala-Salvador Dali Foundation, DACS, London 2006

In 1943 Dali was in America and was accepting commissions for a variety of different projects. The American impresario Billy Rose had recently bought the Ziegfeld Theatre in New York and asked Dali to produce a series of paintings for the theatre's foyer. Seven works were commissioned to illustrate the theatre's opening production in a series called *The Seven Lively Arts*. The works included *The Cinema, The Opera, The Ballet, The Theatre, The Radio* and *Boogie Woogie*.

The pictures were a huge draw for the theatre although they were destroyed in a fire in 1956. Dali repainted the complete cycle in that year, but *Boogie Woogie* had gone out of fashion and Dali replaced it with *Rock 'n' Roll. La Danse – Rock 'n' Roll* is a visceral image of the energy of rock and roll. On another of Dali's endless beaches, two dancers, who appear oblivious to each other, are being destroyed by an all-consuming passion that causes their bodies to writhe and contort.

In the same year that he produced the second *Seven Lively Arts* series, Dali and Gala launched a new perfume under their own Dali 'brand', also called Rock 'n' Roll.

MEDIUM

Oil on canvas

PERIOD

Nuclear Mystic

RELATED WORK

Francis Picabia, *Spanish Night*, 1922

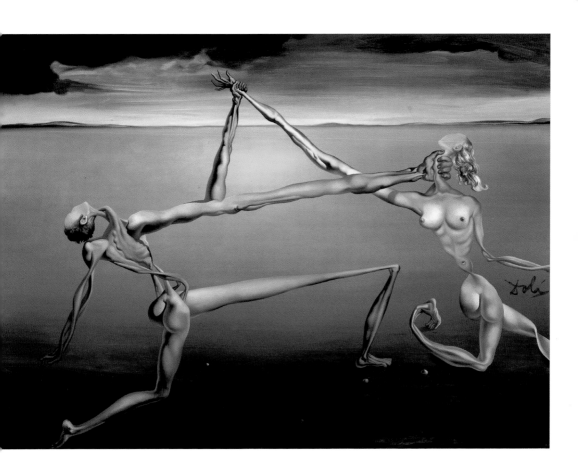

The Invisible Lovers, 1946

Within a couple of years of their arrival in America, it became clear to Gala and Dali that they could make money by associating the Dali 'brand', already growing fast, with other commercial enterprises. Dali's ability to turn out unique high-quality illustrations in a variety of media, virtually to order, quickly made him popular. In 1943, the couturière Elsa Schiapperelli commissioned him to produce illustrations publicizing a new range of designer cosmetics. The hosiery manufacturer Bryants followed and soon upmarket companies were queuing up to use Dali's images in their advertising.

The Invisible Lovers is part of a series known as *The Desert Trilogy* commissioned by the Shulton Company, producers of Old Spice, to advertise a new brand of perfume. Dali was quite mercenary in his approach to these commercial commissions and was often prepared to do little more than recycle images from his earlier work in an apparently arbitrary way to satisfy his clients' demands.

The invisible lovers of the title refer to the rocky outcrops on the horizon of the work. Their shapes echo *Archaeological Reminiscence of Millet's Angelus*, one of Dali's many representations of Millet's famous painting.

CREATED

America

MEDIUM

Oil on canvas

PERIOD

Classic

RELATED WORK

Max Ernst, *Napoleon in the Wilderness*, 1941

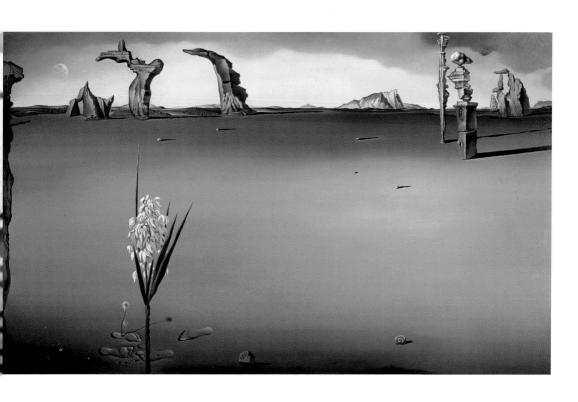

Flesh Wheelbarrow, c. 1947

Dalí had an obsession with Millet's painting *The Angelus* and quotes elements from it in many of his works. In this heavily annotated drawing he selects just the wheelbarrow from Millet's painting and, instead of the sacks depicted in the original, shows it carrying a box or cabinet containing a contorted and barely recognizable human form.

Dali used this drawing to illustrate an essay called *Fifty Secrets of Magic Craftsmanship*, written in 1947, in which he discusses the art of painting, in his typically eccentric style. He claims that the image of the wheelbarrow appeared to him in a dream, and describes this process in detail.

In around 1953, Dali wrote the screenplay for a film called *The Flesh Wheelbarrow*, sadly never put into production, based on a story about a paranoiac woman who falls in love with a wheelbarrow, which eventually reincarnates and becomes flesh. The scenes, described in Dali's *Diary of a Genius*, would have included six rhinoceroses falling out of windows into the Trevi Fountain in Rome, a bald old woman standing in the middle of a lake with an omelette on her head, and five swans, stuffed with pomegranates, exploding.

CREATED

America

MEDIUM

Pen and ink on paper

PERIOD

Classic

RELATED WORK

Félix Labisse, *Libidoscaphes dans la Baie de Rio*, 1962

Flesh wheel barrow

Typical reverie of A[?] "slumber with a Key"

"instantane"

Continuum of Four Buttocks, Five Rhinoceros Horns Making a Virgin, Birth of a Deity, 1960

Of all Dali's cryptic works *Continuum of Four Buttocks...* is among the most enigmatic. The painting appears to be little more than five vaguely phallic shapes converging on a nail, against the background of a placid sea and a bright blue sky.

By the time Dali painted this work in 1960, many of his symbols were so deeply related to his own personal view of the world as to be almost impenetrable. Rhinoceroses, and more particularly their horns, held a fascination for Dali and show how he could hold seemingly contradictory beliefs about the same thing at any one time. On the one hand Dali makes the common connection between rhinoceroses and virility since rhinoceros horns are both phallic in shape and are said to have aphrodisiac qualities. However, he also conflates the rhinoceros horn and the unicorn horn. In legend the unicorn can be tamed only by a virgin, leading Dali to associate rhinoceroses with chastity.

The nails appear to be symbols of the Crucifixion, but may also relate to Dali's experiments at the time using an ancient firearm, called an arquebus, to fire nails at canvases to create images.

MEDIUM

Oil on canvas

PERIOD

Nuclear Mystic

RELATED WORK

René Magritte, *The Voice of the Winds*, 1928

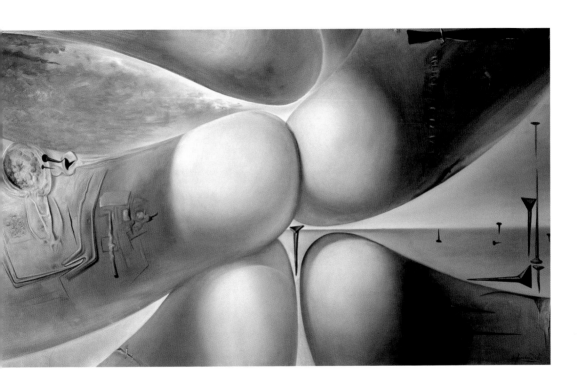

L'*Antiracisme* ('Anti-racism'), 1973

Dalí produced this image of the Three Graces for Maurice Weinberg, who worked for the United Nations Educational, Scientific, and Cultural Organization (UNESCO). He asked Dalí to execute an accessible work that would show goodwill and understanding between Caucasian, Asian and Black races. In response, Dalí produced this unusual and rather atypical image. It has a photographic quality, yet in fact the figures are crisply embossed out of thick paper and then rendered with casually applied watercolour, including streaks of colour below the feet of the figures to represent reflections. This seems to have been an experimental technique that Dalí did not pursue.

The image has certain similarities with *Le Calm Blanc* (1936, see page 40), produced almost four decades earlier. Both have a snapshot-like quality and the figures appear to be standing on the shore of an endless stretch of water.

Whether the image meets the demands of the brief is debatable. Even given the date it is naïve in its approach, and fails to show any understanding or empathy between the three women, who appear bored and hostile.

MEDIUM

Watercolour, gouache, brush and black ink on embossed paper

PERIOD

Late

RELATED WORK

Sigmar Polke, *Girlfriends*, 1965

Illustration for *Vogue*, 1944

During the nine years Dali made his home in America he became increasingly involved in undertaking commercial illustration work. Dali's enduring involvement with haute couture, jewellery and the trappings of wealth meant his work often appeared in magazines such *Vogue*.

In 1941 *Vogue* published an article in which Dali discusses jewellery he had made in collaboration with the Duke of Vedura. In 1943 *Vogue* featured the murals that Dali had produced for Helena Rubinstein's Manhattan apartment and, in early 1944, published an article with the intriguing title 'Dream vs Reality', illustrated by Dali. By the end of 1944 Dali was an established contributor to the magazine having already produced the cover for the April edition. As well as producing a number of other *Vogue* covers including the 1946 Christmas edition, Dali collaborated on fashion shoots for *Vogue* with the photographers Philippe Halsman and Horst P. Horst.

This image shows a proposal for a cover of another of the 1944 editions of *Vogue*. Three sketchily depicted female figures stand on a plain with distant sea and rocks. The figure to the left is elegantly clad whereas her two companions are more shadowy figures.

CREATED

America

MEDIUM

Watercolour and pen and ink on card

PERIOD

Classic

RELATED WORK

Irving Penn, *Twelve Most Photographed Models, New York*, 1947

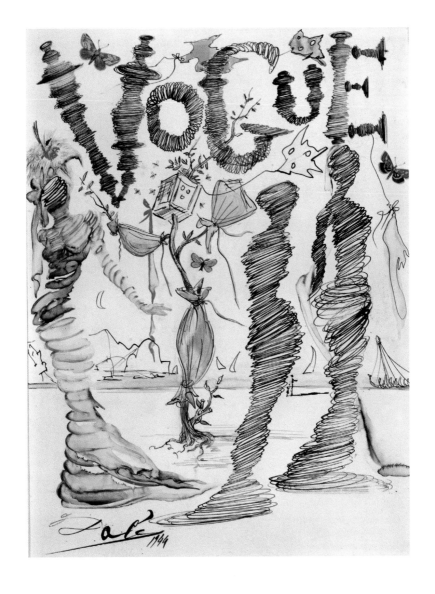

Composition à la Jambe ('Composition with a Leg'), 1944

One of the reasons for Dali's split with the Surrealist movement was his willingness to accept commissions for what they perceived as purely commercial motives. By the 1940s Dali was becoming an extremely successful commercial designer and illustrator, but his commissions never constricted his creativity.

Composition à la Jambe is part of a series of advertisements Dali produced for Bryants' hosiery from 1944 to 1947. Although one of Bryants' products certainly features predominantly, the photograph of the stockinged leg is set in a typical Dalinian landscape. An ant crawls across a rock in the foreground while the leg itself is part of a strange mechanical construction resting on a further three legs. Various unrelated characters go about their business, including an elderly couple who appear to be riding on turtles, while an almost-human clock tower, its face a visual pun, can be seen crumbling in the distance.

A year later the clock tower appeared again, its hands still pointing to five past five, in one of a series of two hundred illustrations for Dante's *The Divine Comedy* that the Italian Government commissioned Dali to produce.

MEDIUM

Pen, brush, india and brown inks with collage on paper

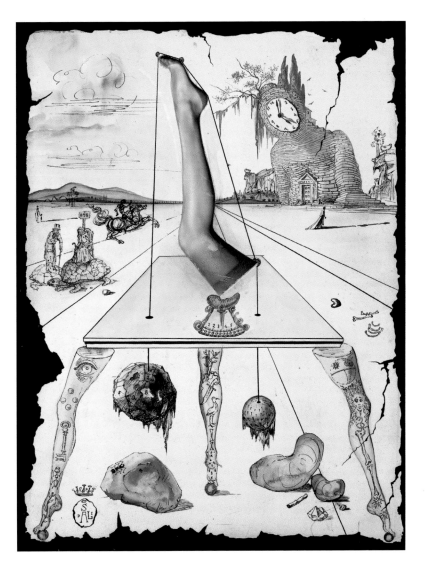

Design for the Costume for 'The Woman of the Future', 1953

Dali had a passion for the trappings of wealth, which was a constant source of irritation to his fellow Surrealists, and was in part to lead to his expulsion from the movement. Throughout his life he produced designs for expensive jewellery, lavish stage sets, haute couture and hair design and even endorsed his own brand of perfume.

In his *Design for the Costume for 'The Woman of the Future'*, a New York fashion contest Dali entered in 1953, his concept of Futurism does not extend to practicality. In his watercolour and collage sketch for his entry, a woman holds a huge butterfly fan and poses in an elaborate ball gown. The gown is suspended from her hair, which extends behind her in a rigid mass supported by a crutch held up by a servant. The completed dress, made up to Dali's design, was so vast that the photographer, Philippe Halsman, found it impossible to photograph in the street.

A woman wearing an earlier version of this particular dress design can be seen in Dali's watercolour sketch *Lago di Garda* (1949, see page 162)

CREATED

America

MEDIUM

Watercolour, collage and pen and brown ink on paper

PERIOD

Nuclear Mystic

RELATED WORK

Philippe Halsman, *The Woman of the Future*, 1953

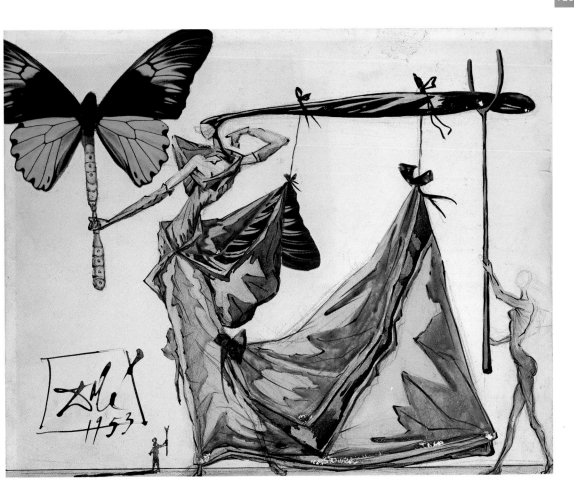

Masked Mermaid in Black, 1939

The New York Fifth Avenue department store Bonwit Teller had gained huge publicity by commissioning Dali to design window displays for them in 1936 and 1939.

The success of the window displays and a record-breaking exhibition at the Julien Levy Gallery led to a lucrative commission to design a 'Surrealist Pavilion' in the Amusement Area of the vast 1939 New York World's Fair. Dali's outlandish design for the pavilion was originally called *Bottoms of the Sea*, but soon renamed *Dream of Venus*. *Masked Mermaid in Black* is one of Dali's costume designs created for 'splendid female underwater swimmers' who were to be placed in an enormous tank that was the centrepiece of the design. The overtly fetishist costumes were to be produced in rubber, apparently by a co-sponsor of the pavilion.

In the event, Dali's ideas were too much for the organizers, who decided to retain the tank with its rubber telephones and 'supine rubber woman painted to resemble the keyboard of a piano', but to replace the rubber-clad mermaids with, 'living girls, nude to the waist and wearing little Gay Nineties girdles and fish-net stockings'.

MEDIUM

Gouache on paper

PERIOD

Surrealist

RELATED WORK

Alberto Giacometti, *Woman with her Throat Cut*, 1932

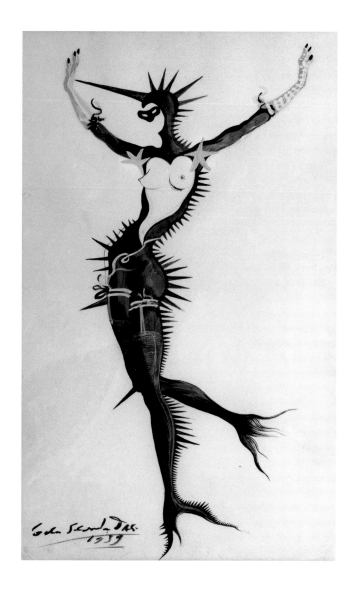

Rousillon – French Railways, France, 1969

In 1969, Dali was commissioned by the SNCF (*Société Nationale des Chemins de Fer Français* – the French national railways) to produce a series of six posters, each of which was to depict a specific region of France. The six posters advertise the attractions of the Alps, Alsace, Auvergne, Normandy, Paris and Rousillon. A limited edition of three hundred signed and numbered lithographic prints was produced for each image, as well as an unlimited number of posters, which were used for a Europe-wide publicity campaign by the French railways.

Roussillon, shown here, includes the painting *The Railway Station at Perpignan* as the upper part of the poster. Perpignan is the cultural capital of Roussillon, the French Mediterranean region immediately north of Spain. Painted by Dali in 1965, the original image contains elements from Millet's *The Angelus*. Here it has been modified by the addition of a red border and collaged images of butterflies.

Dali had a fascination with Perpignan Railway Station and said that it was similar in structure to the universe. He also claimed that when he was approaching it on a train he experienced a 'mental ejaculation'.

MEDIUM

Lithographic poster

PERIOD

Late

RELATED WORK

Francis Picabia, *Machaon, c.* 1926–27

Peridot, diamond and gold jewellery, *c.* 1965

Dali used every form of artistic expression available to him to pursue his vision of art as a global language on which no limits were placed. Toward the end of the 1930s, encouraged no doubt by the wealthy Americans he and Gala were increasingly socializing with, Dali became interested in the design and production of jewellery. Over the rest of his lifetime he produced the designs for many unique and beautiful pieces of jewellery. As well as producing the detailed designs for the pieces, Dali chose each unique stone and jewel that was used, paying attention not only to their value but also to their symbolic associations.

This particularly spectacular collection of jewels, made by the American goldsmith Charles Valliant for a Mrs Owen Cheatham, includes the 'Fantasy Necklace', a fabulous piece described when it last came to auction as, 'a flexible textured gold-brick choker, enhanced by three sculpted lion motifs, each with circular-cut emerald eyes, spilling a baguette and circular-cut diamond waterfall'.

The piece's detachable collar is set with peridots. These are a particularly ancient gemstone, said to be the favourite jewel of Cleopatra.

CREATED

America

MEDIUM

Textured gold, platinum, diamonds and precious stones

PERIOD

Late

RELATED WORK

Salvador Dali, *The Tree of Life Necklace*, 1949

Solitude, 1931

In an earlier painting, *Illumined Pleasures* (1929), a small figure can be seen, his face and body turned towards a solid frame. In *Solitude* this figure has become the central image leaning in towards a rock as though attempting to enter into its very essence.

Solitude is painted in shades of limpid green that give land something of the appearance of water. The thin figure facing a large green outcrop adopts a prayer-like, suppliant pose oblivious of his surroundings. Indeed he appears so engrossed in the rock that his head seems to be absorbed into it. His right shoulder appears to be metamorphosing into shells and fossils, an image repeated in *The Great Masturbator* (1929, see page 100) and *The Lugubrious Game* (1929, see page 312). Shellfish held a fascination for Dali, for whom they symbolized the hard outer casing that protected the soft, vulnerable inner self.

In his youth and early manhood Dali spent much of his time alone, and there is no doubt that isolation suited him. Initially he was worried that his relationship with Gala would destroy his privacy and 'annihilate my solitude'.

MEDIUM

Oil on canvas

PERIOD

Surrealist

RELATED WORK

René Magritte, *Homesickness*, 1949

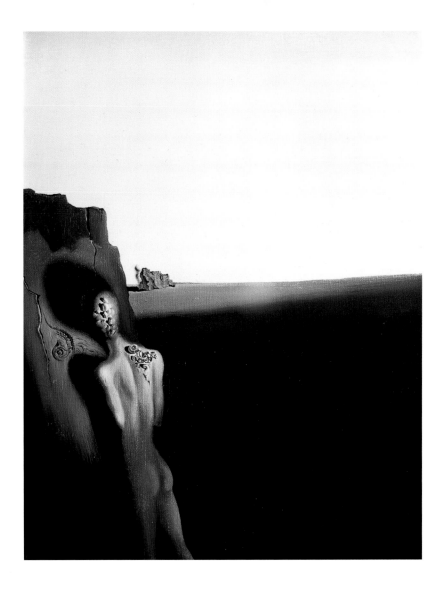

Autumnal Cannibalism, 1936

Autumnal Cannibalism is one of several major works Dali produced in response to the threat and subsequent outbreak of the Spanish Civil War in 1936. *Soft Construction with Boiled Beans* (1936, see page 142), the work that most closely resembles *Autumnal Cannibalism*, depicts the full horror and agony of war. In *Autumnal Cannibalism* itself, however, Dali's stated belief in the pathos, inevitability and pointlessness of all warfare is clearly apparent.

Dali saw conflict as being as natural as the landscape itself, 'a pure phenomenon of natural history', and remained detached from the civil war, refusing to take sides even when the Fascist forces brutally murdered his great friend the poet Lorca.

The image of two entangled torsos devouring each other is made all the more horrific by the languid, almost affectionate, way they are going about it. On one of the heads rests a peeled apple alluding to the story of William Tell, in which a father is forced to shoot an apple from the head of his son. Dali used this legend to symbolize his struggle to break free from the unhealthy influence of his father.

MEDIUM

Oil on canvas

PERIOD

Surrealist

RELATED WORK

Max Ernst, *Zoomorphic Couple*, 1933

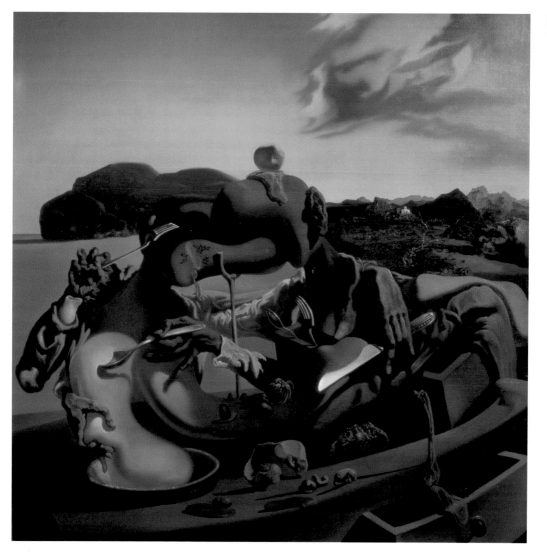

Sans Titre ('Untitled'), 1942

Dali's father had a prudish attitude to his young son's development. To discourage a relationship he thought his son was having, Dali claims his father left a book containing lurid full-colour illustrations of the results of venereal disease open on the grand piano in the living room of their home. The incident had a profound effect on the impressionable adolescent.

Dali's association of sex with death and his fear of venereal disease are expressed in this poster he produced as part of a campaign called 'Soldier, take warning'. In 1942, following America's entry into the Second World War, sexually transmitted diseases were rife among American soldiers newly commissioned to fight. In this arresting image, two sexually alluring women pose provocatively under a moth-infested streetlight while a wide-eyed soldier looks on. Dali creates a striking double-image in which the two women can also be seen as a skull, their thighs and suspenders forming its teeth and their downcast heads its eyes.

In a famous photograph by Dali's regular collaborator Philippe Halsman, he recreates Dali's related drawing *Human Skull Consisting of Seven Naked Women's Bodies* using naked women.

CREATED

America

MEDIUM

Oil on canvas

PERIOD

Classic

RELATED WORK

Philippe Halsman, *Human Skull consisting of Seven Naked Women's Bodies*, 1951

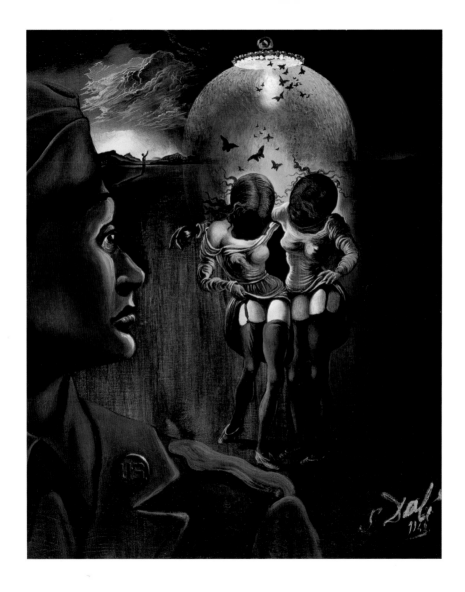

Flaming Giraffe (detail), 1935

Spain began a brief period of democracy in 1931 with the declaration of a republic, only to see the republicans fail in the elections of 1933 and then narrowly win back power in 1936. Watching these events unfold Dali was haunted by 'forebodings of civil war' and claimed that these were the inspiration for several of his works of this period, including *Flaming Giraffe*, *The Invention of Monsters* and *Premonition of Civil War*.

Flaming Giraffe, which was completed after the outbreak of the Spanish Civil War, has a particularly disturbing quality with its ethereal dream-like landscape of stunning aquamarine, in which a sleepwalking woman with flayed arms raised in supplication, a burning giraffe and another female figure holding a strip of raw meat, exist in disquieting isolation from each other. Familiar Dali symbols, open drawers, crutches and phallic shapes, are for once subordinate to the overall effect.

The flaming giraffe of the title also appeared in *L'Age d'Or* ('The Golden Age'), a film Dali made in 1930 with his friend and collaborator Luis Buñuel (1900–83).

MEDIUM

Oil on panel

PERIOD

Surrealist

RELATED WORK

René Magritte, *The Discovery of Fire*, 1934–35

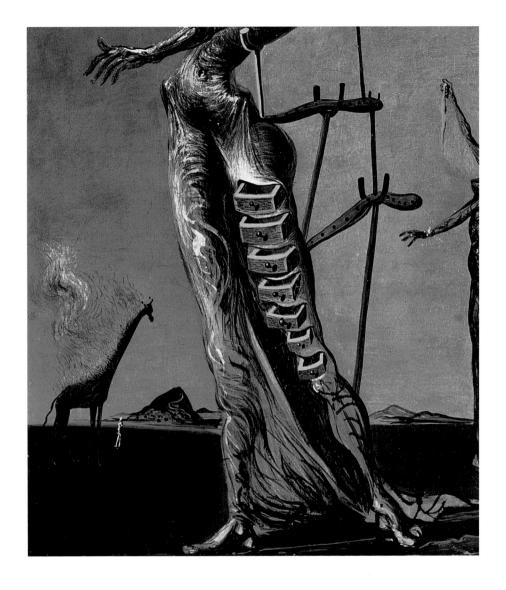

The Face of War, 1940–41

Dali was intensely interested in all forms of artistic expression and in the 1940s became involved in film making and the illusory world of Hollywood. In 1941 he created five sketches and three paintings for the film *Moontide*, initially directed by Fritz Lang and starring Jean Gabin. The artwork was used in the opening nightmarish sequence when Gabin's character is so drunk that he later believes he has murdered a young woman.

The Face of War is the work on which Dali based the film sequence, and is itself a truly harrowing image. Dali does not attempt to use his double-image technique to form the shape of the face as he did in other skull images. He simply shows a decomposing medusa-like head, its snake 'hair' attacking it from both sides. The eyes and the mouth contain further skulls, which in turn have skulls in their eye and mouth cavities, a sequence we assume carries on ad infinitum.

As much as anything the picture gains its power from the face's palpable expression of fear and mute helplessness that Dali so pitilessly conveys.

CREATED

America

MEDIUM

Oil on canvas

PERIOD

Classic

RELATED WORK

Conroy Maddox, *Untitled*, 1950

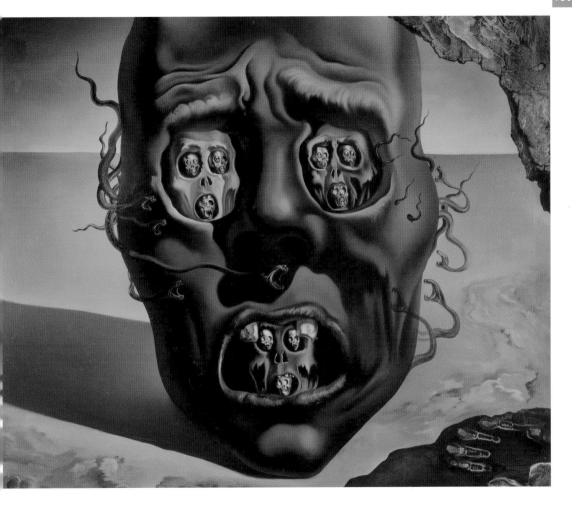

The Disintegration of the Persistence of Memory, 1952–54

By the 1950s, Dali's interest was turning increasingly to the recent major developments and discoveries that were taking place in atomic and nuclear physics. In 1945 the Americans exploded the first atomic bomb over Hiroshima, an event that had a profound effect on Dali. He was fascinated by atomic theory and the concept that seemingly solid objects could be broken down to infinitesimally small particles that are in a continual state of flux and constantly gaining and emitting energy.

The Disintegration of the Persistence of Memory shows Dali reassessing his Surrealist theories of the 1930s in the light of the new reality that particle physics presented. All of the major elements in his established masterpiece, *The Persistence of Memory* (1931, see page 314), are present in this new work: the soft clocks, Dali's head, the dead trees and the view of Port Lligat. However, these surreal elements are now of lesser relevance. They have been superseded by the 'atomic' view of the world, which Dali represents with the blocked grid of particles that are advancing toward the bay, firing torpedo-like particles. For Dali Surrealism was firmly in the past. The future lay in atomic physics.

MEDIUM

Oil on canvas

PERIOD

Nuclear Mystic

RELATED WORK

Yves Tanguy, *Globe de Glace*, 1934

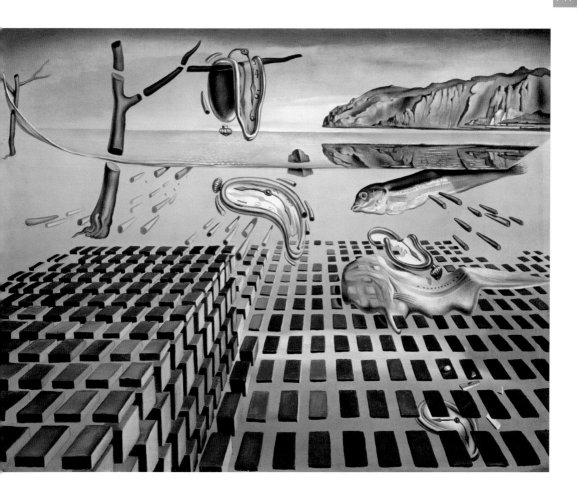

Soft Construction with Boiled Beans, 1936

Dalí claimed that *Soft Construction with Boiled Beans* was inspired by forebodings of the Spanish Civil War. Although he did retitle the work *Premonitions of Civil War* some six months before the outbreak of war in 1936, there is evidence that he began work on the picture as early as 1934. It may be that the work began as a more general statement about conflict and was adapted to refer specifically to the approaching civil war.

Unlike most contemporary European artists who were violently opposed to Franco and his Fascist forces, Dalí appeared unconcerned with the political issues at stake, and saw the conflict as inevitable. In the painting a giant, alone in a vast inhospitable landscape, tears himself apart in great agony, a powerful image of the carnage that was to overtake Dalí's homeland.

As a statement on the horror of war it is much closer in spirit to Goya's (1746–1828) *The Colossus*, a depiction of Napoleon's invasion of Spain, than to Picasso's (1881–1973) much more political *Guernica*, which was a portrayal of the brutal air raid and subsequent massacre of the inhabitants of the small Basque town of Guernica in 1937.

MEDIUM

Oil on canvas

PERIOD

Surrealist

RELATED WORK

Francisco de Goya, *The Colossus*, 1810

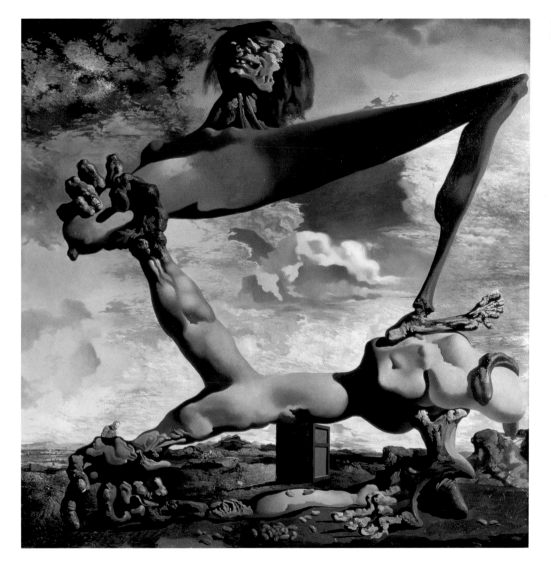

Dalí

Places

View of the Church and Abbey of Vilabertràn, c. 1918–19

Dalí probably painted this undated picture of the former Augustinian monastery of Santa Maria de Vilabertràn when he was about 15 years old and still entranced by the Impressionist style. He uses thick, impasto oil paint and applies it in energetic, swirling dabs. His clearly visible brushstrokes suggest the leaves moving in the breeze and the clouds scudding across the sky. The lower part of the image consists of reflections of the trees in water, produced with bold vertical strokes of paint. This Impressionist technique is in stark contrast to his later work, where he takes enormous pains to disguise the brushstrokes completely.

Vilabertràn is a small village within walking distance, less than a couple of kilometres northeast, of Figueras. The subject of Dalí's painting is the simple little church of Santa Maria, founded in 1101, and he depicts its attractive Romanesque bell tower partly concealed by trees. To the right is the collegiate abbey, which has beautiful gothic windows. Ramon Pichot, his artist-mentor at this time, was fond of the colour orange, which may account for Dalí's considerable use of it here to suggest the glow of evening.

CREATED

Spain

MEDIUM

Oil on canvas

PERIOD

Early

RELATED WORK

Claude Monet, *White Water Lilies*, 1899

Salvador Dalí *Born* 1904 Catalonia, Spain

Died 1989

Port of Cadaqués (Night), 1919

This dramatic night-time scene depicts a schooner, surrounded by smaller vessels, in the harbour at Cadaqués. This is the fishing village where Dali spent idyllic summers as a child, less than an hour's drive along a winding mountainous road from Figueras, Dali's home town.

The looming shape of Mount Pani and the dark bulk of the boat's prow contrast with the tightly packed whitewashed houses on the harbour front. The silhouette of the prow has a menacing, shark-like quality, and its projecting bowsprit almost seems to be impaling the little church of Santa Maria. A fire on the deck of the boat, reflected in the sea below, creates a startling and sophisticated lighting effect.

Dali uses the paint in a fluid and vibrant fashion. The picture itself is tiny, just 19 cm by 24 cm (7.5 in by 9.5 in), which gives the impression that Dali's bold brushstrokes are even more dramatic than they really are. When Dali painted this image he was only fourteen and was still experimenting with a wide range of derivative styles and techniques, yet has chosen for his subject matter a location that was familiar and dear to him.

CREATED

Spain

MEDIUM

Oil on canvas

PERIOD

Early

RELATED WORK

Edouard Manet, *The Port of Boulogne in Moonlight*, 1869

Dalí's House at Es Llane, 1918

Dalí's father was born and spent the first nine years of his life in Cadaqués before his family moved to Barcelona. By coincidence, his great friend Josep 'Pepito' Pichot later moved to Cadaqués where he established a small estate. It was Pepito who encouraged Dalí's father first to move to Figueras and then to rent and finally buy a house for the summer near the Pichots on the little beach of Es Llane.

The house at Es Llane and the nearby estate of the Pichots was paradise for the young Dalí. Not only was it an idyllic setting, but the Pichots, who were part of an extended family of talented artists, also encouraged the young Dalí's growing interest in painting, even giving him the use of a studio to work in. During his childhood and youth Dalí developed an intense love of Cadaqués and its immediate surroundings and this was to endure until his death.

In this informal ink sketch of the house at Es Llane, drawn by Dalí at the age of fourteen, the young artist can be seen experimenting with perspective and different styles of figurative representation.

CREATED

Spain

MEDIUM

Ink on paper

PERIOD

Early

RELATED WORK

Joan Miró, *Vegetable Garden with Donkey*, 1918

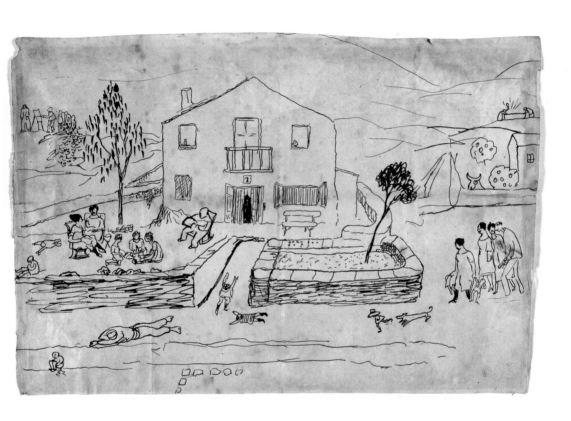

Santa Creus Festival in Figueras – The Circus, 1921

Catalan life was filled with feast days and religious festivals. This early painting, produced by Dali in 1921, depicts one such local celebration, the Santa Creus Festival. A church procession, consisting of enormous effigies of saints that dwarf the surrounding people, is passing rather incongruously though a funfair packed with revellers dressed in their best clothes. Dali neatly contrasts the religious origins of the event with the secular celebrations at the funfair and the circus tent, where a scantily clad woman entices customers inside.

Still to find his own unique visual language, Dali is experimenting with yet another style. Here he opts for a decorative, folk-art approach, which results in a lively image that has an endearing childlike quality. The faces are all very similar, there are discrepancies in the scale of the figures, and the sky is simply produced by dabbing pink dots on to a pale blue background.

The painting is rendered in gouache, an opaque water-based paint favoured by designers because it allows the creation of smooth, flat areas of bold colour.

CREATED

Spain

MEDIUM

Gouache on cardboard

PERIOD

Early

RELATED WORK

Wassily Kandinsky, *Colourful Life*, 1907

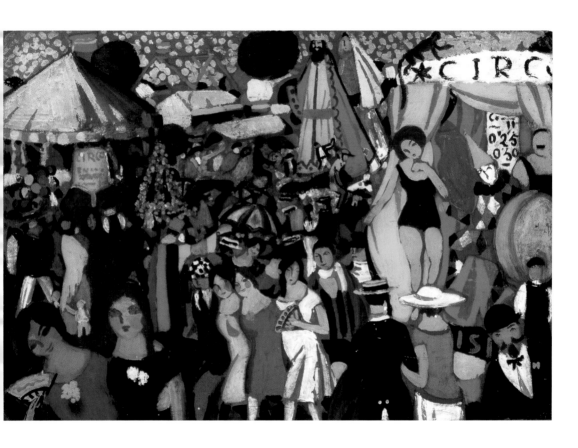

Woman at the Window in Figueras, 1926

In 1926 Figueras was a prosperous market town in the Catalunya region of north-east Spain, inland from what we now call the Costa Brava. After qualifying as a lawyer, Dalí's father moved there to take up the post of notary, and it was there that Dali was born.

Woman at the Window in Figueras is a portrait of Dalí's younger sister and only sibling, Ana Maria. Until the appearance of Gala in Dali's life, Ana was his favourite model and he painted many studies of her, including *Figure Standing at a Window*, one of his favourite works from this period. As in many of Dali's pictures of his sister, little of her face is shown. She is making lace, which may relate to Dalí's obsession with Vermeer's painting *The Lacemaker* (c. 1669–70) , and the view is of the town of Figueras with the coastal mountains rising behind. The style of the painting shows the influence of the Classical-Realism movement that was sweeping across Europe.

Dali and Ana Maria were to fall out irrevocably in the 1950s following the publication of her autobiography, which Dalí felt described him in a less-than-flattering light.

CREATED

Spain

MEDIUM

Oil on canvas

PERIOD

Early

RELATED WORK

Jan Vermeer, *The Lacemaker*, c. 1669–70

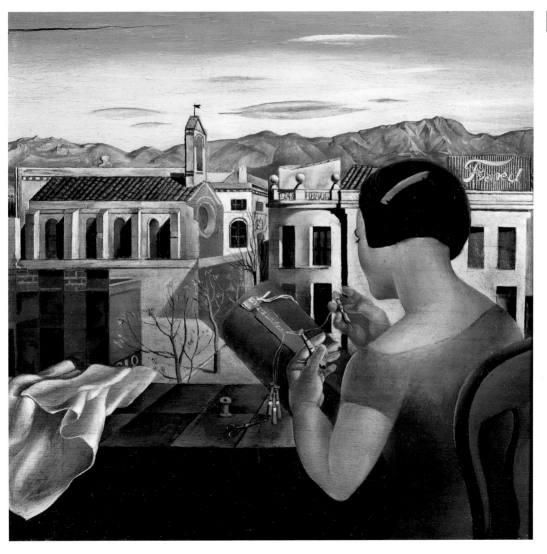

Spain, 1938

During the Spanish Civil War (1936–39), Dali left the country, travelling extensively in Europe and America. Dalí's exile was a practical rather than a political gesture. He saw the war as inevitable and steadfastly refused to take sides, even when in the early months of the war the Fascists executed his great friend Federico Garcia Lorca.

By 1938, when Dali painted *Spain*, the Fascist forces had control of most of Spain. The war was bloody and unremitting and over 500,000 Spaniards died, including many civilians. *Spain* clearly shows Dali's fatalistic attitude to the conflict that was destroying his country. In a double image made up of tiny Leonardo-style fighting figures, some on horseback and others on foot, Mother Spain leans against a chest of drawers from which hangs what appears to be a blood-soaked cloth, but which could equally be a tattered flag. The figure of Mother Spain, whose fragile, ghost-like quality relates to the effect of two years of war, regards the chest with an expression both resigned and compassionate. Dali returned to Spain very briefly at the end of the civil war, leaving again almost immediately for America.

MEDIUM

Oil on canvas

PERIOD

Surrealist

RELATED WORK

Leonardo da Vinci, *The Adoration of the Magi*, 1481–82

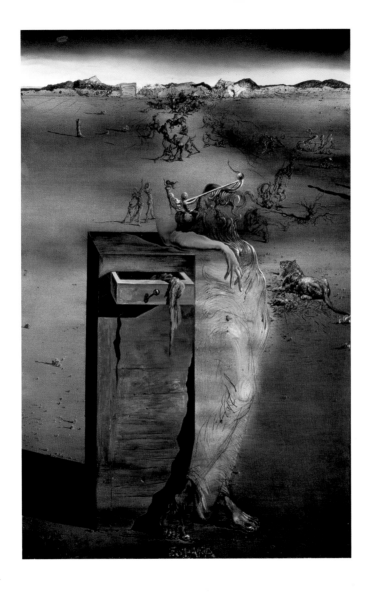

The Arrival (Port Lligat), 1950

Port Lligat, a tiny fishing community adjacent to Cadaqués, was Dali's true home for most of his life. He bought a small fisherman's hut there in 1929 and spent the rest of his life adding to and extending it, often by incorporating other old huts into the new structure. By 1950, when Dali painted *The Arrival*, the house and studios at Port Lligat were already substantial and in that year Dali made further major additions. The house was gaining an international reputation and in 1950 *Homes and Gardens* published an article on Dali's 'geometric fantasy on the Catalan coast'.

During the early 1950s Dali produced many works based on the bay at Port Lligat, notably the two versions he painted of *The Madonna of Port Lligat*. *The Arrival* is a much simpler work. A ship, similar to the galleon in *The Discovery of America by Christopher Columbus* (1958–59, see page 172), has moored in the bay to be greeted by *anges familiers et pecheurs* ('friendly angels and fishermen'). Clearly visible to the right is the terraced hillside and tower so familiar from other works produced throughout Dali's career.

CREATED

Spain

MEDIUM

Oil on canvas

PERIOD

Nuclear Mystic

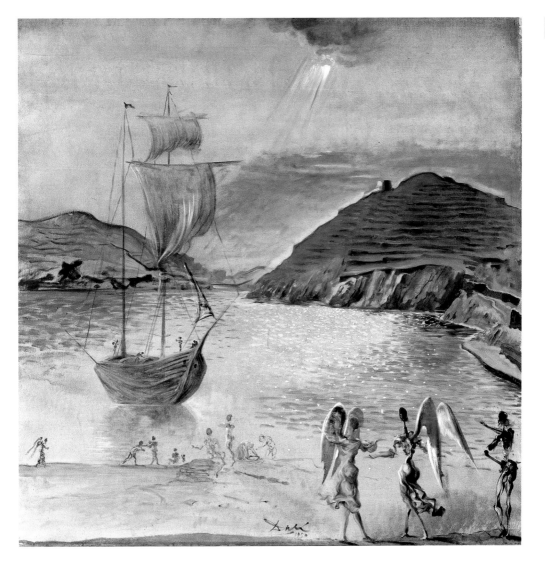

Dalí Lifting the Skin of the Mediterranean to Show Gala the Birth of Venus, 1977

Like *Gala's Foot* (1973, see page 64) this painting is one of a stereoscopic pair, which, when viewed through a special apparatus, forms a three-dimensional image.

The dominating element is an enormous nude woman who represents Venus, the Roman goddess born from the sea when foam from Uranus's castrated genitals fell into the water, linking this image to Dalí's castration fears. Dalí, who is standing next to Gala, points at the gigantic figure whose distorted left leg is reminiscent of the extended giant's leg in *Soft Construction with Boiled Beans* (1936, see page 142).

In Dalí's hand is a piece of string, attached to the far left-hand corner of the surface of the sea. Dalí is pulling the string, which makes the surface curl back, like a piece of paper. Dalí may here be alluding to the phenomenon of the meniscus of water, whereby the surface molecules cling to each other to form a sort of 'skin'. This idea of peeling back the surface of the sea occurs in several of Dalí's works, including *The Disintegration of the Persistence of Memory* (1952–54, see page 140).

MEDIUM

Oil on canvas

PERIOD

Late

RELATED WORK

Marcel Duchamp, *Etant Donnés*, 1948–49

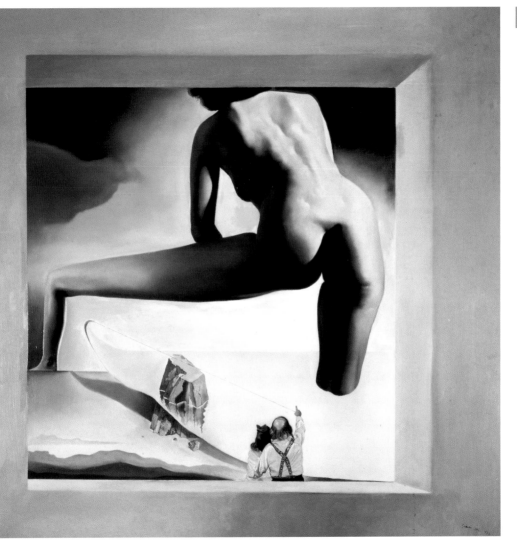

Lago di Garda ('Lake Garda'), 1949

Dali made many visits to Italy where he clearly felt an affinity both with its great cultural heritage and his Mediterranean roots. In 1949, the year he produced this delightful work, he had an audience with the Pope in Rome, a measure of Dali's international stature.

Lake Garda is the largest lake in Italy and has always been a popular tourist destination. This tranquil work, executed on board in pen, ink, gouache and watercolour, is very different in style and technique to the oil paintings he was producing at the time.

The peaceful, almost monochrome, view of the lake and the hills behind is brought into focus by the remarkable grouping of flowers in the right foreground, where Dali has allowed the wet watercolours to merge and blot, creating an 'accidental' dreamlike effect. Even in this relaxed setting Dali cannot resist introducing a phallic tower on the summit of the breast-like hill and the enigmatic figure in the centre foreground who appears to be floating, rowing her dress across the lake, a parasol attached to her head.

CREATED

Italy

MEDIUM

Watercolour, gouache, and pen and indian ink on board

PERIOD

Classic

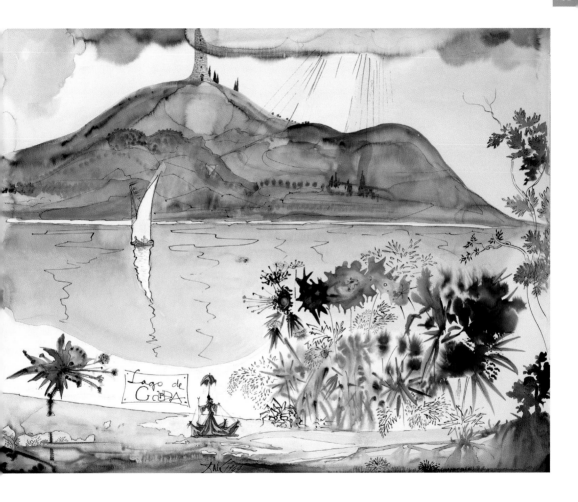

Lago de GaBA

Venise, 1949

Dali spent much of 1949 travelling around Italy. During his stay he painted a number of watercolour images for the Laskers, a wealthy American couple, including *Lago di Garda* (see page 162) and *Roma* (see page 166).

In this painting of Venice, Dalí focuses on the prominent landmark church of Santa Maria della Salute, built in gratitude to the Virgin Mary for the end of the terrible plague that struck Venice in the seventeenth century. Dali emphasizes the volutes or scrolls that form curvaceous shapes on either side of the church, making them appear bigger than in real life. He adds a fictitious phallic bell tower to contrast with the church's womanly curves.

Dali also includes three large dancing and trumpeting angels that are not present on the building in reality, and who appear to be saluting the surreal sunrise. These figures link to the more sedate angel in the foreground playing a lute, and give a sense of joy and celebration to an image of a city steeped in culture and the arts, particularly music, painting and architecture.

CREATED

Italy

MEDIUM

Watercolour, gouache, and pen and indian ink on board

PERIOD

Classic

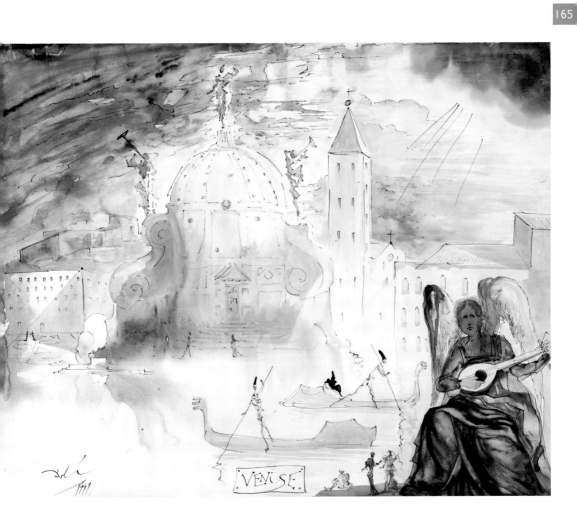

VENISE

Roma, 1949

Before he left America in 1948, wealthy New York art collectors Albert and Mary Lasker commissioned Dali to produce a series of Italian watercolours. *Lago di Garda* (see page 162), the sketch of Lake Garda, was part of the same series as this delicate watercolour, gouache and pen portrait of Rome, the eternal city.

Dali chose to represent Rome with the Castel Sant Angelo, a fortress and refuge for the Pope in dangerous times that contains the mausoleum of the great Roman emperor Hadrian. The whole scene is bathed in 'divine light' shining down from the clouds. Two angelic figures, based on sculptures on the real bridge, dance in the foreground. The painting is largely monochrome save for patches of colour provided by three trees that Dali paints with the same blurring of colour used in *Lago di Garda*.

At the bottom right of the picture sits an elfin-like jester in a Catalan hat, the same jester that appears in Dali's painting of Naples for the series. This figure is a reference to the artist himself who liked to play the jester and was famous for his many stunts and pranks.

CREATED

Italy

MEDIUM

Watercolour, gouache, and pen and Indian ink on board

PERIOD

Classic

RELATED WORK

Giovanni Battista Piranesi & Desprez, *The Girandola at the Castel Sant' Angelo*, c. 1783

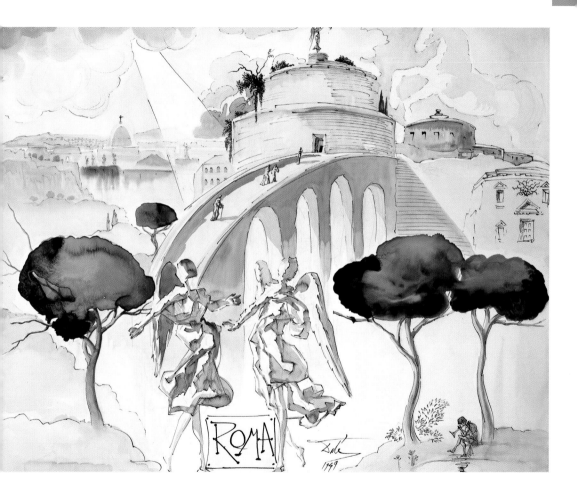

Apparition de la Ville de Delft ('Apparition of the Town of Delft'), 1935–36

In the mid 1930s, Dali painted several images showing cars as fossils or made from stone. Dali had no time for mechanical objects, including cars, and in these images he depicts the car as a redundant object.

On the left-hand side of the small painting *Apparition de la Ville de Delft*, Dali quotes directly from Jan Vermeer (1632–75), whom he greatly admired as an artist, and reproduces in miniature almost all of Vermeer's landscape *View of Delft* (c. 1660–61). Dali omits the river running between the town and the viewer and instead depicts a flat plane. He adds a cabinet with an open drawer, out of which spills a piece of cloth. The cabinet is a motif that Dali often refers to, alluding to Freud's notion of repressed ideas being locked away from our conscious minds.

To the right of the townscape, Dali depicts a rocky outcrop on top of which is a precariously perched car made of brickwork and stone. The car appears to be anchored in place by a dead tree, which is growing out of the car window.

MEDIUM

Oil on panel

PERIOD

Surrealist

RELATED WORK

Jan Vermeer, *View of Delft*, c. 1660–61

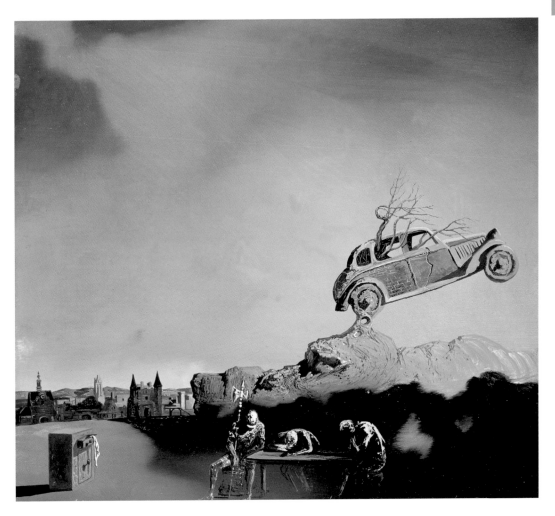

Impressions of Africa, 1938

The title of Dali's painting *Impressions of Africa* is taken from a book of the same name by the French writer Raymond Roussel (1877–1933) that Dali and other Surrealists admired. In this short novel, genders are confused, words are continually given double meanings and the central character invents a photo-mechanical contraption that automatically produces paintings.

In the foreground of the work Dali sits at an easel, his foreshortened right hand outstretched in a way that prefigures the three-dimensional stereoscopic paintings he was to produce later in his career. Behind him ranged across a desert plain is an assortment of double images and visual illusions, including the rather ghostly face of Gala in the far left, her eyes created by the arches of an arcaded building.

In 1938 when he painted this picture Dali was in Italy where he was studying the works of the great Renaissance masters. He travelled extensively at this time in self-imposed exile from the civil war in Spain. Dali never actually visited Africa and the work is in fact based on a Sicilian landscape.

MEDIUM

Oil on canvas

PERIOD

Surrealist

RELATED WORK

Diego Velázquez, *Las Meninas*, 1656

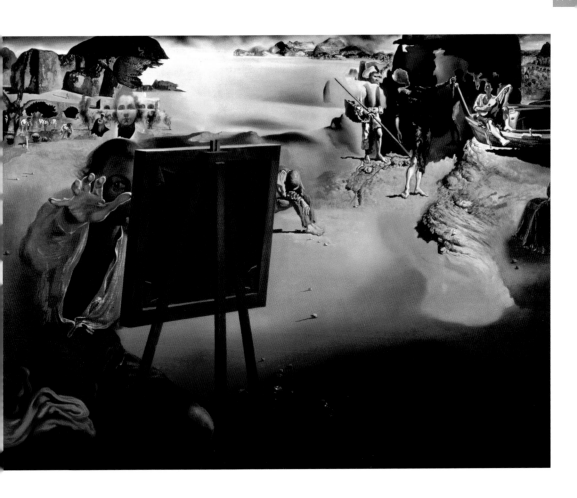

The Discovery of America by Christopher Columbus, 1958–59

History painting, the representation of heroic, religious or mythical events from the past, was the highest genre of painting from the Renaissance to the nineteenth century. *The Discovery of America by Christopher Columbus*, a vast painting measuring over 4 m by 3 m (13 ft by 9 ft), is Dalí's version of the Renaissance genre.

While the painting seems at first glance to be Classical in style, in fact Dalí has adapted the genre to incorporate his photorealistic technique and his fascination for atomic theory. In the foreground a young Christopher Columbus hauls his ship on to the shores of the New World, holding in his right hand a banner of the Immaculate Conception that depicts Gala as the Madonna. Emerging from the turbulent sea that rises up behind him, painted in a completely impossible perspective, are figures from the church, naked boys bearing banners, an image of the crucified Jesus and Dali himself holding a crucifix.

Dali felt that, like Columbus, he had discovered America and had conquered it with his flamboyant creativity and boundless energy. Bizarrely Dali also claimed that he and Columbus shared a common Catalan ancestry, although there is no doubt that Columbus was born in the Italian port of Genoa.

MEDIUM

Oil on canvas

PERIOD

Nuclear Mystic

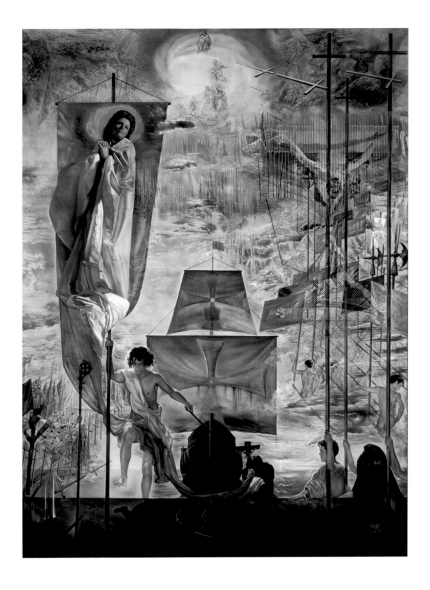

Allegory of an American Christmas, 1934

Courtesy of Christie's Images Ltd/© Salvador Dali, Gala-Salvador Dali Foundation, DACS, London 2006

In 1934 Dali and Gala made their first trip to America, travelling by ocean liner to New York. Dali's work *The Persistence of Memory* (1931, see page 314), had already been shown in 1932 as part of a Surrealistic retrospective at New York's Julien Levy Gallery, and this gallery was now exhibiting a much more extensive selection of Dali's work.

For Dali, America, which had intrigued him since his youth, was a new and exciting world full of opportunities both creative and financial.

Allegory of an American Christmas reflects Dali's excitement at the possibilities and the attention that the New World seemed to offer in such abundance. The hatching egg, which was to reappear later in *The Metamorphosis of Narcissus* (1937, see page 260), represents birth, rebirth or major change as it hovers over the space between two landmasses, the further one bathed in the light of a new dawn. The hole in the egg, out of which a golden aeroplane appears to be breaking free, forms the shape of North America while the golden form of South America glistens below.

MEDIUM

Oil on board

PERIOD

Surrealist

RELATED WORK

Jacques Prévert, *The Dove*

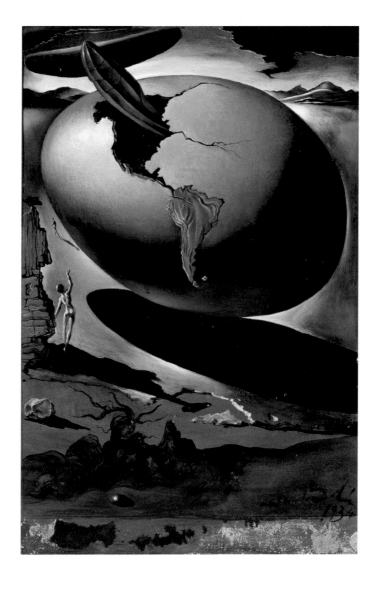

Geopolitical Child Watching the Birth of the New Man, 1943

The egg is a potent symbol of new birth and Dalí often refers to it in his work, notably in *Allegory of an American Christmas* (1934, see page 174) and *Metamorphosis of Narcissus* (1937, see page 260). In 1942, the year before he painted this work, Dalí collaborated with the photographer Philippe Halsman to produce *Dali in the Egg*, a photographic montage showing the naked figure of Dalí in foetal position, apparently inside an egg.

While in *Allegory of an American Christmas* the egg can be seen to represent Dalí's personal 'rebirth' in America, *Geopolitical Child* ... shows a figure forcing its way out of a complete ovoid globe. Although the new man emerges from North America, other continents can be seen clearly. Europe and Asia are 'soft' and are sliding off the map, and Africa appears to be weeping.

Dalí was extremely concerned that the conflict in Europe would spread across the entire world with cataclysmic results. America had recently entered the war and here Dalí shows the emerging giant, watched by a young child and its androgynous guardian, waking to redress the geopolitical balance of the world.

MEDIUM

Oil on canvas

PERIOD

Classic

RELATED WORK

Philippe Halsman, *Dali in the Egg*, 1942

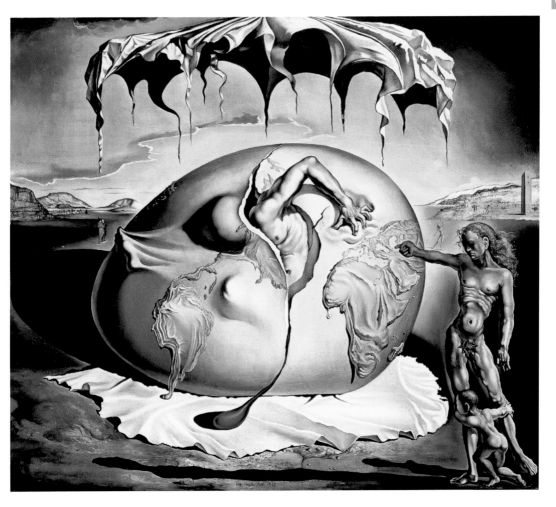

The Poetry of America, The Cosmic Athletes, 1943

Although Dali claimed to have no interest in politics and studiously avoided any involvement with the terrible civil war that had torn apart his homeland, he clearly followed and was affected by world events.

In *The Poetry of America, The Cosmic Athletes* Dali addresses a number of contemporary sociopolitical and economic issues. While a disinterested naked spectator looks on, two American-football players clash. The player on the right, representing the dominant white ruling class in America, leaps at his opponent. His torso appears to have been stabbed in several places and his arms have been reduced to stumps terminating in cheerleaders' pom-poms, rendering him impotent. The player on the left, representing Black African America, covers his face for protection but from his back a new player is born holding the ball that controls the game. In the background we see the exhausted and bleeding outline of Africa.

The white player is burdened down by capitalism, which Dali represents as a perfectly realized Coca Cola bottle, anticipating Andy Warhol's iconic use of the image twenty years later.

MEDIUM

Oil on canvas

PERIOD

Classic

RELATED WORK

Raphael, *The Marriage of the Virgin*, 1504

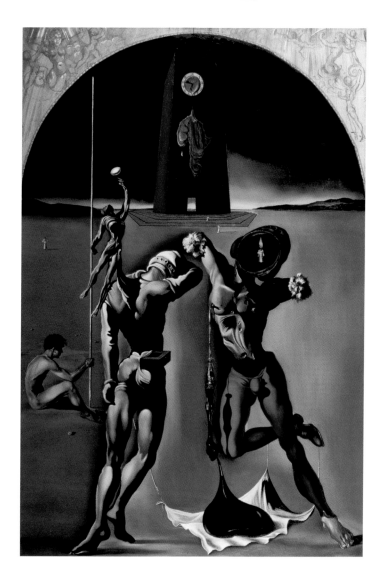

L'Automobile Fossile de Cap Creus ('The Fossilized Automobile of Cap de Creus'), 1936

Cap de Creus, the massive headland that lies just to the north-east of Cadaqués, was a place that Dali spent many of his childhood summers exploring. Here, exposure to the wind and the sea had produced rock formations eroded into strange shapes, given names such as 'The Eagle', 'The Monk' and 'The Dead Woman' by the local fishermen. Among the bizarre and shifting landscapes of Cap de Creus, Dali began his lifelong fascination with transformations, double- and multi images, and the paranoid-critical view of reality.

In *L'Automobile Fossile de Cap Creus*, an American sedan car appears to be emerging from the rocks of the cape. Fishermen below, oblivious to the car, struggle exhaustedly to haul a boat out of the water while others sit dejectedly, heads in hands.

Dali achieves the scratchy effect in his representation of the car, the fisherman and the foreground by scraping into the wet paint with the end of his brush. This contrasts with his normal meticulous paintwork when using oils. His more usual technique can be seen in the background of the painting, where a tiny figure is framed by a hole in the rock formation.

CREATED

Spain

MEDIUM

Oil on panel

PERIOD

Surrealist

Image Mediumnique Paranoïaque, 1935

Promontories and strange rock formations surrounded the bay at Cadaqués; however, the Bay of Rosas, just to the south, was a great sweep of uninterrupted golden sand. Dali used this beach as a backdrop when he wanted to describe a more open, featureless landscape.

In *Image Mediumnique Paranoïaque*, four people appear on a beach just as the sun is setting. In the right foreground two men look up. The first is writing, the other bent as though looking for something in the sand. To the left a fully clothed woman sits in a pool of water on the sand her back towards us, and in the background a man cycles towards them. Although Dali titles the work 'mediumnique paranoiac', there are none of the double or multi images that usually appear in his 'paranoiac' paintings. However, the figures seem to have little to do with the setting or each other. It is as though they have suddenly appeared from elsewhere, perhaps from the pages of a photograph album.

The woman in the picture is Lidia Nougés, an eccentric local living in Cadaqués whom Dali described as having, 'the most marvellously paranoiac brain aside from my own that I have ever known'.

MEDIUM

Oil on panel

PERIOD

Surrealist

RELATED WORK

Jacques Prévert, *By the Sea*

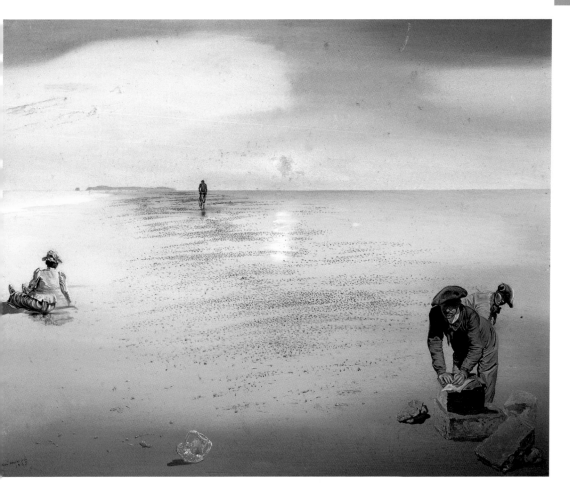

Charrette Fantome ('Phantom Cart'), 1933

The many double-image and multi-image works that Dali painted during his Surrealist period show the viewer alternate versions of the same apparent reality. Some of the multi-image paintings are extremely complex, others are more straightforward.

Charrette Fantome is one of Dali's simplest double-image works. On a desert plain a cart with driver and horse are heading towards a small town in the distance. The whole scene is suffused with a golden light. In what Dali referred to as a paranoid-critical reading of the painting, the cart and driver can also be seen as the arched entrance to the town, the wheels forming stakes in the ground, the driver and horse becoming building and towers in the town.

The setting is not a desert but rather the golden sands of the magnificent beach at Rosas, then a very small coastal village situated on a large bay south of Cadaqués. Dali was proud of his Catalan heritage, and the broken jug or amphora in the foreground refers to the many Greco-Roman remains found in coastal Catalunya.

MEDIUM

Oil on panel

PERIOD

Surrealist

RELATED WORK

Max Ernst, *The Stolen Mirror*, 1941

Suburb of the Paranoid-Critical Town; Afternoon on the Outskirts of European History, 1936

Dalí succinctly summed up his paranoid-critical theory thus: 'Of a Cubist picture one asks, "What does that represent?". Of a Surrealist picture one sees what it represents but one asks, "What does it mean?". Of a paranoiac picture one asks everything, "What do I see? What does it represent? What does it mean?".'

In the centre of the *Suburb of the Paranoid-Critical Town...*, a smiling Gala holds out a bunch of grapes standing on a vast plain on which are arranged three architectural scenes. Dalí represents the breadth of the Catalonian architectural tradition by referring to three places with personal connections: Palamós, the home of his friend the artist Jose Maria Sert (1876–1945); Vilabertràn, a village near Figueras; and Calle del Cal the home of his grandfather in Cadaqués, who suffered from paranoia and committed suicide. To the right of the work is a safe with its key beguilingly sitting on top, suggesting secrets that are about to be revealed.

With its calm, almost deserted air, the landscape is reminiscent of the abandoned cityscapes by the painter Giorgio de Chirico (1888–1978).

MEDIUM

Oil on panel

PERIOD

Surrealist

RELATED WORK

Giorgio de Chirico, *Piazza d'Italia*, 1943

Oasis, 1946

This is the second in the *Desert Trilogy* series, a set of three images commissioned from Dali by William Lightfoot Schultz of the Shulton Company, New York, to advertise a new perfume, Desert Flower. The first in the series of three was *Invisible Lovers* (1946, see page 110) and was produced to launch the perfume. The desert flower is in the foreground, on the left-hand side of the painting

The second image, shown here, is *Oasis*. The oasis of the title is on the left, with a bridge reflected in it and, to the left, a spindly tree, typical of early paintings by Dali's hero Raphael (1483–1520). The 'lovers' are on the right, and much more apparent than in the earlier image, *Invisible Lovers*, where only the heads are suggested by the bizarre rocky outcrops. Here, full-length figures are formed as a double image, mainly from the negative shapes created by the rocks, with the eponymous desert flower between them.

All three paintings in the *Desert Trilogy* series are in landscape format because they were used across a double-page spread of the magazine.

CREATED

America

MEDIUM

Oil on canvas

PERIOD

Classic

RELATED WORK

René Magritte, *Perpetual Motion*, 1935

Paysage Fantastique; Midi Héroïque ('Fantastic Landscape; Heroic Midday'), 1942

As soon as Dalí and Gala arrived in America they set about establishing themselves in the social circles of the rich and famous. Gala and Dalí were both unashamedly materialistic, Dalí once saying, 'Liking money like I like it is nothing less than mysticism. Money is glory'. One of his first wealthy American clients was the multimillionaire 'cosmetic queen' Helena Rubinstein.

Having painted her portrait, Dalí then produced three large panels for the dining room of her vast Manhattan apartment, 625 Park Avenue. In this room Madame Rubinstein kept a remarkable collection of Venetian shell furniture. *Paysage Fantastique; Midi Héroïque* shows a detail from the first panel of the set. In it an androgynous figure ,with female breasts but somewhat masculine arms and legs, appears dancing across a Catalan beach. In a rather unsubtle double image, the figure's upper body is created from part of the cloud formation, its head from passing sea birds. Dalí was never afraid to adapt the symbols and techniques of his serious works for his commercial commissions.

Between the legs of the figure is a broken column bearing the inscription, 'Gala, S Dalí' a reference to the Dalí 'brand' that they were so single-mindedly promoting at the time.

CREATED

America

MEDIUM

Oil on canvas

PERIOD

Classic

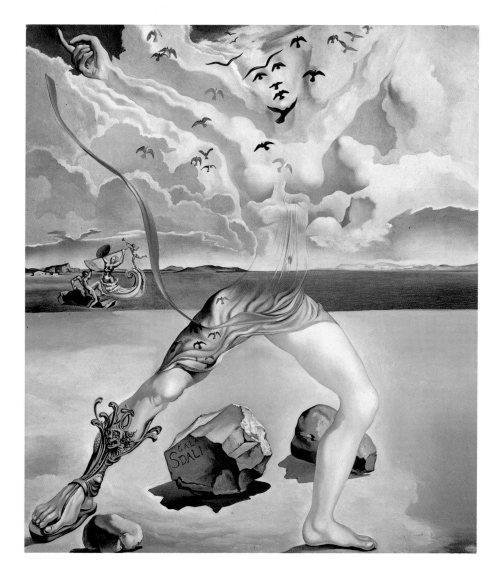

Paysage Surréaliste Animé ('Lively Surrealist Landscape'), 1936

Courtesy of Christie's Images Ltd/© Salvador Dali, Gala-Salvador Dali Foundation, DACS, London 2006

Dali produced the textural element in this small work by employing a transfer process known as decalcomania. He inked the surface of a sheet of glass or stiff paper, and then laid paper on it to pick up the ink randomly. The artist has little control over the outcome in this type of 'accidental' process, which particularly appealed to the Surrealists for its element of chance. Having made the print, the artist can then examine it from all angles for what it might suggest, rather like the psychoanalytical inkblot test that Rorschach first published in 1921.

By 'animating' the print with depictions of tiny figures and pieces of an old boat, Dali turned this smudgy image into a remarkably convincing picture of a rocky foreshore, making reference to the rocks at Cap de Creus and his childhood experience of being dwarfed by the enormous outcrops.

Dali's fellow Surrealists used the same or similar techniques to produce images. Max Ernst (1891–1976) is also known for 'frottage', whereby he made wax rubbings of textured surfaces and used them as the basis for many of his paintings.

MEDIUM

Black ink on paper

PERIOD

Surrealist

RELATED WORK

André Breton, *Untitled (Decalcomania)*, 1936

Salvador Dalí 1936

Mirage, 1946

This is the third image in the *Desert Trilogy* series, produced by Dali for the Shulton Company, New York, to advertise their Desert Flower perfume. The first image is *The Invisible Lovers* (1946, see page 110) and the second is *Oasis* (1946, see page 190). In this third image, *Mirage*, Dali relies less on double images and more on Classicism and dramatic perspective for effect.

Here Dali equates a mirage with the illusion of love. The girl appears to be in love with the ethereal Apollo-like figure balanced on bizarre Classical ruins. These have either appeared out of her imagination or from the heat haze of the desert plain, which is almost certainly the flat and desolate beach of Rosas, near Cadaqués. Dali was proud of the legacy of the ancient world found in his native Catalonia, most notably Ampurius, and sometimes included an amphora in his paintings as a symbol of this.

The girl appears to be in a trance-like state and is admiring the desert flower, a reference to the name of the perfume, which has appeared on the forehead of the Classical male figure.

CREATED

America

MEDIUM

Oil on canvas

PERIOD

Classic

RELATED WORK

René Magritte, *L'Annonciation*, 1930

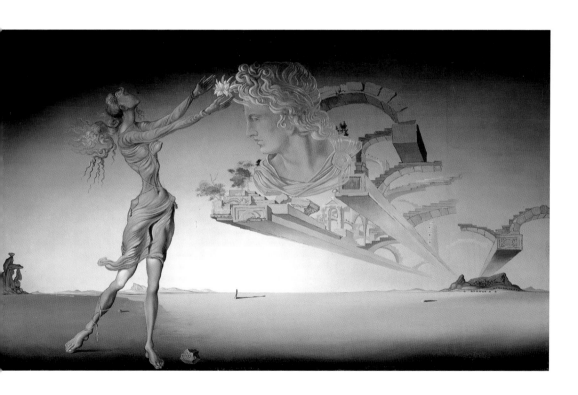

Study for *Trilogy of the Desert*, 1946

In 1946 Dali was commissioned by perfume makers Leigh to produce paintings and an advertising programme for a new fragrance called Desert Flower. From June to September of that year, he worked on a number of oil paintings and related advertising material while staying at the Del Monte Lodge, Pebble Beach, California. At the end of this period he had created three large oils which would be used to market the perfume: *Oasis*, *The Invisible Lovers* and *Mirage*. Dali kept detailed miniature versions of all three in his study.

Trilogy of the Desert is an an early study for *Mirage*, although in the finished painting the draped figure of Venus, aroused by the scent of the desert flower, caresses the disembodied head, rather than the crystalline torso, of her lover Apollo. In his notes to an exhibition of the paintings at M. Knoedler & Co. in New York in 1946, Dali explained the scene thus: 'the aura of classic antiquity evokes the desert flower, issuing from the forehead of Apollo.'

CREATED

California

MEDIUM

Watercolour over pencil on paper

RELATED WORK

Salvador Dali, *Mirage*, 1946

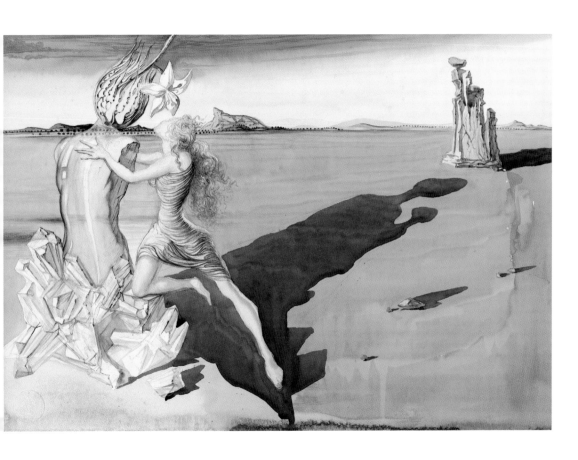

Paysage Surréaliste ('Surrealist Landscape'), 1947

This is one of a series of images produced by Dali for Bryants hosiery in 1947. For an earlier image in the series, produced in 1944, see page 120. Both these pictures show a disembodied, eroticized, stockinged leg in the midst of a landscape. In the earlier image Dali cuts out a ready-made image of a leg and pastes it into an image that contains a bizarre mechanism with pulleys and weights.

The later picture, shown here, is in a very different style from the earlier one. Dali creates a much more complex, although less surreal, rocky landscape with trees, figures and a unicorn being calmed by an angel. The stockinged leg is formed as a negative shape among the red rocks in the upper centre of the image, and is far less dominant than the cutout leg in the earlier image. Indeed, it is possible to miss this double image at first glance.

Dali ensures his signature is dominant and places this within a circular rock-like cartouche below the toe of the leg, emphasizing the Dali 'brand'.

CREATED

America

MEDIUM

Watercolour and pencil on paper

PERIOD

Classic

RELATED WORK

Hans Bellmer, *The Doll, Part II*, 1936

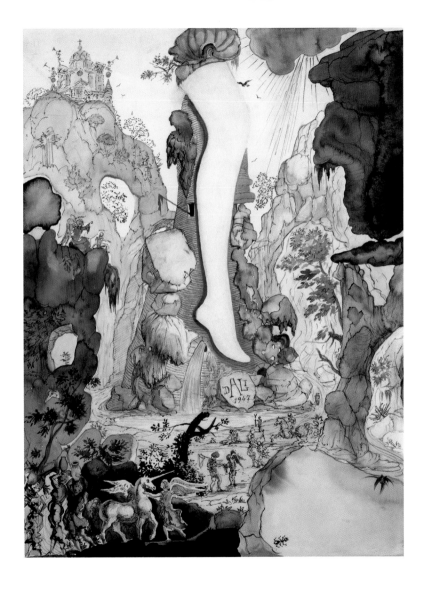

Paysage Surréaliste ('Surrealist Landscape'), 1958

In this gouache painting on card (unrelated to the previous image), Dali combines many of his trademark motifs from the previous three decades. By this stage of his career, Dali had a tendency to capitalize on past successes. Because of his enormous international reputation, he seemed tempted to produce instantly recognizable Dalinian images, pastiches of his earlier work. Dali's signature, in a rectangular cartouche, is dominant at the centre bottom of the image, rather like a trademark.

One of the main elements of this particular *Paysage Surréaliste* is the giraffe with a flaming mane, which we first see in *Flaming Giraffe* (1935, see page 136) and *Burning Giraffe* (1936–37). The giraffe's tail is threaded through a soft watch, which first appears as a motif in *The Persistence of Memory* (1931, see page 314). The watch is supported by the ubiquitous Dalinian crutch, which we first see in the early 1930s, for example in *L'Enigme de Guillaume Tell* (1933, see page 266).

In the background is a mounted horseman, drawn in the style of Leonardo da Vinci (1452–1519), which had already been used in *Les Juges* (c. 1933, see page 256) and *Messenger in a Palladian Landscape* (c. 1936, see page 254).

MEDIUM

Gouache, watercolour, pen with Indian ink and collage on board

PERIOD

Nuclear Mystic, but relates to Surrealist imagery

RELATED WORK

Max Ernst, *Butterfly Collection*, 1930–31

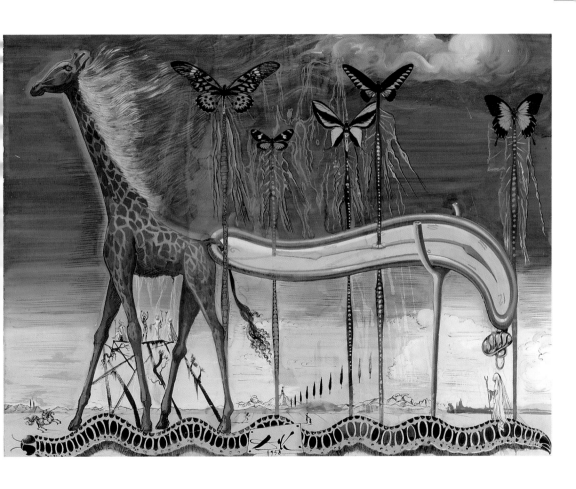

Geological Evolution, 1933

This painting was owned by Julian Green, who recorded in his diary that he and eleven others were involved in a scheme whereby each paid Dali an amount of money and in return would receive either a large work or a small work and two drawings during the following year. Dali would provide images each month, and the 'patrons' drew lots to see which month they would receive their picture. Mr Green was pleased he picked February, since he would not have to wait long for his picture.

Dali offered him a choice between a large painting with a rocky landscape and a nude man with side whiskers, his head filled with shells and pearls, or this painting, *Geological Evolution*, plus two drawings. Mr Green chose the latter.

The image shows an old carthorse inexplicably alone on a desert plain, with two skulls on its back. It is turning to stone from the feet upwards, as though fossilizing, its hooves cracking like crumbling stone. The skulls suggest this is a memento mori, a painting that reminds us that this is the ultimate fate of all of us, including the tiny adult and child in the background.

MEDIUM

Lithograph

PERIOD

Surrealist

RELATED WORK

Oscar Dominguez, *Souvenir de Paris*, 1932

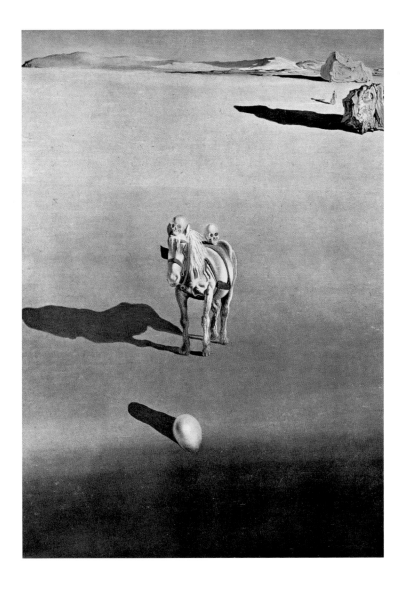

THE W

GREAT

Dalí

Influences

Self Portrait with the Neck of Raphael, 1920–21

As is the case with many painters, much of Dali's development as an artist can be traced from his self-portraits. *Self Portrait with the Neck of Raphael*, painted in the Impressionist style, shows the influence of the Spanish Impressionist Ramon Pichot. Ramon was part of the extended Pichot family with whom Dali stayed during his first period of study in Madrid, where he painted this striking self-portrait.

In *Self Portrait With The Neck of Raphael*, Dali's head is seen in three-quarter view, set against a backdrop of the bay at Cadaqués where the Pichot family lived. Dali's beloved mother, Felipa, was either very ill or had just died when he painted this self-portrait, and Dali shows us something of his grief in his serious, almost despondent expression. Dali's unusual choice of colours, the violet of the sea set against the orange of the hills and sky, is a direct reflection of Ramon Pichot's technique, which Dali clearly admired. The allusion to Raphael's neck refers to the work of the great High-Renaissance master Raphael (1483–1520), although strictly speaking elongated necks are typical of the slightly later Mannerist movement.

CREATED

Spain

MEDIUM

Oil on canvas

PERIOD

Early

RELATED WORK

Raphael, self-portrait in *The School of Athens*, 1510–11

Salvador Dali *Born* 1904 Catalonia, Spain

Died 1989

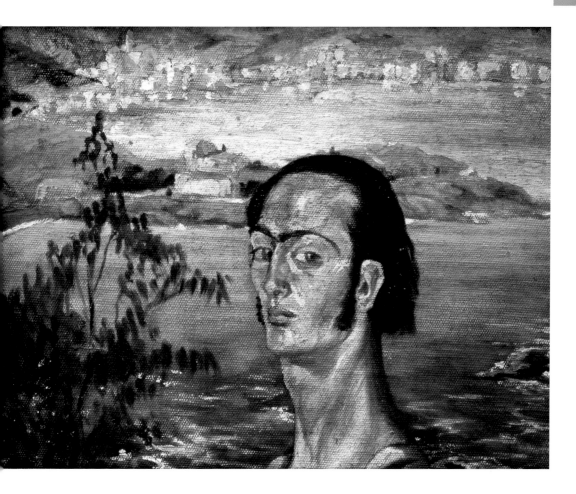

Harlequin, 1927

In 1927, Dalí was still under the influence of Picasso's Cubism and during this year he produced a range of images in the Cubist idiom, including *Barcelona Mannequin* (1926–27, see page 306) and *Harlequin*.

Harlequin at first glance barely resembles a portrait, appearing more like a crumpled paper bag. Yet the very fact that we read the left-hand side of the face as crumpled paper testifies to Dalí's ability to create convincing *trompe-l'oeil* effects. This may be a reference to Picasso's inclusion of pieces of the real world, such as newspaper and wallpaper, in his paintings.

The hole at the top of the 'head' of *Harlequin* suggests a pair of malevolent eyes, while the black and red clothing of the figure alludes to the traditional costume of a harlequin, typically made from diamond-patterned fabric, with one side of the costume a different colour from the other. Yet the eyes are empty, and this is simply a mask. Like *Soft Self-Portrait with Fried Bacon*, painted 15 years later in 1941 (see page 50), this is a portrait that doesn't show the soul, but merely the external wrappings.

CREATED

Spain

MEDIUM

Oil on canvas

PERIOD

Early

RELATED WORK

Pablo Picasso, *Harlequin Playing a Guitar*, 1918

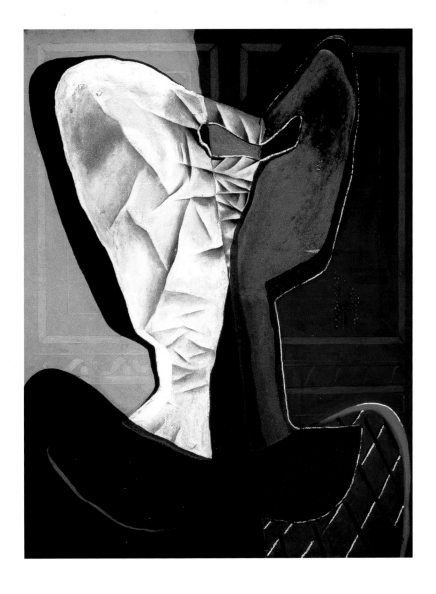

The Ghost of Vermeer of Delft, c. 1934

This is one of a series of images of Jan Vermeer (1632–75) that Dali produced in the mid 1930s. He depicts the seventeenth-century Dutch artist with his back to us, his head reduced to a large oval hat, his back and arm supported by a crutch and one leg extended into a right angle. Like the huge rotting female figure in *The Spectre of Sex Appeal*, (1934, see page 104) the figure has no feet.

The scene is taking place next to the cemetery in Port Lligat. The cemetery wall is to the right and we can see a cypress, a tree associated with burial grounds, growing above it. A spectre, whose details we can hardly make out in the moonlight, appears before the frightened figure of Vermeer.

A more detailed image from the series, called *The Ghost of Vermeer of Delft, Which Can be Used as a Table* shows Vermeer's back view more as it appears in his work *The Art of Painting* (1666–73). In Dali's version he shows Vermeer's right leg extended to form a flat surface, on which stand a wine bottle and a glass.

MEDIUM

Oil on canvas

PERIOD

Surrealist

RELATED WORK

Jan Vermeer, *The Art of Painting*, 1666–73

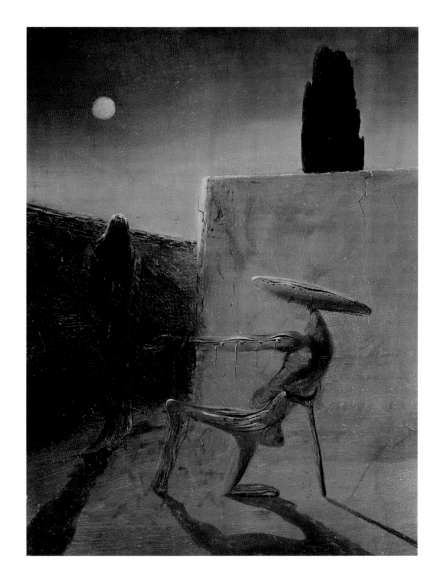

Venus and Sailor – Homage to Salvat-Papasseit, 1925

Of all the influences on his early work, it was Dali's fellow Spaniard, the incomparable Pablo Picasso (1881–1973), to whom he owed the most. Indeed Dali described Picasso as, '...doubtless the man I have thought most about, after my father'.

Venus and Sailor ... shows the influence both of Picasso's late Cubism and his early Neo-Classicism. In the painting, the dark steamy world of the embracing couple is contrasted with the sailor's natural home, the sea, visible through the French window. Whereas the barefooted sailor is painted in the Cubist style, flat and almost devoid of detail, the woman he holds in his arms is a more substantial, monumental figure, and here Dali uses light and shade to create an illusion of solid form.

Joan Salvat-Papasseit (1894–1924), to whom *Venus and Sailor* ... is dedicated, was a Catalan avant-garde poet, anarchist and leading member of the Vanguardist movement in Catalunya. He died of tuberculosis at the age of thirty. The theme of the painting, the sailor and his lover, is thought to come from one of Salvat-Papasseit's late erotic poems.

CREATED

Spain

MEDIUM

Oil on canvas

PERIOD

Early

RELATED WORK

Pablo Picasso, *The Lovers*, 1919

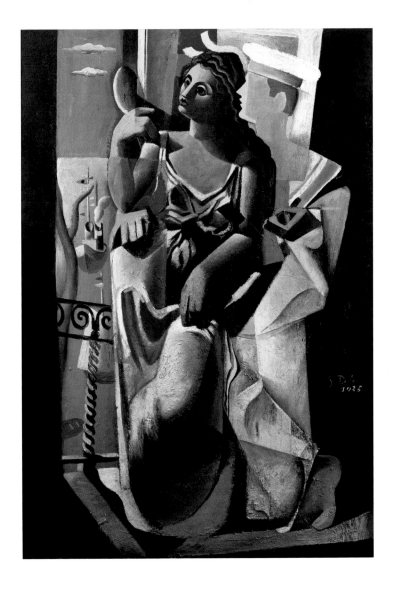

Venus de Milo with Drawers, 1936

A popular anecdote from Dali's relationship with his English patron Edward James in the 1930s recounts how when Dali heard the phrase 'chest of drawers' in conversation he became obsessed with the image it conjured up of a (woman's) chest with drawers.

Whether or not that was the inspiration for *Venus de Milo with Drawers*, the piece itself is a remarkable *tour de force*, both of surreal imagination and straightforward craftsmanship. Aided by his fellow Surrealist Marcel Duchamp (1887–1968) Dali created a plaster cast of the iconic ancient sculpture of Venus de Milo and then modified it to accommodate five opening drawers.

The drawers in the piece also refer to the work of the German psychoanalyst Sigmund Freud (1856–1939). Dali said of Freud's work, 'the only difference between immortal time and the present time is Sigmund Freud who discovered that the human body – purely Neo-Platonic in the Greek age – is today full of secret drawers which only psychoanalysis is capable of opening'. In *Venus de Milo with Drawers*, Dali brilliantly juxtaposes the cool grace and elegance of the Classical Venus with ' ...the countless narcissistic smells that waft out of all our drawers'.

MEDIUM

Bronze on a plaster base

PERIOD

Surrealist

RELATED WORK

René Magritte, *Les Menottes de Cuivre*, 1936

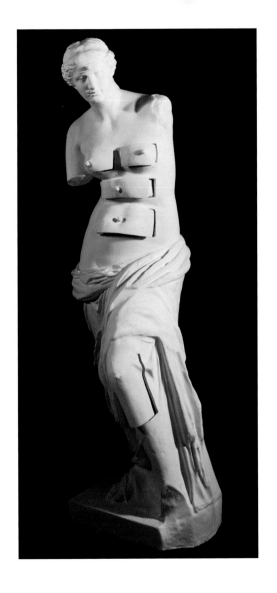

Venus Spatiale, 1984

This bronze sculpture, produced at the end of Dalí's life in collaboration with friend and collector Beniamino Levi, features classic Dalí motifs. In front of the woman's womb sits a large egg shape, polished to give it prominence. Eggs appear in several Dalí works, and he fantasized about being able to return to the womb at will (see *Family of Marsupial Centaurs*, page 48).

There are two spiders on the figure, one close to the navel and the other on the flat surface of the leg section, suggesting Dalí's association of eroticism with revulsion. The missing head and arms recall Classical nude sculptures from the ancient world, but the soft watch that hangs from the neck, almost like a thin slice of meat, hints that this work can also be read as the depiction of a mutilated corpse.

The torso of the statue is considerably offset from the legs, although this is not so apparent from the front view. When seen from the side, the figure appears to have been sliced horizontally at the hips and the upper part pushed back, making the torso seem precariously supported.

MEDIUM

Bronze with brown and gilt patina

PERIOD

Late

RELATED WORK

René Magritte, *La Folie des Grandeurs (Megalomania)*, 1967

Dutch Interior, 1914

Even at the age of ten when Dali produced this copy of a painting by the Spanish artist Manuel Benidito y Vives (1875–1963) we can discern the hand of an artist confident in his own ability, but happy to learn and absorb influences from the work of other artists.

Dali's parents were particularly concerned about their son's health following the death of their first-born son in 1903 barely ten months before Dali's birth. Consequently he spent much of his early youth cosseted and 'recovering' from various ailments. During these periods of convalescence Dali began to take an interest in art books, including one on Dutch interiors showing the work of the great Dutch masters Pieter de Hooch (1629–84) and Jan Vermeer (1632–1675).

Benidito's work, in the style of the Dutch masters, was reproduced in the review *Museum* in 1912 where Dali saw it. Although rougher and sketchier in execution than Benidito's painting, Dali's copy remains very close to the spirit of the original, and is a remarkable achievement for a ten year old.

MEDIUM

Oil on canvas

PERIOD

Early

RELATED WORK

Pieter de Hooch, *Woman Reading a Letter*, 1664

Apparatus with Hand, 1927

The Greek-born Italian artist Giorgio de Chirico (1888–1978), although not a member of the Surrealist movement, certainly influenced the work of the Surrealists and his earlier metaphysical paintings were highly regarded by them.

Apparatus with Hand shows the impact of de Chirico's work but also introduces some of the essentially Dalinian themes that were to dominate the next period of his work. The central form tottering in the teeth of a whirlwind of spectral forms certainly owes a debt to de Chirico's cityscapes. However, the flayed and bloody hand that sits at the top of this vaguely human form is very much Dali, as is the Catalan shoreline in the distance. Among the swirling images is the putrefying form of a donkey, a symbol that was to be taken to extremes in *Un Chien Andalou* two years later.

Possibly because of its confused symbolism or simply its avant-garde style, *Apparatus with Hand* was not well received by the critics. Dali dismissed his critics, accusing them of failing to appreciate the meaning of a work that was easily understood by children and 'the fishermen of Cadaqués'.

CREATED

Spain

MEDIUM

Oil on wood

PERIOD

Early

RELATED WORK

Giorgio de Chirico, *Il Grande Metafisico*, 1917

La Infanta Maria Teresa
(after Diego Velázquez), 1961

Dali had a lifelong admiration for the work of fellow Spanish artist Diego Velázquez (1599–1660), and at times even saw him as an alter ego, producing self-portraits that compared his own appearance to that of Velázquez. Dali first became familiar with Velázquez's work in the Prado, the superb art gallery that Dalí was able to visit frequently while living in Madrid as a student.

This watercolour painting, in which the colours bleed freely into each other, appears almost abstract in the absence of knowledge of its subject. It is one of a series of interpretations of Velázquez's work produced by Dali around 1960, the three hundredth anniversary of Velázquez's death. This image is almost certainly based on *Maria Teresa of Spain (with Two Watches)* by Velázquez, painted in 1652–53, and now in the Kunsthistorisches Museum, Vienna. A similar portrait of the Infanta Margarita is in the Prado.

Picasso was also preoccupied with the work of Velázquez and in 1957 produced a large number of variations on the masterpiece *Las Meninas*, painted by Velázquez in 1656.

MEDIUM

Watercolour and gouache on paper

PERIOD

Late

RELATED WORK

Pablo Picasso, *Las Meninas – after Velázquez*, 1957

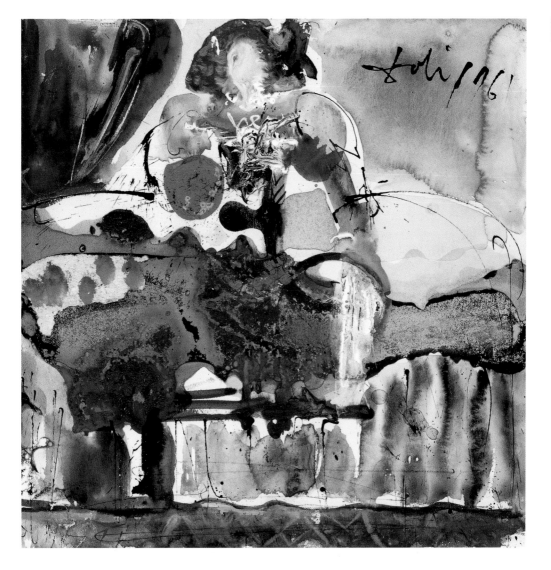

The Architectonic Angelus of Millet, 1933

In 1910, Dali's father enrolled him at the newly opened college of the Christian Brothers in Figueras. On the corridor walls of the splendid new building were framed prints including a reproduction of Jean François Millet's (1814–1875) *The Angelus*, a painting showing a peasant couple stopping to pray when they hear the distant bells of the village church. In a precursor to Dali's paranoid-critical visions, he saw the form of the two peasants symbolized by two cypress tress growing outside his classroom window.

Millet's *The Angelus* exerted a profound influence on Dali throughout his life and he referred to the figures in the painting again and again in his own work. In *The Architectonic Angelus of Millet* he represents the peasant couple by two large white stones eroded by the sea that he found on the beach at Cadaqués. Although the male figure on the left appears to dominate the female figure he is passive. In fact the female figure with her long phallic horn is attacking him.

The minute figures of the young Dali and his father can just be seen under the towering figure of the male.

MEDIUM

Oil on canvas

PERIOD

Surrealist

RELATED WORK

Jean François Millet, *The Angelus*, 1858–59

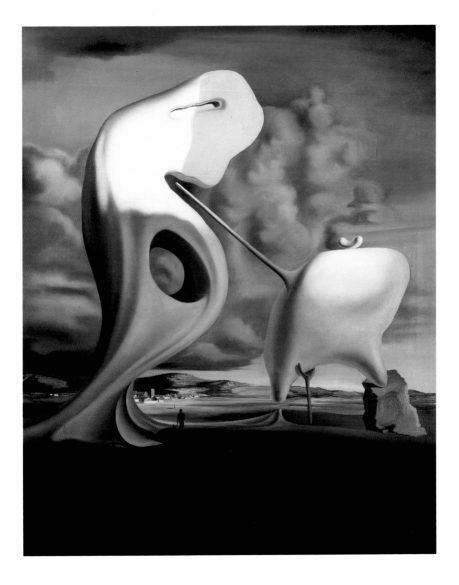

Gala and the Angelus of Millet Before the Imminent Arrival of the Comical Anamorphoses, 1933

Courtesy of National Gallery of Canada, Ottawa, Ontario, Canada/Bridgeman Art Library/© Salvador Dali, Gala-Salvador Dali Foundation, DACS, London 2006

Time and again Dali returned to Jean François Millet's (1814–1875) painting, *The Angelus*, and in 1933 he wrote an extended essay, *The Tragic Myth of Millet's Angelus. A Paranoiac-Critical Interpretation*, in which he sought to explain both the popularity of the picture and his own peculiar obsession with it.

Although many of Dali's paintings reinterpret *The Angelus*, here Dalí creates an almost perfect reproduction of it, which he places above the door of a room. In this room sit Gala and a bald-headed character identified as Lenin, a familiar figure from several of Dali's paintings of the period including, *L'Enigme de Guillaume Tell* (1933, see page 266) and *Partial Hallucinations: Six Apparitions of Lenin on a Piano* (1931, see page 78). To the left of the painting another figure appears to be either closing the door or about to enter the room. This strange character with his flowing moustache, a lobster attached to his head (see *Téléphone Homard*, page 38) and wearing a green dress, has been identified as the Russian writer and dramatist Maxim Gorky (1868–1936). Gala does not seem in any way alarmed by these enigmatic visitors; indeed she appears to be laughing at them.

MEDIUM

Oil on panel

PERIOD

Surrealist

RELATED WORK

Jean François Millet, *The Angelus*, 1858–59

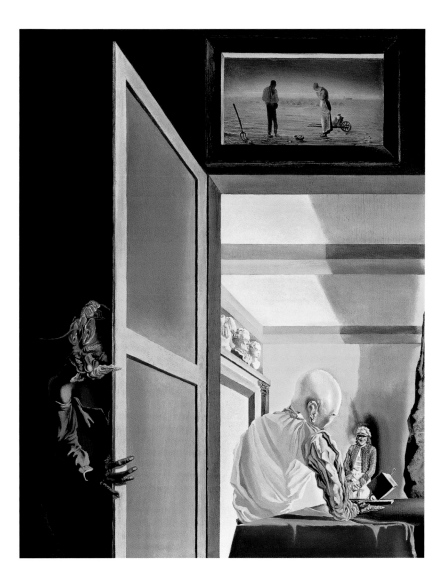

The True Painting of the Island of the Dead by Arnold Böcklin at the Hour of the Angelus, 1932

The title of this work refers to two paintings that preoccupied Dali throughout the early 1930s. He referred to Millet's *The Angelus* in countless of his own paintings and commentaries. At the same time as he was writing at length about *The Angelus* he was also engaged in analyzing *The Island of the Dead* for a book he was planning.

The Island of the Dead is a painting by the Swiss Symbolist painter Arnold Böcklin (1827–1901), who had been commissioned to paint a picture on the theme of bereavement by a woman whose husband had recently died. Böcklin produced no less than five versions of the work, which shows a boat approaching a small sombre-looking island at twilight. In the centre of the island is a glade of cypress trees reaching upwards into the evening sky.

Dali's painting makes no obvious pictorial reference to either work, and even the island on the horizon bears no resemblance to Böcklin's. Dali reworked this picture in 1946 as *Giant Flying Mocha Cup with an Inexplicable Five Metre Appendage* (see page 54) and, although the title is more straightforward, the content is just as enigmatic.

MEDIUM

Oil on canvas

PERIOD

Surrealist

RELATED WORK

Arnold Böcklin, *The Island of the Dead*, 1880

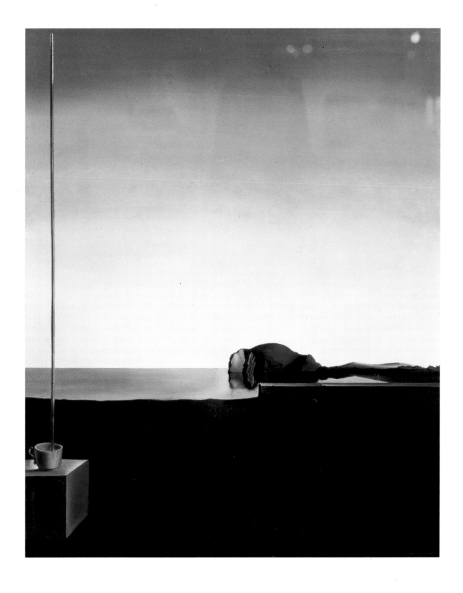

Yeux Surréalistes ('Surreal Eyes'), 1980

This tiny sculpture, less than 35 cm (14 in) tall, depicts a 'wall' of eyes, and was produced in an edition of nine hundred and ninety-nine as an affordable sculpture for private collectors. Since windows are considered to be the eyes of a house, this image links to Dali's preoccupation with creating double images of faces from inanimate objects. However, whereas windows are both for looking out of and into buildings, these eyes permit no intrusion into the edifice and instead we find ourselves on the uncomfortable end of 'the gaze', perhaps a sign of sexual interest. Yet, like the front of a building, this sculpture remains just a façade.

The wall of eyes rests on a stepped plinth, recalling iconic examples of Classical architecture such as the Parthenon in Athens, and giving the small structure a sense of importance and grandeur. A phallic protuberance on the left-hand side rests on a trademark Dali crutch.

Emphasized by a break in the stepped plinth, a keyhole has pushed forward from under one of the eyes and acts as a front door to the 'building'. Dali used keys and keyholes earlier in his career as Freudian symbols of male and female genitalia, and clearly this is being referred to here.

MEDIUM

Bronze patinated with silver

PERIOD

Late

RELATED WORK

René Magritte, *Painted Object: Eye*, 1936–37

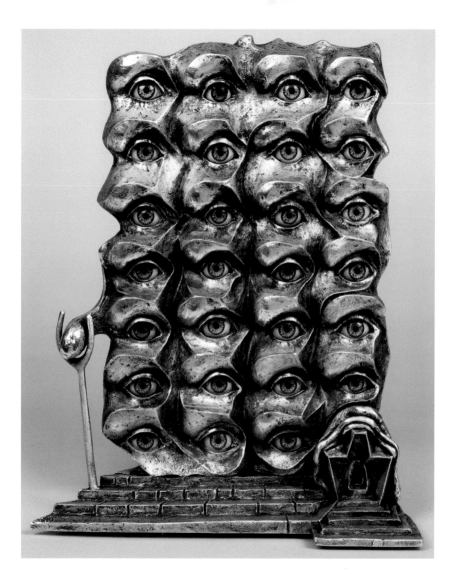

The Dream, 1931

The original Surrealist concept of automatism was an attempt to exert no control over the functioning of the creative impulse. As the Surrealist movement developed, automatism was gradually overtaken by a greater interest in the content and form of dreams. Fantastic dreamlike images were at the core of Dali's work and in *The Dream* Dali incorporates the image of dreamer as part of the dream.

The central image of *The Dream*, the bust of a sleeping woman, is taken from *The Font*, (sometimes referred to as 'The Fountain'), a work Dali produced during the previous year. With her Medusa-like hair, her eyes sealed like the eyes in *Le Sommeil* (1937, see page 234), and her non-existent mouth recalling *The Great Masturbator* (1929, see page 100), she is as disturbing as the subject of her dream, which is shown to her left.

In an often-quoted scene from Dali and Buñuel's film *Un Chien Andalou*, a girl's mouth is removed when a man wipes his hand across her face. The recurring image of the absence of a mouth in Dali's figures symbolizes helplessness, impotence and the inability to cry out even in distress.

MEDIUM

Oil on canvas

PERIOD

Surrealist

RELATED WORK

Paul Delvaux, *Venus Asleep*, 1944

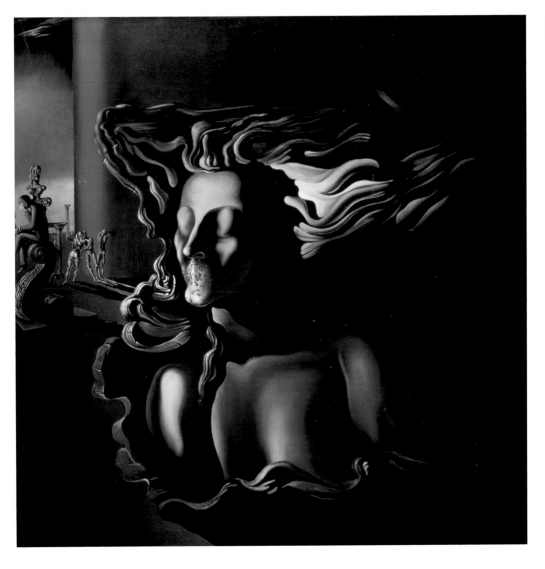

Le Sommeil ('Sleep'), 1937

Dalí first showed *Le Sommeil* at the Paris International Surrealistic Exhibition in 1938 and many commentators consider it to be among the finest works, not just of his Surrealist period but also of his entire career.

Against a limpid blue background, where the gently lit land, sea and sky seem to merge, floats an image of Dalí's form familiar from *The Great Masturbator* (1929, see page 100) and *The Persistence of Memory* (1931, see page 314). However, in *Le Sommeil*, Dalí has given himself a mouth and, rather than resting on the ground, his image is supported by a series of large and small crutches. Only a small, beached boat, a dog whose neck is supported by a crutch and the small hillside town in the distance, disturb the emptiness of the background.

Sleep is the source of dreams, so important to the imagery of the Surrealists. At the time of this work, sleep was also a source of respite for Dalí from the appalling carnage of the Spanish Civil War that consumed so many of his friends, including the poet Lorca (1898–1936).

MEDIUM

Oil on canvas

PERIOD

Surrealist

RELATED WORK

Piero della Francesca, *The Discovery and Proof of the True Cross*, c. 1452–66

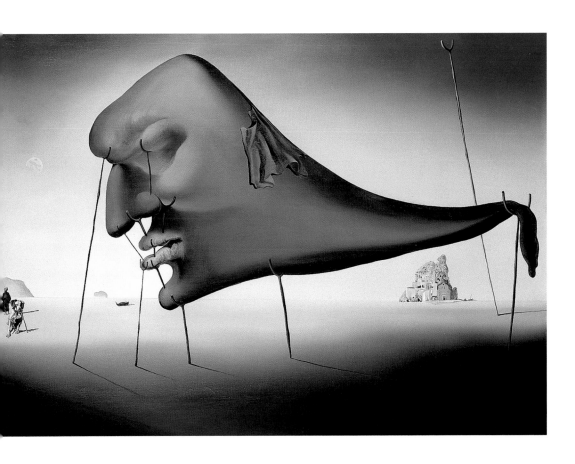

Le Rêve Approche
('The Dream Approaches'), 1931

Dreams and dream-like states were important concepts for the Surrealist movement. The Surrealists believed that an almost unaltered representation of the images of dreams was sufficient to achieve one of their principle aims, to disorientate the viewer and directly challenge their perception of reality. Dali refined this theory using his paranoid-critical technique, through which he claimed he could create dream-like and delirious images while fully conscious.

In *Le Rêve Approche* a classically posed naked figure gazes out to sea. This slight, androgynous figure appears to have a decorated body. In the right-hand corner of the picture is a draped form, possibly a coffin, on which tiny birds are feeding. On the corner of the drape is a strange womb-like pod, while to the right stands a tall phallic tower, its plaster cracked revealing brickwork below.

The tower, which appears a year earlier in *Gravida finds the Ruins of Anthropomorphis* (1931) and later in *The Horseman of Death* (1934), symbolizes sex, violence and death. The whole scene is bathed in an eerie dream-like golden glow giving it an otherworldly quality.

MEDIUM

Oil on canvas

PERIOD

Surrealist

RELATED WORK

Giorgio de Chirico, *Anguish of Departure*, 1914

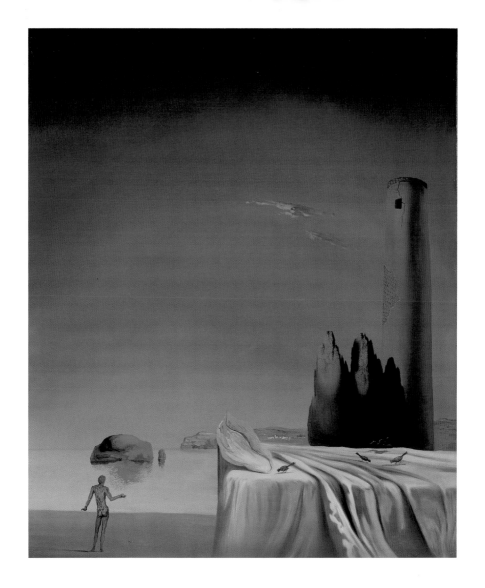

L'Ascension de Christ (Pietà), 1958

This is one of a series of religious paintings Dali produced in the 1950s, which includes *Christ of St John of the Cross* (1951) and *The Sacrament of the Last Supper* (1955, see page 244). As in *Christ of St John of the Cross*, the figure of Jesus is shown extremely foreshortened. Dali had had a glass panel fitted in the floor of his studio enabling him to see a figure standing above or below it in exaggerated perspective.

Dali used a boy called Juan from Cadaqués as the model, whom he and Gala treated like an adopted son. The female figure, based on a portrait of Gala, represents the Virgin Mary or Mary Magdalene and is also extremely foreshortened, creating an uneasy relationship between the two figures. The dove below Gala's chin represents the Holy Spirit.

Behind Christ is the centre of a sunflower, enlarged. Dali was fascinated by the dynamics of self-perpetuating logarithmic spirals and the way these shapes occur in nature, for example, in the floret of flowers, shown here, and in the growth pattern of seashells and the curve of the rhinoceros horn.

CREATED

Spain

MEDIUM

Oil on canvas

PERIOD

Nuclear Mystic

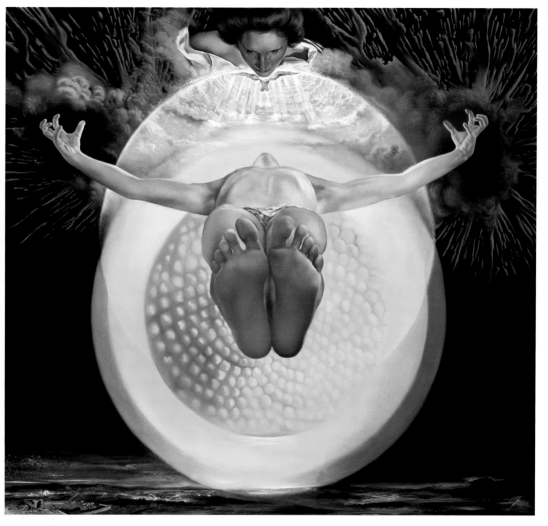

Composition: The Virgin and Child, 1942

Dali painted many images of the Virgin Mary later in his career, often with the features of Gala. In this watercolour, however, he creates a ghostly double image of Mary, her face formed from a flock of birds, her body suggested by slightly darker areas of 'sea', and only her sandled foot and her left hand, holding Jesus, being depicted as solid forms.

The way Dali creates faces in his double images taps into the innate desire that humans have, from birth, to recognize and gaze at human faces. This essential part of an infant's survival mechanism never leaves us, and even as adults we tend to see faces in anything that vaguely resembles a pair of eyes, nose and mouth. And having identified facial features in an object or series of objects, it becomes impossible not to continue to do so.

Dali uses this same motif of a figure with a face made from a flock of birds in one of the murals he executed for Helena Rubinstein at her New York apartment (see page 190).

MEDIUM

Watercolour on ivory

PERIOD

Classic

RELATED WORK

Raphael, *The Madonna of the Pinks, c.* 1506–07

Assumpta Corpuscularia Lapislazulina, 1952

After the Second World War, Dalí was increasingly drawn to religion and mysticism, and religious themes become central to much of his work. Dali's relationship with the church was a complex one. Indeed he claimed at one point to be simultaneously both Roman Catholic and agnostic.

Part of Dali's genius was his ability to incorporate thoroughly disparate themes into one homogenous whole. In *Assumpta Corpuscularia Lapislazulina* the main theme is the Assumption into heaven of the Virgin Mary, an apocryphal event that was the subject of papal pronouncements shortly before Dali painted this picture. From a variety of different spatial perspectives we see his muse Gala as the Virgin, a crucified body of Christ virtually identical to the figure in *Christ of St John on the Cross* (1951), and what appears to be an exploding dome prefigured in *Raphaelesque Head Exploding* (1951).

As well as containing references to thoroughly contemporary issues that fascinated Dali, such as the development of particle physics, this image shows the enduring influence on Dali's work of the great seventeenth-century European artists, particularly the Madonnas of the Spanish artist Bartolome Esteban Murillo (1618–82).

MEDIUM

Oil on canvas

PERIOD

Nuclear Mystic

RELATED WORK

Bartolome Esteban Murillo, *The Immaculate Conception of the Escorial*, c. 1660–65

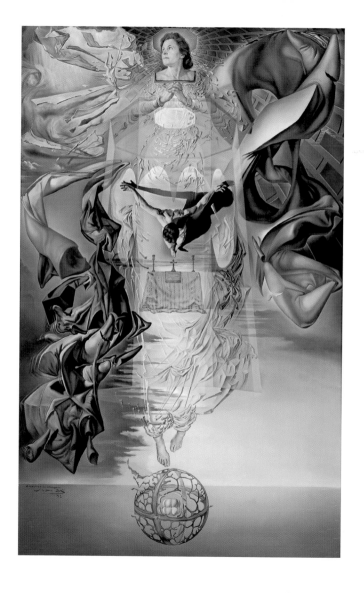

The Sacrament of The Last Supper, 1955

In the 1950s Dali became increasingly involved with the Catholic Church, even being granted audiences with two popes. Religious themes appeared as the subject of much of his work at this time, albeit given a subversive Dalinian twist.

In Dali's huge canvas *The Sacrament of The Last Supper*, which measures 2.95 m by 1.67 m (10 ft by 5 ft), he shows the final supper of Jesus and his twelve disciples against a background of four geometric windows. Through the windows the bay of Port Lligat can clearly be seen. It was at Port Lligat that Dali produced the work with the help of Isador Bea, a Spanish scenery designer who collaborated with Dali on his large-scale paintings. The painting did not meet with critical acclaim, but did attract a great deal of controversy when it was realized that Dali had given Gala's features to the face of Christ.

Chester Dale, a founding benefactor of the National Gallery of Art in Washington DC and a leading collector of nineteenth- and twentieth-century art, admired the painting greatly and, unaffected by its critical reception, bought it, later donating it to the gallery's permanent collection.

CREATED

Spain

MEDIUM

Oil on canvas

PERIOD

Nuclear Mystic

RELATED WORK

Leonardo da Vinci, *The Last Supper*, 1498

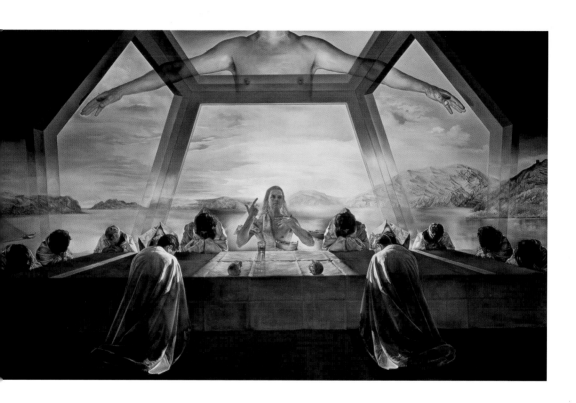

The Ecumenical Council, 1960

Dali's renewed interest in religion, particularly Roman Catholicism, which began in the late 1940s, led to audiences with Pope Pius XII in 1949, and Pope John XXIII in 1959. In 1960, Pope John announced that an Ecumenical Council would be held to chart the way forward for the church. This major event became known as The Second Vatican Council (or 'Vatican Two'), and more than 2,500 senior clerics were present at its opening mass at St Peter's in Rome.

Dali's painting celebrates the announcement of the Council and was the last of his large-scale religious works. Like the other paintings in the series, which include *The Discovery of America by Christopher Columbus* (1958–59, see page 172) and *Saint James of Compostela* (1957), *The Ecumenical Council* is a huge piece, measuring 4 m by 3 m (13 ft by 10 ft).

In the bottom left-hand corner of the canvas we see Dali seated at his easel adopting a pose similar to Velázquez's in *Las Meninas*. Here Dali presides over a great swirl of religious and quasi-religious symbols culminating with the naked body of Christ framed within an arch of St Peter's, Rome.

CREATED

Spain

MEDIUM

Oil on canvas

PERIOD

Nuclear Mystic

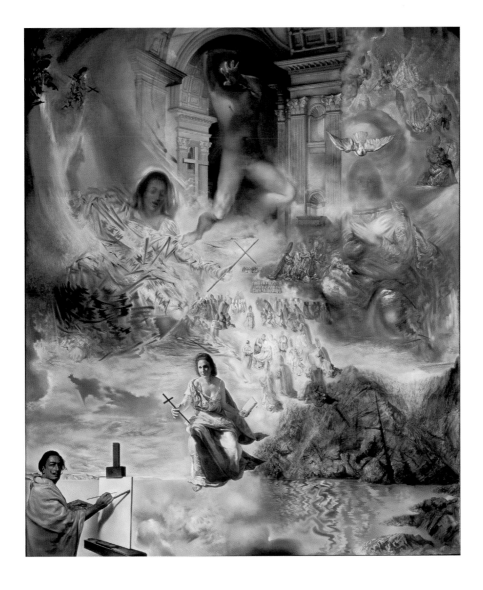

The Sistine Madonna, 1958

Throughout Dali's career he painted many representations of the Madonna, usually using Gala as his model. In *The Sistine Madonna*, however, Dali uses an image of the Madonna taken from a work of the same name by the great Renaissance artist Raphael (1483–1520) whose work Dali admired enormously.

Dali places the Madonna and her child into an image of the ear of Pope John XXIII taken from a photograph in *Paris Match*. By placing the Madonna in an ear Dali refers to the Catholic doctrine of the impregnation of the Virgin Mary simply by hearing the word of the angel Gabriel announcing that she will bear God's child.

The technique that Dali uses of enlarging a photograph taken from a magazine, until the component half-tone dots of the printing process are clearly visible, symbolizes the breaking down of matter into its atomic parts, which can then be re-formed into other things. As the viewer moves away from the painting the dots appear to form and re-form first as the Madonna, then an ear, and finally as the Madonna in the ear.

MEDIUM

Oil on canvas

PERIOD

Nuclear Mystic

RELATED WORK

Raphael, *The Sistine Madonna*, 1513–14

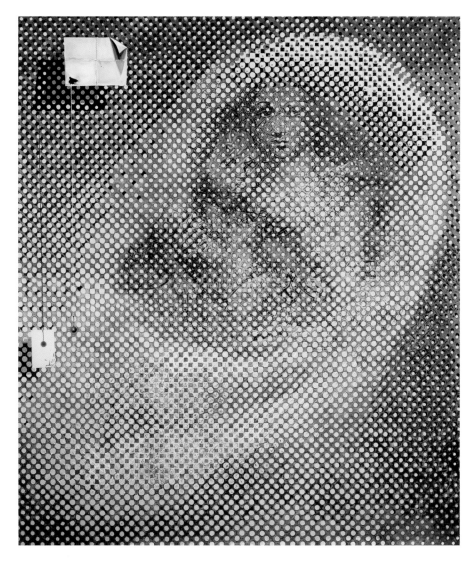

Pietà, 1982

In 1981 Dalí returned to Spain for the final time. Remarkably, that winter was the first he and Gala had ever spent at Port Lligat. Winters were miserable on this part of the Spanish coast, it rained often and the wind howled down from the Pyrenees. Dalí and Gala were old and their health was failing.

Even in his old age, Dali continued to study the works of the old masters searching for their secrets, and in the 1980s he produced a series of paintings informed by the works of Velázquez and Michelangelo. In February 1982, the year that Gala was to die, he painted *Pietà*, based on Michelangelo's statute of Mary cradling the dead body of her son Jesus Christ. Against the sketchily drawn landscape of the bay at Port Lligat, Dalí paints the figures of Mary and Jesus as though they were becoming part of the landscape of Cap de Creus. Holes have been eroded through Mary's breasts and Christ's abdomen showing distorted views of the bay, as though viewed through a lens.

In one of Dali's final double images, the brow and nose of Christ become the rock visible through Mary's right breast.

CREATED

Spain

MEDIUM

Oil on canvas

PERIOD

Late

RELATED WORK

Michelangelo, *Pietà*, 1501

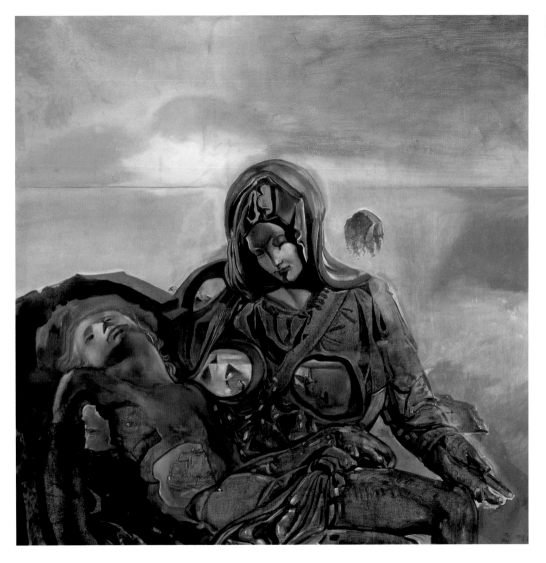

The Path of Enigmas (Second Version), 1981

In the second of two similar paintings, which Dalí produced in 1981, a straight path flanked by levitating sacks leads towards the horizon with a hazy sun shown above the vanishing point.

Although Dalí was by now in his late 70s, he was still using motifs from decades earlier in his career. The sacks are references to the sacks on the wheelbarrow in Millet's *The Angelus*, which Dalí discussed at length in *The Tragic Myth of Millet's Angelus* in 1933. Dalí produced many images that refer to *The Angelus*, and the sacks first appear by themselves as the breasts of the decomposing woman in *The Spectre of Sex Appeal* (1934, see page 104). The levitation of the sacks is a reference to Dalí's exploration of the theories of particle physics in the 1950s.

In the version of *The Path of Enigmas* shown here, the sacks are old and torn and have been tied up erratically in a vain attempt to prevent the contents spilling out. The sack in the foreground appears to be leaking money, suggesting material possessions coming between Dalí and his path to the absolute achievement of his goals, whether in this life or the next.

CREATED

Spain

MEDIUM

Oil on canvas

PERIOD

Late

RELATED WORK

Meindert Hobbema, *The Avenue at Middelharnis*, 1689

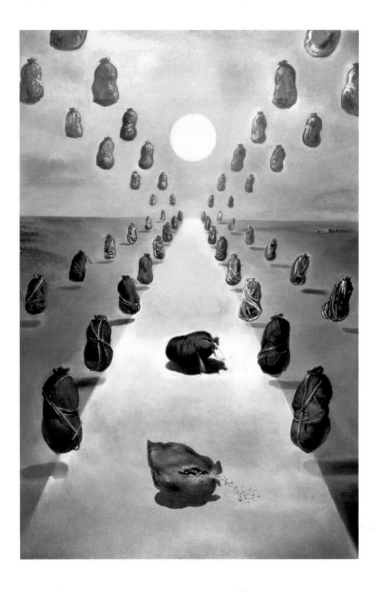

Messenger in a Palladian Landscape, c. 1936

This sketchy pen drawing of around 1936 depicts a mounted messenger in a Classical Italian setting, which Dali refers to as 'Palladian', namely in the Neo-Classical style of the Italian architect Andrea Palladio (1508–80). Classical and Neo-Classical architecture are based on the styles of the ancient Greeks and Romans, and here we can see a large piazza surrounded by elegant buildings with colonnades, columns and arches.

The figure of the horseman and his mount is in the style of Leonardo da Vinci's (1452–1519) drawings for the battling figures in the background of *The Adoration of the Magi* (1481–82), the *Study for the Sforza Monument* (c. 1488–89) and *Study for the Trivulzio Monument* (c. 1508–12). Dali was a great admirer of da Vinci, and these mounted figures are a recurring motif in his work.

The image is mounted in an asymmetrical frame that bears little or no relationship to the image contained within it. Fellow Surrealist René Magritte (1898–1967) uses a similar type of shaped frame for *La Représentation* (1937), except that in this case the frame fits exactly around the cut-out image.

MEDIUM

Pen and ink on paper

PERIOD

Surrealist

RELATED WORK

René Magritte, *La Représentation*, 1937

Les Juges ('The Judges'), c. 1933

This vibrant pen drawing is dominated by the depiction of an equestrian monument standing on a large plinth. The sculpture is depicted in front of a large palace-like edifice built in the Classical style. On the front of the building are two sculptures of dignitaries, the judges, holding out scrolls.

Despite its elegance, the building seems to be crumbling and plants are growing on the roof, between the stones. Pieces of Classical carving lie on the ground as though the palace has been abandoned, except for the adult and child standing in the distance on the enormous piazza, gazing at something that is beyond our view, and dwarfed by the gigantic monument. It is as though these relics no longer mean anything: the old order is no more, and a new society has replaced it.

Dali has clearly worked quickly here, using pen and ink, and adding darker areas with a brush. Yet despite the apparent haste, Dali creates an image of an equestrian sculpture in the foreground of the drawing that has believable form, bulk and vivacity.

MEDIUM

Pen and Indian ink on wove paper

PERIOD

Surrealist

RELATED WORK

Georgio de Chirico, *Ribera de Tesalia*, 1926

Benvenuto Cellini and Jupiter, 1945

Dali had a lifelong interest in Italian Classical art and the work of the great masters of the Renaissance. In 1945 he was commissioned to illustrate a new edition of Benvenuto Cellini's (1500–1571) autobiography. As well as being a celebrated sculptor, goldsmith and soldier, Cellini had been a larger-than-life character with a reputation for a quick and violent temper. He has been described as the hooligan of the Renaissance, which may go some way to explaining Dali's interest in him.

In this watercolour and pencil drawing Dali illustrates the unveiling of a solid silver sculpture of Jupiter (the supreme Roman deity), which Cellini produced for the King of France. To achieve the maximum theatrical effect Cellini positioned the sculpture at the end of a dark corridor and had it lit from behind by a servant holding a flaming torch.

Cellini's artifice in the display of the piece must surely have appealed to the showman in Dali and he shows the servant with the torch, and a Jupiter who seems to be breaking free from the confines of the corridor and advancing threateningly on his creator, Cellini, who is dressed in red.

MEDIUM

Watercolour and pencil

RELATED WORK

Michelangelo, *Three of the Tasks of Hercules,* 1530

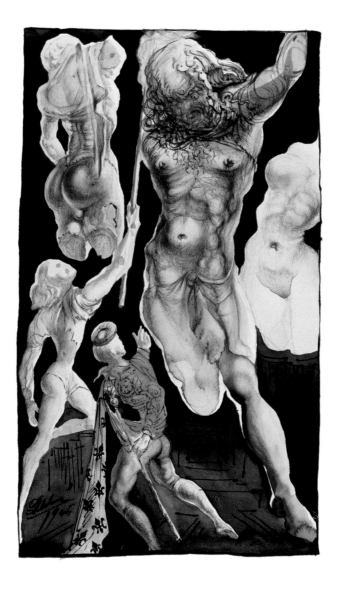

The Metamorphosis of Narcissus, 1937

Dali met Freud in London in July 1938. It was Dali's only meeting with the man whose work was such a seminal influence on Dali's entire career. Dali took only one work with him to show Freud, *The Metamorphosis of Narcissus*, completed the previous year.

The Metamorphosis of Narcissus was painted in Italy, and demonstrates an Italian influence both in its Classical theme and in Dali's adoption of Renaissance conventions of composition and colour. The painting shows Narcissus, a mythical Greek figure unable to love anything other than his own reflection, whom the gods turned into a flower. On the right of the picture the flower (narcissus/daffodil) is shown emerging from a fractured egg held by the hand, mirroring the image of Narcissus on the left contemplating his reflection. On a plinth in the middle-distance we see a statue of Narcissus admiring himself while in the far distance the image of the hand is repeated in a gap in the mountains.

Freud's rather ambivalent judgement on seeing the work was that it showed, 'undeniable technical mastery'.

CREATED

Italy

MEDIUM

Oil on canvas

PERIOD

Surrealist

RELATED WORK

Giorgio de Chirico, *Le Consolateur*, 1929

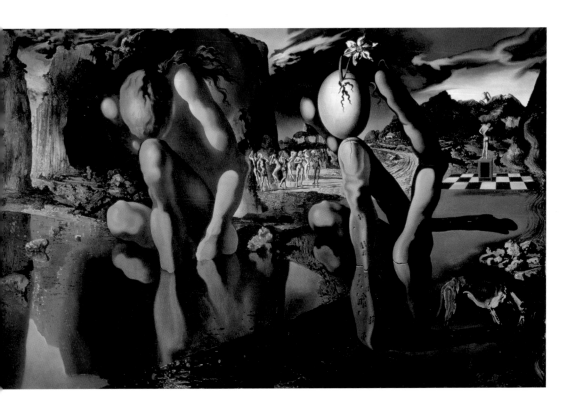

Palladio's Corridor of Dramatic Surprise, 1938

Dali admired the work of the Italian architect Palladio, and the title of this painting relates to the illusionistic perspective at his Teatro Olimpico at Vicenza in northern Italy, dating from around 1580. The proscenium of Palladio's theatre consists of an elaborate Classical structure with a large archway in the centre and a door on either side. These give on to what appear to be long corridors, but this is an illusion as they are constructed with false perspective.

In this painting, Dali suggests the dramatic perspective of one of these 'corridors'. In the foreground of the painting a partially clad woman, reminiscent of the figure in *Spain*, (also 1938, see page 156), rests on a cabinet. She is being handed a telephone receiver, a Dalinian symbol of communication breakdown. At the end of the corridor is the familiar girl in a white dress with the skipping rope, based on Dali's cousin Carolinetta who died of tuberculosis while still a child.

Dali visited Sicily at the time of the painting, and saw the catacombs in Palermo where mummified corpses were propped against the walls. These were possibly the inspiration for the rather sinister figures that line the corridor.

CREATED

Italy

MEDIUM

Oil on canvas

PERIOD

Surrealist

RELATED WORK

Titian, *The Finding of the Body of Saint Mark*, 1562

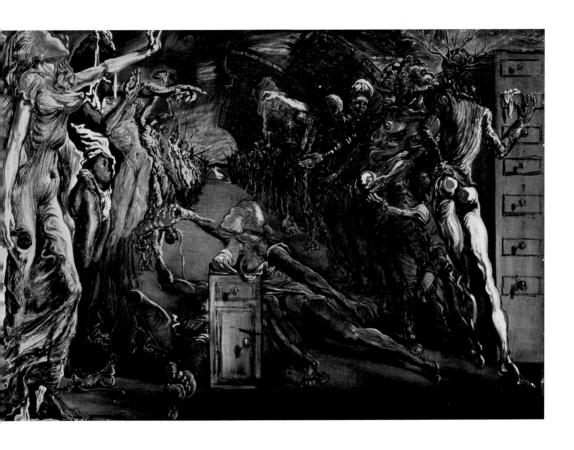

Parade of Cavaliers, 1942

Also known as 'Equestrian Parade', this image may have been produced as part of a series of set designs for the ballet *Romeo and Juliet*.

Like *Suburb of the Paranoid-Critical Town* (1936, see page 186), the image gives juxtaposed views with different perspectives and is divided into two distinct halves. The left-hand half shows a mounted horseman holding a lance, which he appears to be about to plunge into a large ball. During the same year that he painted this picture, Dali also produced a tiny image of *Saint George and the Dragon* on ivory, which shares certain similarities. A woman's arm runs along the bottom left-hand corner of this section, and her head may be formed by the rump and tail of the horse to the right.

The right-hand section has an exaggerated single-point perspective, with the mounted cavaliers forming a guard of honour for the woman and child who are walking towards the basilica at the end. In the foreground is a skull, a memento mori, or reminder of our mortality, which also appears in the foreground of *Saint George and the Dragon*.

MEDIUM

Oil on canvas

PERIOD

Classic

RELATED WORK

Paolo Uccello, *The Battle of San Romano, c.* 1454–57

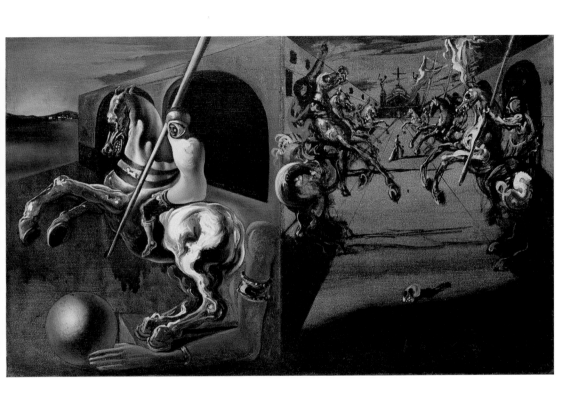

L'Enigme de Guillaume Tell
('The Enigma of William Tell'), 1933

When *L'Enigme de Guillaume Tell* was first shown in Paris at the Salon des Independants in 1934 it infuriated many Surrealists. The depiction of the central character as Lenin, naked from the waist down, his right buttock grossly elongated and supported by a crutch, was such an insult to their deeply held Marxist principles that one group tried to destroy it.

Why Dalí chose to represent William Tell as Lenin may be the enigma, but the painting itself is an extended reference to Dalí's troubled relationship with his father. Dalí's father, a complex and difficult character himself, was determined to end Dalí's affair with Gala and did everything within his considerable power as a notary to make Dalí's life in Catalunya difficult. At one point he even instructed the hotel in Cadaqués to refuse Dalí and Gala a room.

The central semi-naked figure represents Dalí's father holding his baby son. To distract his father's 'cannibalistic' tendencies consuming him, Dalí has placed a piece of raw meat on his head in place of the apple of the original legend.

MEDIUM

Oil on canvas

PERIOD

Surrealist

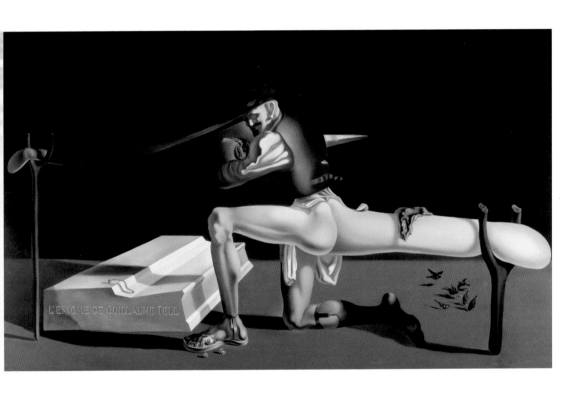

Saint George and the Dragon, 1962

Strangely, for a painting entitled *Saint George and the Dragon*, there is no dragon. St George is setting out on his quest, looking rather like a jouster, and has not yet encountered the mythical beast. A Don Quixote-like figure is depicted sitting in the bottom left-hand corner of the painting, looking passively across the plain. Perhaps he is waiting to witness the saint's safe and triumphal return.

Compared to the detail and sophistication of many of Dalí's works, *Saint George and the Dragon* has a rather slapdash and careless appearance. The landscape is suggested by a few rough brushstrokes, the horse's front legs are out of proportion and the figures, village and trees lack detail and appear unconvincing.

An earlier version of the same subject, produced by Dalí in 1942, shows an androgynous St George naked, astride a stallion, thrusting a phallic lance into the wide-open mouth of the dragon, while a naked damsel looks nonchalantly on. Painted on ivory and encrusted with seed pearls, this earlier work depicts a far more impassioned and dramatic image than the 1962 work of the same name shown here.

MEDIUM

Oil on canvas

RELATED WORK

Paolo Uccello, *Saint George and the Dragon*, c. 1470

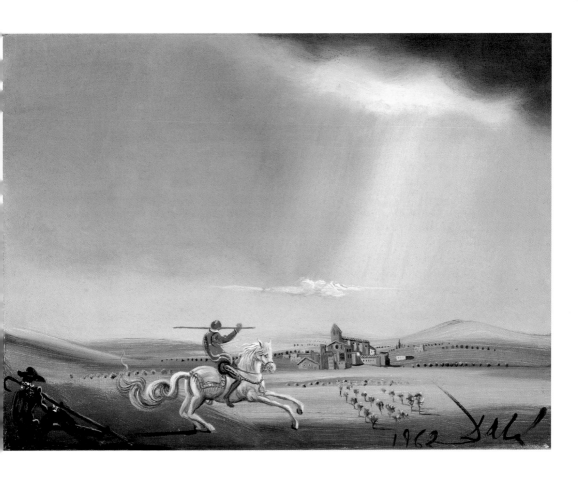

1962 Dalí

Temple de Diane à Ephesus ('Temple of Diane at Ephesus'), 1954

Courtesy of Christie's Images Ltd/© Salvador Dali, Gala-Salvador Dali Foundation, DACS, London 2006

This small image, painted in oil on canvas, measures 21 cm by 43 cm (8 in by 17 in). The focal point is the Classical portico of the Temple of Diana at Ephesus, an important city in the ancient world, in what is now modern-day Turkey. A few isolated columns standing on swampy ground are all that remain of this once-magnificent marble building, which was one of the Seven Wonders of the Ancient World, built around 550 BC by Croesus, King of Lydia.

Dalí's reconstruction of the façade of the temple appears to be his own invention. The columns are shown unevenly spaced, with a wider gap in the centre, which would not have been the case, and with three openings in the triangular pediment above the columns, for which there is no historical evidence. Dalí includes a series of posturing 'Classical' figures, which frame the temple on either side.

In the early 1950s Dalí produced a series of set designs for a film called *The Seven Wonders of the World*. It is possible that this painting relates to his designs for this production.

CREATED

America

MEDIUM

Oil on canvas

PERIOD

Nuclear Mystic (but Classic subject matter)

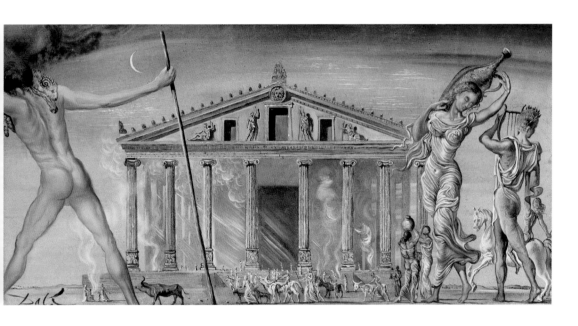

Tristan and Isolde, 1941

Ever the showman, Dali had a love of the theatre and first produced set designs for a production by his friend Lorca in 1927. While living in America, Dali was involved in the staging of a number of theatrical and ballet productions.

This is a design for a stage set dating from 1941 for *Tristan and Isolde*, an opera by Wagner that Dali much admired. Later, in 1944, Dali was to produce designs for his own Surrealist ballet *Tristan Insane*, based on the same story, although Dali made the sets so complex that the ballet was almost impossible to perform.

Dali constructs a powerful sense of a receding plain by the use of diagonal perspective lines or orthogonals, which meet at a single vanishing point on the horizon. This point is concealed behind the central large cypress tree. There is a powerful sense of the macabre here, with scattered human bones, dismembered limbs and a central throne made of skeletal parts. A large dark hole in the foliage of the central tree suggests the entrance to hell.

MEDIUM

Oil on canvas

PERIOD

Classic

RELATED WORK

Giorgio de Chirico, set design for *Protée*, 1938

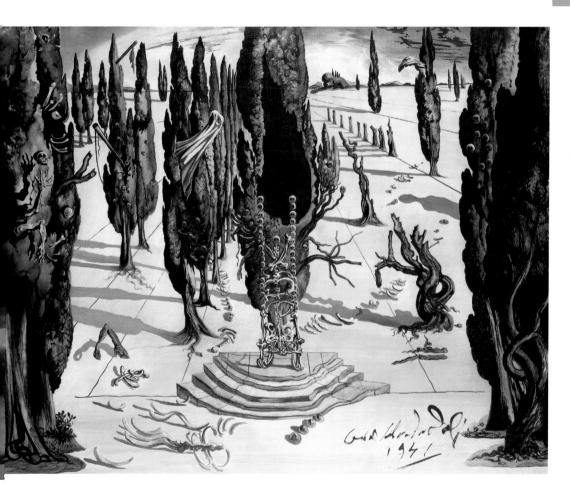

Costume for *Tristan Insane*, The Ship, 1942–43

The ballet *Tristan Insane*, *Mad Tristan* or *Tristan Fou*, was devised by Dalí using musical themes from Wagner's opera *Tristan and Isolde*. Dalí designed the costumes and sets for the production, which included painted backdrops featuring a range of Dalinian motifs, including bizarre architecture, fossilized cars and cypress trees.

The choreography was by Léonide Massine (1896–1979), the Russian-American choreographer of the Ballets Russes. Massine choreographed more than one hundred ballets in his lifetime, including in 1917 in collaboration with Pablo Picasso, *Parade*, 'the first Cubist ballet', so Massine was no stranger to avant-garde productions.

Tristan Insane was performed by the Ballet International in New York in 1944 and was described by Dali as 'the first paranoiac ballet based on the myth of love in death'. Unfortunately the stage design was so complex, so expensive and so unmanageable that the production was almost impossible to perform. The costume here is for 'the boat', and consists of full sails attached to the dancer's body, with a blue floating outfit that creates a remarkable illusion of the sea.

MEDIUM

Watercolour on paper

PERIOD

Classic

RELATED WORK

René Magritte, *Le Séducteur*, 1951

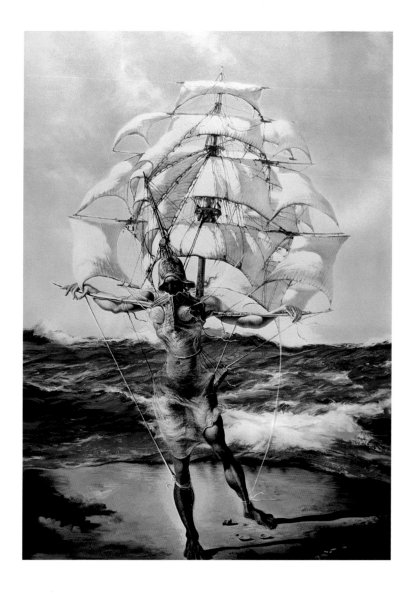

Enchanted Beach with Three Fluid Graces, 1938

In this image, Dali creates a double image of three female figures on a vast plain. Elements of the figures are depicted realistically, but objects on the plain suggest other parts of their bodies. For example, the head of the left-hand woman is formed from a rock; the face of the central woman is created from a horse and rider and other figures; and the face of the right-hand woman is suggested by a rock arch with a landscape beyond.

The Three Graces emanate from Greek mythology: three goddesses embodying grace, elegance, beauty and generosity, named Aglaia (splendour), Euphrosyne (joviality) and Thalia (good cheer). They are always depicted together as young maidens, either nude or clothed in flimsy garments, usually dancing in a circle. Like the Muses, the Graces were believed to endow artists and poets with the ability to create beautiful works of art. Dali's choice here of mythological subject matter anticipates his Classical period of the 1940s.

The Graces were a popular subject in Classical and Renaissance art and Dali would have been familiar with his hero Raphael's (1483–1520) *The Three Graces* (c. 1503–04).

MEDIUM

Oil on canvas

PERIOD

Surrealist

RELATED WORK

Raphael, *The Three Graces*, c. 1503–04

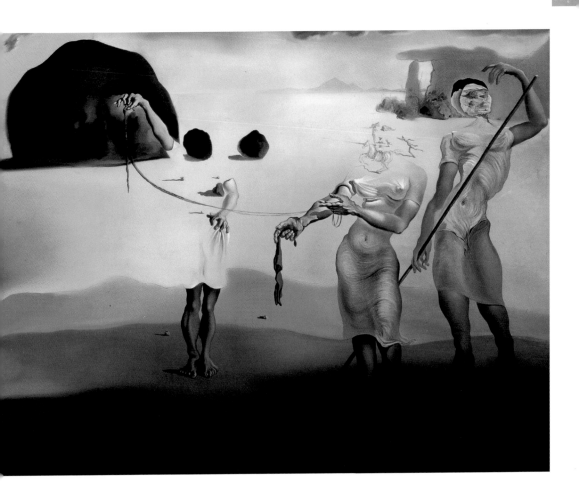

Hallucinogenic Toreador, 1968–70

The bullfight, part sacrifice, part theatrical performance, part fertility right and part test of macho courage, appears repeatedly in great works of Spanish art from Goya to Picasso. Dali was not a great devotee of bullfighting in the way that Picasso was, but he did make it the subject for one of his most powerful late works.

Hallucinogenic Toreador is a large painting measuring 3 m by 4 m (10 ft by 13 ft). In it Dalí refers to many of his perennial themes, using a variety of styles including photorealism and the simulation of Benday dots – a printing process combining two or more different small, coloured dots to create a third colour, something seen particularly in the work of American artist Roy Lichtenstein (1923–97). The toreador, a single tear in his eye, represents Dalí's deceased brother and friends, particularly Lorca, whose poem 'Lament for the Death of a Bullfighter', written shortly before his own death in 1936, had a lasting effect on Dali. Surveying the scene is Dali as a little boy dressed in the same sailor suit he wore in *The Spectre of Sex Appeal* (1934, see page 104). The paranoid-critical double image of the toreador's face is formed by the repeated image of Venus de Milo that Dali had seen on a box of English 'Venus' brand pencils.

CREATED

Spain

MEDIUM

Oil on Canvas

PERIOD

Late

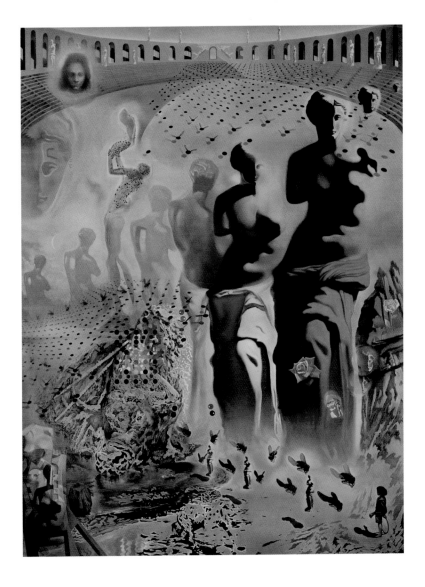

Dematerialization of Nero's Nose, 1947

Courtesy of Gala-Salvador Dali Foundation, Figueras, Spain, Index/Bridgeman Art Library/© Salvador Dali, Gala-Salvador Dali Foundation, DACS, London 2006

This painting is typical of Dali's Nuclear-Mystical period, during which he depicted objects levitating in space, a reference to his fascination with atomic particles and the fact that they do not touch.

Dali also introduces a strongly Classical theme in this work, with references to the ancient world, including a triumphal arch with its pediment suspended above, and a bust of Nero with a broken-off nose, which is floating below the sculpture's chin. Several of Dali's recurring motifs are also included. For the setting, he chooses his beloved Ampordán plain, on the left of which is a cypress tree, relating to his preoccupation with Arnold Böcklin's *The Island of the Dead* (1880) and Millet's *The Angelus* (1858).

As in *Dream Caused by the Flight of a Bee* . . . (1944, see page 52), Dali has depicted two pomegranates. One is small and floats near the trunk of the cypress tree. The other is large and sliced in half with surgical precision, spilling some of its seeds, a symbolic reference to Dali's fears of castration. The pomegranate is also a symbol of the unity of the Christian Church, and Dali was at this time looking to return to Roman Catholicism.

MEDIUM

Oil on canvas

PERIOD

Nuclear Mystic

RELATED WORK

Giorgio de Chirico, *The Uncertainty of the Poet*, 1913

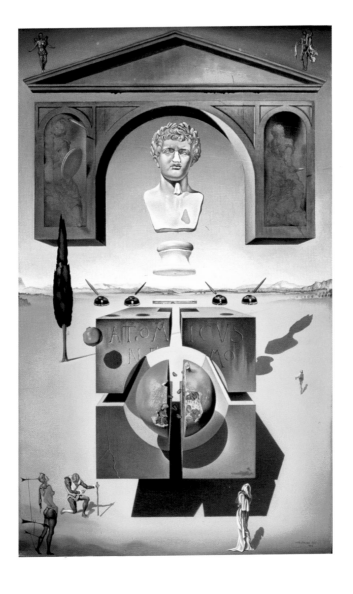

Hommage à Newton
('Homage to Newton'), 1969

Given Dalí's interest in the advances in physics in the 1950s and 1960s, and particularly nuclear physics, it is not surprising that he should have created a homage to Sir Isaac Newton (1642–1727). Newton, whose vast achievements spanned the fields of mathematics, optics and physics, laid the foundations for our modern understanding of the physical world and continues to influence scientific thought.

Dalí's homage, created in 1969, takes the shape of a bronze figure from whose hand a ball is dropping. Dalí uses a ball, rather than the legendary apple, to show the importance of the theory that Newton devised, rather than the event that led to its formation. The appearance of the figure is vaguely androgynous, its vital organs missing, its head no more than an outline. Rather than produce a likeness of Newton, Dalí refers the viewer to the mystical nature of Newton's achievements.

In 1985, Dalí accepted a commission to redesign a plaza for the city of Madrid. The finished design includes a huge version of *Hommage à Newton*, weighing over one tonne, facing a dolmen (horizontal stone) of granite propped up on three cement legs.

MEDIUM

Patinated bronze

PERIOD

Late

RELATED WORK

Pablo Gargallo, *The Prophet*, 1933

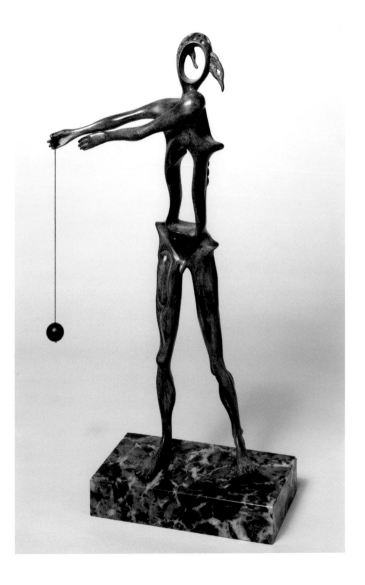

Philosophy Lit By Moonlight, 1939

In November 1941, the Museum of Modern Art (MoMA) in New York held retrospective exhibitions for Joan Miró (1893–1983) and Dali. In the 1940s MoMA was, and remains today, one of the greatest museums dedicated to modern art in the world. With this major exhibition, Dalí could justifiably claim to have achieved international fame as an artist.

Dali exhibited more than forty oil paintings including this one, also referred to as *Philosopher Illuminated by the Light of the Moon and the Setting Sun*, which came from his private collection. Of the many sombre works that Dali produced in the late 1930s this is certainly among the very darkest. The philosopher, barefoot, his clothes in rags, sprawls in the darkness, his head held dejectedly in his hand. The huge black cloud that obscures the moon almost seems to enter his head.

The New Yorker review of the two exhibitions contrasted the spontaneous gaiety of the Miró exhibits with the dark solemnity of the Dali works, which is epitomized by this melancholy painting.

CREATED

Spain

MEDIUM

Oil on canvas

PERIOD

Surrealist

RELATED WORK

Joseph Wright of Derby, *Sir Brooke Boothby*, 1781

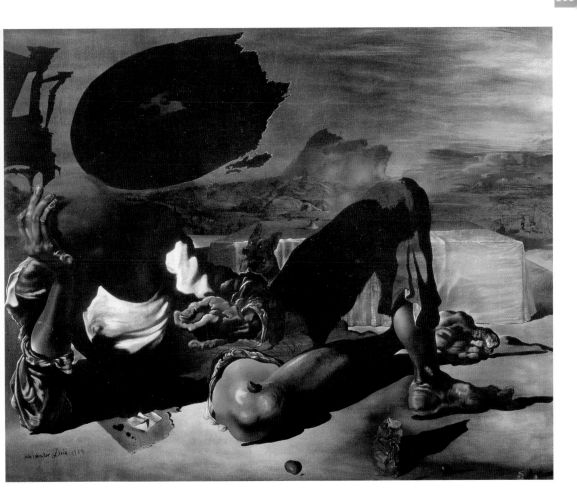

Don Quixote Blessé
('Don Quixote Wounded'), 1964

Dalí produced a series of lithographic illustrations of the story of *Don Quixote* in 1957. This illustration dates from seven years later, and shows Don Quixote wounded. He appears to be being attacked by black abstract shapes, rather like giant nails. In 1960 Dalí experimented with shooting nail bombs from an old arquebus into several of his works, and around this time he also includes images of nails in his paintings, for example *Continuum of Four Buttocks . . .* (1960, see page 114).

Don Quixote de la Mancha, the great Spanish satirical novel, was written in two volumes in 1605 and 1615 by Miguel de Cervantes (1547–1616). It tells the story of an impoverished knight who is obsessed by chivalry and travels Spain on his old horse in search of adventures, accompanied by his long-suffering squire Sancho Panza. Don Quixote has an overactive imagination, which results in some absurd adventures, most notably when he tilts at windmills, mistaking them for giants. In the same way, in this image, swirling shapes rather than a real, tangible enemy are attacking Don Quixote. Like Dalí, Don Quixote creates his own reality.

MEDIUM

Watercolour, brush and ink on paper

PERIOD

Late

RELATED WORK

Honoré Daumier, *Don Quixote and Sancho Panza*, c. 1855

Don Quixote, 1964

In this unusual and atypical work we see Don Quixote, the hero of Cervantes' satirical novel, kneeling before a farm girl in skimpy attire who is tending an enormous pig with a huge litter of piglets. The presence of the pig emphasizes the ludicrous nature of Don Quixote's chivalrous gesture in kissing the woman's hand, and it is likely that we are intended to draw a comparison between the woman's breasts, revealed by her loose-fitting garment, and the pig's udders.

When Don Quixote sets off on his adventures he decides he must have a lady to right wrongs for. He chooses a peasant girl called Aldonza Lorenzo, whom he has seen but never spoken to. He refers to her as 'Dulcinea del Toboso', and never actually meets her. She is, however, claimed to be the best pork salter in all of La Mancha, suggesting that she is the woman in the painting, although the event described is a fantasy of Don Quixote's.

The painting has been carried out in oil on a metal plate, which gives a very smooth finish and permits the artist to render the brushstrokes almost invisibly.

MEDIUM

Oil on metal

PERIOD

Late

La Montre Molle
('The Soft Watch'), 1949

Dali ended his self-imposed exile in America in 1949. For nine years he had been the darling of high society, the American media and Hollywood. He and Gala had firmly established the Dali brand as an international concern, and it seemed as though Dali himself was involved in every kind of creative activity imaginable, even hairdressing.

So occupied had Dali become in the commercial aspects of his work that André Breton (1896–1966) gave him the soubriquet Avida Dollar, a near-anagram of Salvador Dalí, referring to his insatiable appetite for money. As well as continuing to produce serious works of art, Dali was by now looking for ways to capitalize on the success of his earlier works. He reworked some of them to incorporate his more recent thinking, particularly his understanding of nuclear and atomic physics.

La Montre Molle takes the image of the watch draped over the rock in *The Persistence of Memory* (1931, see page 314). Now, however, the watch floats above the rock, and is seen exploding into its elemental parts, some of which are in the shape of rhinoceros horns.

PERIOD

Nuclear Mystic

RELATED WORK

Salvador Dali, *The Persistence of Memory*, 1931

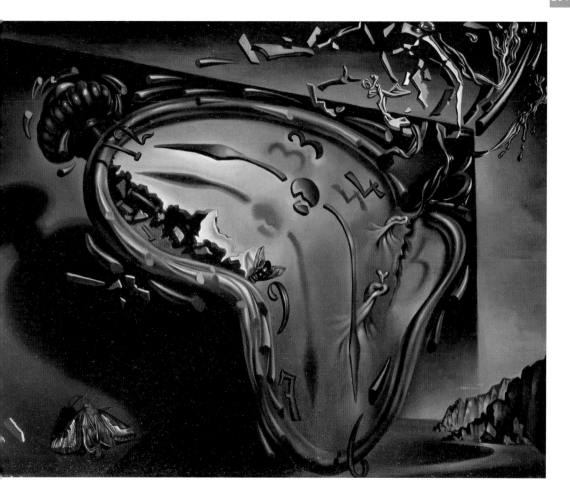

Profil du Temps
('Profile of Time'), 1984

The soft watch, possibly the most famous of all Dali's many Surrealist images, first appeared in his painting *The Persistence of Memory* (see page 314). The soft watch motif occurs in many other works, but it is the three watches depicted in *The Persistence of Memory* (one draped over a dead tree, one draped over a block of stone and a final one covering the sleeping figure of Dali) that are the most enduring.

Towards the end of his life Dali conceived and commissioned a number of statues based on images taken from his earlier paintings, particularly those created during his Surrealist period in the 1930s. *Profil du Temps* is just such a piece. Based on the watch draped over the tree in *The Persistence of Memory*, it has been redesigned to appear even softer and more malleable than the original. Indeed the base of the watch appears to have liquefied.

This is a large piece standing 1.5 m (5 ft) tall, and is one of an edition of seven. A dull green patina has been applied to the base and the tree to emphasize their age and hardness, whereas the watch itself has been highly polished to create the illusion of fluidity.

CREATED

Italy

MEDIUM

Bronze with green patina and polished bronze

PERIOD

Late

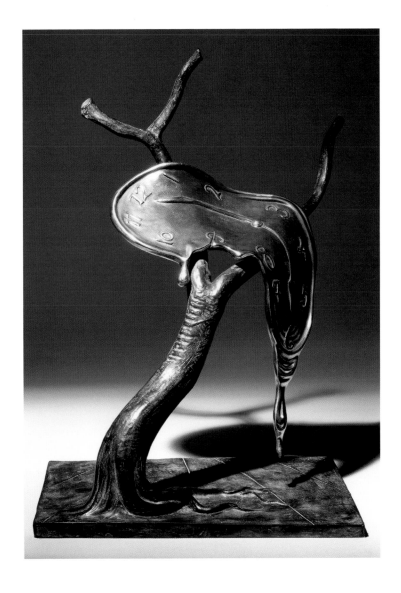

Dalí

Styles &
Techniques

The Basket of Bread, 1945

Of the many types of food that Dalí uses symbolically in his work, it is bread that appears the most often. Dalí himself refers to it as, 'one of the oldest fetishist and obsessive subjects in my work, the one to which I have remained most faithful'. Bread, modern man's most basic source of nourishment, had both religious and sexual connotations for Dalí, in its association with Communion, and in the form of depictions of erotically charged baguettes.

Dalí painted *The Basket of Bread* in 1945 and it demonstrates his technical mastery of the style of still lifes painted by the Spanish old masters, particularly Francisco de Zurbarán (1598–1664) and Juan Sanchez Cotan (1560–1627). The work is clearly the direct descendant of the similarly titled *Basket of Bread*, which Dalí painted in 1926 some nineteen years earlier. Both works show a 'hyper-realistic' representation of a woven basket containing a partial loaf of bread, sliced in the earlier work and torn in the later one.

Describing the later work Dalí said, 'Here is a painting about which there is nothing to explain: the total enigma!'.

MEDIUM

Oil on panel

PERIOD

Classic

RELATED WORK

Francisco de Zurbarán, *Still Life with Pottery Jars*

Salvador Dalí *Born* 1904 Catalonia, Spain

Died 1989

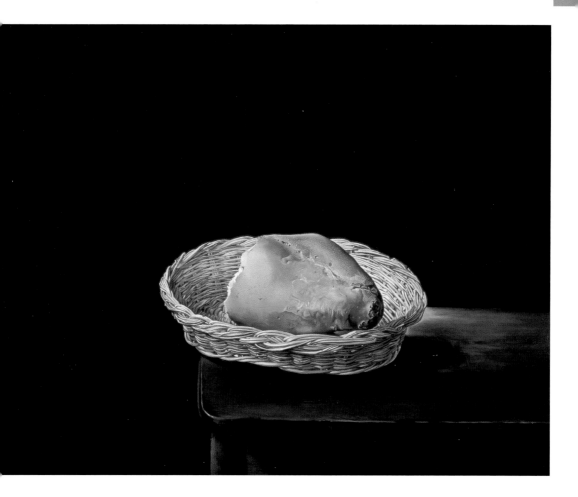

The Smiling Venus or *Nude in a Landscape*, 1922–23

The Smiling Venus is part of the tradition of the reclining nude that stretches back to the Renaissance. By referring to such a figure as Venus, the artist provides a Classical context that is intended to justify the nakedness of the woman.

In this decorative and playful work the stylized nude reclines on a draped bed with sea and sailing boats beyond. The figure is framed with foliage and blossom, creating a kind of bower. It is an idealized scene, and Dali makes no attempt to individualize the central figure; instead she looks more like a folk-art wooden doll. Despite being rather childlike, her smiling face is remarkably provocative and flirtatious, and she engages the viewer's gaze in a relaxed and unabashed fashion, with no sense of personal modesty.

Dali paints the background of the scene using dots of colours, in a coarse version of Pointillism or Divisionism, developed by Neo-Impressionist Georges Seurat (1859–91). This use of fragmented colour creates a shimmering effect, suggesting sunlight sparking on rippling water, with haze rendering the horizon indistinct.

MEDIUM

Oil on cardboard

PERIOD

Early

RELATED WORK

Edouard Manet, *Olympia*, 1863–65

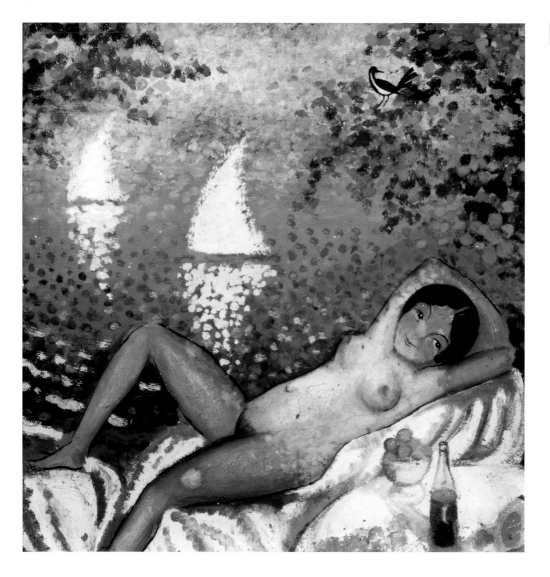

Cadaqués (Seen from the Tower at Cap de Creus), 1923

In the early 1920s, Dali painted several views of Cadaqués and the surrounding countryside employing the Realist style known as the New Classicism, which swept western Europe after the Second World War. It is clear from its name that the style is associated with tradition and elegance, hence the posing female figures artfully placed in the bottom left-hand corner, balancing the massed forms of the village and creating stylized human interest. The women's curvaceous forms also contrast with the blocky shapes of the buildings. Despite Dalí's adoption of the new Realist style here, there are still references to analytical Cubism in the colour palette Dalí has chosen, and the way he has depicted the buildings and stormy-looking sky.

Dali painted this panoramic view of Cadaqués, hemmed in by the mountains beyond, from the tower at Cap de Creus. This squat cylindrical tower is clearly visible in several of his other landscape views of the area, such as *The Beach of Llané* (1923) and *Cadaqués* (1923). Apart from the women's clothing, the colours that Dali uses for this image are shades of brown, creating a sepia-like effect, as though the image was, in part, produced from a contemporary photograph.

CREATED

Spain

MEDIUM

Oil on canvas

PERIOD

Early

RELATED WORK

André Derain, *View of St Paul-de-Vence*, 1910

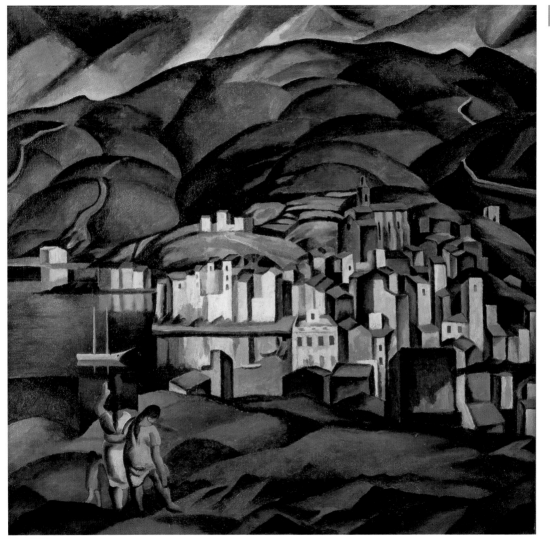

Untitled – The First Days of Spring, c. 1922–23

This small and delightful watercolour was produced early in Dalí's artistic career when he was experimenting with an astonishingly wide range of avant-garde styles in an attempt to create his own visual language. The painting is clearly influenced by the work of Paul Klee (1879–1940), a Swiss artist whose work has a quirky, childlike quality.

The image shows various cameos of daily life, including a woman on a balcony, a pair of lovers, dogs in the street sniffing each other, and a girl embroidering, bottom centre, which relates to Dalí's fascination with Jan Vermeer's *The Lacemaker* (1669–70).

On the lower left-hand side of the painting is a vignette of children playing in a playground. One of the little girls has a skipping rope, which is caught at the moment when the rope is up in the air, and this image is repeated again near the centre of the image. Dalí liked this motif of the skipping girl and we see it repeated in his later works, often as a child lost in its own thoughts, isolated from the other figures in the painting.

CREATED

Spain

MEDIUM

Wash on paper

PERIOD

Early

RELATED WORK

Paul Klee, *Dry, Cool Garden*, 1921

Circus Acrobats, 1919–20

This tiny early work, no bigger than a postcard, is executed in the Expressionist style typical of the German *Die Brücke* group, whose works are characteristically painted energetically in bright colours. The depicted scene takes place backstage, in the changing room of a circus. We can catch a glimpse of the ring itself, indicated by a trapeze in the top-left part of the image. The female acrobats shown either side of the foreground figure are unselfconsciously in various stages of undress, including one woman whom we can only see by her back view reflected in an oval mirror, top right.

Circuses are usually associated with jollity and fun, yet there is a hint of menace here. The foreground figure (probably a self-portrait) is a voyeur, watching these working women with a degree of sexual interest, indicated clearly by his raised eyebrow and shifty sideways glance. Perhaps he too is standing in front of a mirror, which would be the case if this is a self-portrait, and can therefore view everything that we can see behind him. His blue skin tone suggests he is lurking in the shadows and is a loner, set apart from his fellow human beings.

CREATED

Spain

MEDIUM

Gouache on cardboard

PERIOD

Early

RELATED WORK

Ernst Ludwig Kirchner, *Girl Circus Rider*, 1912

Barcelona Mannequin, 1926–27

Absorbing the influences and imitating the work of the great artists is part of almost all eminent artists' development. Indeed Dali said, 'Those who do not want to imitate anything produce nothing.'

Barcelona Mannequin, a large work produced in oil on canvas, is one of the later works of Dali's 'early' period where he was experimenting with different styles and techniques before finding a unique style of his own. It clearly shows the influence of Pablo Picasso's (1881–1973) work of the early 1920s, especially perhaps his *Harlequin* (1923). The mannequin in Dali's picture, which appears as though caught in a spotlight, is graphically represented in overlapping layers. The figure appears to be a female form; we can see breasts and a womb, a feather-edged negligee and obviously feminine legs. However, it is generally assumed that the two interlocking heads represent Dali and his friend the poet Federico Garcia Lorca (1898–1936).

Barcelona Mannequin was first exhibited in the Dalmau Gallery, Barcelona, in the autumn of 1926 alongside works by Raoul Dufy (1877–1953), Joan Miró (1893–1983), Francis Picabia (1879–1953) and Robert Delaunay (1885–1979).

CREATED

Spain

MEDIUM

Oil on canvas

PERIOD

Early

RELATED WORK

Pablo Picasso, *Girl with a Hoop*, 1919

Little Ashes, 1928

For Dali, 1928 is often described as the year of transition. From 1927 his own distinct style has begun to emerge, but in 1928 he seems unwilling to embrace completely the Surrealism that would dominate his work from 1929 onwards.

Little Ashes, sometimes referred to as *Cencitas* ('Little Cinders'), is a collection of dreamlike imagery apparently flowing from the mind of the sleeping Dali, represented by the head to the bottom left of the canvas. At the same time as he sleeps, the head to the right shows the artist staring, wide awake, at the bizarre events taking place in his subconscious, an early reference to the theory of paranoid-critical representation that Dali was developing.

Set against a sky of 'Miró' blue are many of the symbols that Dali was to return to in later works: the putrefying donkeys, the amputated body parts, the fish and the specific references to earlier works. The figure of the floating torso resting on a single point is a precursor at least in shape to the central image of major later works including *The Great Masturbator* (1929, see page 100) and *Le Sommeil* (1937, see page 234).

SMEDIUM

Oil on canvas

PERIOD

Surrealist

RELATED WORK

Joan Miró, *Catalan Landscape, the Hunter*, 1923–24

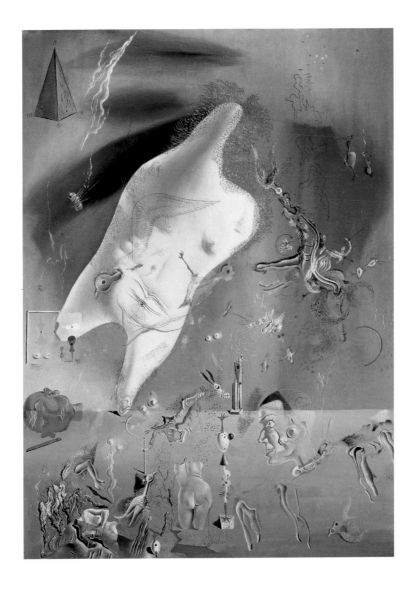

Wounded Bird, 1928

Even by his own prodigious standards, 1928 was a year of intense activity for Dali. As well as experimenting with style and content, which he was by now refining into something recognizably Dalinian, he was also trying out new textures and media.

In *Wounded Bird*, and similar pieces including *Big Thumb Beach*, *Moon and Decaying Bird* and *Anthropomorphic Beach*, Dali uses found objects and textures to add a further dimension to his work. In this he was influenced by the work of the French Surrealist André Masson (1896–1987) and Picasso's Cubist collages. *Wounded Bird* shows a dismembered thumb and the skeleton of a bird as though they have been washed up on a beach. To represent the beach Dali uses two kinds of sand, one fine and one coarse, applied to the surface of the work, creating an interesting textural contrast. The dismembered thumb appears in an almost identical form in *Little Ashes* (see page 308), representing Dali's fear of castration and his apparent shock at seeing his thumb appear through the hole in his artist's palette, as though it had been amputated.

These strangely beautiful, minimal works are unique to 1928. Dali was never to return to this precise, controlled use of mixed media.

MEDIUM

Oil and sand on board

PERIOD

Surrealist

RELATED WORK

André Masson, *Battle of Fishes*, 1926

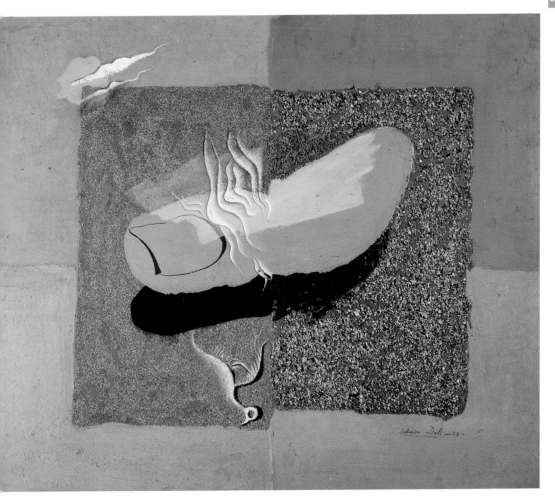

The Lugubrious Game, 1929

It was Paul Eluard, Gala's ex-husband, who gave *The Lugubrious Game* its rather world-weary title. This small painting, just 45 cm by 30 cm (18 in by 12 in), is Dali's first truly surreal work. Into it he poured out his sexual obsessions, almost as a manifesto for the works that were to follow.

In the centre of the painting we see the first appearance of the image of Dali's sleeping head, an image that is to reappear frequently in works such as *The Great Masturbator* (1929, see page 100), *The Persistence of Memory* (1931, see page 314), and *Le Sommeil* (1937, see page 234). From the subconscious mind of the sleeping head emerges a torrent of symbols of masturbation, anal penetration, castration and Dali's overwhelming fear of the female sexual organs.

Of the many shocking images in this disturbing work, it is the scatological reference in the bottom right-hand corner of the work that many, including André Breton, were to find the most unsettling. The man with excrement-stained trousers refers, Dalí claimed, to an episode in his early life when his father, arriving home one day, emerged from a taxi to announce loudly, and with no embarrassment, 'I've crapped myself'.

MEDIUM

Oil and collage on cardboard

PERIOD

Surrealist

RELATED WORK

Salvador Dali, *The Great Masturbator*, 1929

The Persistence of Memory, 1931

According to Dali's notoriously inaccurate autobiography, *The Secret Life of Salvador Dali*, while dining alone one evening he was attracted by an over-ripe Camembert cheese. Its collapsed, 'melted' form gave him the inspiration for the soft watch, his most enduring image. The transformation in Dali's imagination from Camembert to soft watch is a particularly good example of his paranoid-critical method of visualization.

The Persistence of Memory was originally conceived as a view of a sunset at Port Lligat where Dali was to start building his house and studio complex. His addition of the three soft watches, appearing here for the first time, transformed the piece into one of the most iconic paintings of the twentieth century.

On the beach lies the familiar form of the sleeping Dali over whose back is draped one of three soft watches, each one showing a different time. Do these soft watches represent the flow of time, or has the passage of time made them limp and decayed? The back of another, more solid, watch is seen crawling with ants, symbolizing the negative outcomes of a fear of revelation of the truth/time.

CREATED

Spain

MEDIUM

Oil on canvas

PERIOD

Surrealist

RELATED WORK

André Masson, *Gradiva*, 1939

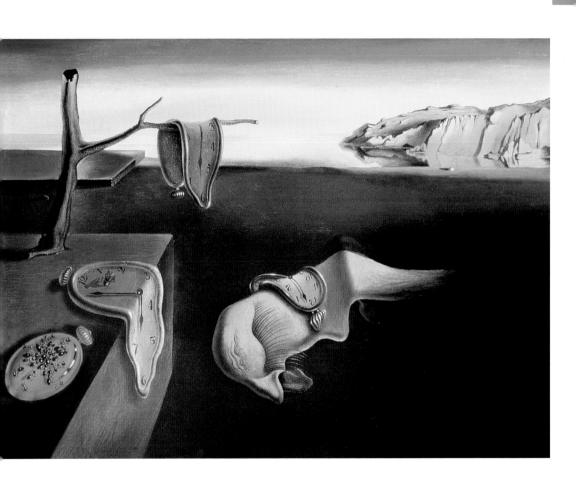

Ballerina in a Death's Head, 1939

At the end of the 1930s and the beginning of the 1940s, Dali produced a number of double images based on the human skull, clearly a potent symbol of death and a reminder of our mortality. A painting that features a skull in this way is known as a memento mori or a vanitas.

For Dali, however, the skull as a symbol of death is not just about facing our mortality but is conflated with sex and desire, since these were inextricably linked in his mind. Here, a coy and alluring girl in a ballet tutu forms the facial features of the skull, which appears to be a cracked and inverted giant amphora behind her. The girl's bent arms and her black mantilla form the eyes, the crumbling nasal passages are created by a black scarf falling around her neck and the frill of the hem of her tutu suggests the rotting teeth. This presents a very powerful symbol of Dali's attitude to physical relationships with women: the beguiling temptress who can infect her partner with horrifying and debilitating sexually transmitted diseases.

MEDIUM

Oil on canvas

PERIOD

Surrealist

RELATED WORK

Pablo Picasso, *Still Life with Skull, Book and Oil Lamp*, 1946

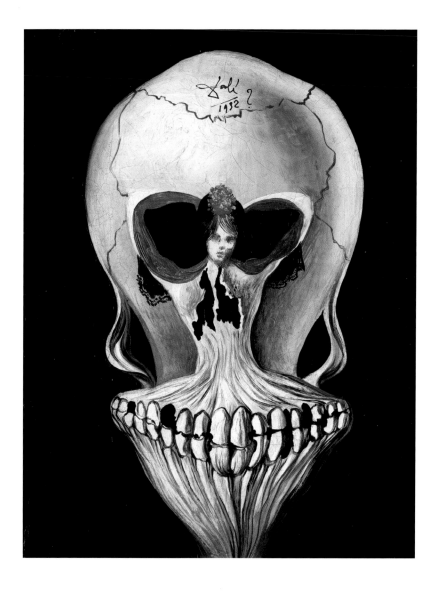

Oeuf sur le Plat Sans Plat ('Fried Egg Without a Plate'), 1932

The French title of this work is a pun: 'oeuf sur le plat' literally means 'egg on the plate' – what we refer to in English as a fried egg. Dali liked puns, and the joke here is that the fried egg has no plate, and therefore it is 'on a plate' and 'not on a plate' at the same time – a verbal version of a double image.

Dali fetishized food and he depicts it in a large number of works. For Dali, eggs had a particularly interesting fetishistic quality in that their liquid content is sticky and slimy and thus reminiscent of milk and semen. So, like sex, eggs can be associated with repulsion and desire at the same time.

Unbroken eggs also appear as motifs in Dali's paintings and link to his fantasies of being in the womb, something he referred to as 'the inter-uterine paradise'. Dali was also fascinated by the soft and delicate interior of the egg, protected by its relatively hard shell. As with the lobster, the idea of the protection of the soft and delicate inner self was something he found intriguing.

MEDIUM

Oil on canvas

PERIOD

Surrealist

RELATED WORK

René Magritte, *The Portrait*, 1935

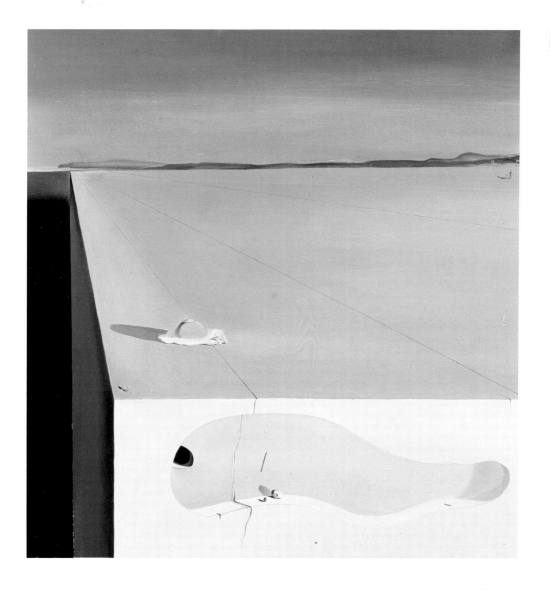

Automatic Beginning of a Portrait of Gala (unfinished), 1932

It is fascinating to see unfinished works as they tell us a great deal about an artist's working methods. Here we can see that Dali produces a detailed drawing, which he copies on to the support, then completes one part of the image before moving on to the next. He appears to be working from a photograph, although a drawing of the same pose, reversed, also exists from this time. However, the title is enigmatic. Did Dali intend it always to remain just the 'beginning' of an image, in other works, deliberately 'unfinished'?

In this image, Gala's hair is turning into a leafy plant, a precursor of the 'flower head' images of 1936. The following year, in 1933, Dali painted a full-length portrait of Gala in front of a small tree, which she appears to be emerging from. This may refer to the Greek myth of Daphne, who transformed herself into a laurel tree to escape from Apollo.

In 1944, Dali produced set designs for *Tristan Insane* and, in 1948, the beautiful *Portrait of Mrs Mary Sigall*, both of which feature women transforming into and out of plant forms.

MEDIUM

Oil on laminated panel

PERIOD

Surrealist

RELATED WORK

Antonio Pollaiuolo, *Apollo and Daphne*, c. 1470

Visage aux Fourmis ('Face of Ants'), c. 1930–35

This study of a woman's face relates to a motif that appears in *The Font* (1930) and *Le Rêve Approche* (1931, see page 236). In each case the woman has her eyes closed, her mouth is covered over or nonexistent, and is crawling with ants.

In his autobiography, *The Secret Life of Salvador Dali*, Dali explains the relationship between a woman with a veiled face and ants. He claims that at the age of five he went for a walk with three beautiful young women, one of whom held his hand. He describes her as, 'wearing a large hat with a white veil twisted round it and falling over her face, which made her extremely moving'.

When, later, this woman urinates in front of him, Dali is shocked and confused. He returns home and his cousin gives him an injured bat, which Dali lovingly treasures. However, the next morning when he goes to see the creature, he finds, 'the bat, though still half-alive, bristling with frenzied ants, its tortured little face exposing tiny teeth like an old woman's'. At the same moment, the woman with the veil reappears, and in his torment and anguish, Dali kills the bat.

MEDIUM

Gouache on black paper

PERIOD

Surrealist

RELATED WORK

Carlo Carrà, *L'Amante*, 1921

Paranoiac Critical Solitude, 1935

Of course, being a painting by Dali, there is no explanation as to why an old car, half-covered with flowering plants, would have been left in front of this desolate rocky outcrop. Yet the presence of the wrecked vehicle does not jar visually because it appears to be formed from the very rock itself.

Dali subtly repeats the image of the car on the left-hand side of the rock by depicting an impression of the vehicle's silhouette in the rock face. At the top of this impression is a piece of rock that corresponds with the shape of the hole above the car, as though the piece cut to form the hole has been removed and attached to the rock face.

Dali included 'fossil' cars in several images at this time, for example in *Apparition de la Ville de Delft* (1935–36, see page 168) and *L'Automobile Fossile de Cap Creus* (1936, see page 180). These are 'dead' cars, and clearly a car that has worn out has no practical use, rather like a corpse, which will eventually rot and decay or, given the right conditions, become fossilized.

CREATED

Spain

MEDIUM

Oil on panel

PERIOD

Surrealist

RELATED WORK

René Magritte, *Memory of a Journey*, 1950

The Great Paranoiac, 1936

There is no doubt that Dali's childhood and early youth produced a vast number of real and imagined neuroses. Dali was to spend the rest of his life examining these obsessions and their consequences. In *The Great Masturbator* (1929, see page 100), Dali laid out his sexual neuroses with surprising candour. In its companion piece *The Great Paranoiac*, painted seven years later, Dali looked at the shame he felt for these feelings.

Dali was fascinated by the work of the sixteenth-century Italian painter Giuseppe Arcimboldo (1527–93). Arcimboldo painted allegorical or symbolic portraits in which the subjects were composed from 'still life' objects. His most famous painting *Rudolph II as Vertummus* (1591) shows the god of horticulture's face represented by flowers and vegetables. In *The Great Paranoiac*, one of Dali's most striking double images, he shows two faces set in a barren landscape. The faces are formed from the bodies of people either turning away or hiding their heads in shame. The image of the shameful person, head buried in his hands, appears in many of Dali's works of this period.

MEDIUM

Oil on canvas

PERIOD

Surrealist

RELATED WORK

Giuseppe Arcimboldo, *Rudolph II as Vertummus*, 1591

Swans Reflecting Elephants, 1937

Throughout the 1930s, Dalí produced numerous paintings containing double, triple and sometimes multiple images. These images varied in their naturalness, some appearing more forced than others.

The central conceit of *Swans Reflecting Elephants*, the reflection of swans and dead trees becoming the heads and bodies of elephants, is not considered to be Dalí's most successful work. However, the painting is rich in enigmatic symbols. On a lake in front of a Mediterranean beach three swans swim. Behind them, broken contorted trees reach up to the sky. In the foreground a squid-like creature crawls on to the shore. To the right a moon hovers over a hillside town, which rises above a burning hillside leading to the lake. On the left a man stands, hands on hips, staring resignedly out of the picture. Throughout the work there is little sense of scale but a strange kind of unity binds the elements together.

Dali was to use the scene he describes in *Swans Reflecting Elephants* as part of the opening scene of *Destino*, the short animated feature that he was commissioned by Walt Disney to produce in the mid 1940s, but which was sadly never realized.

MEDIUM

Oil on canvas

PERIOD

Surrealist

RELATED WORK

Max Ernst, *Celebes*, 1921

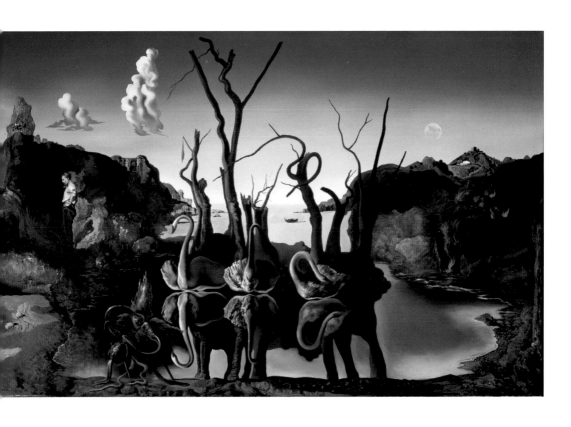

Old Age, Adolescence, Infancy, (The Three Ages), 1940

By 1940, Dali had split irreversibly from the Surrealist movement and was moving toward a more Classical approach for the themes and subject matter in his work. *The Three Ages* shows vestiges of his Surrealist period combined with hints of the more traditional style that was to follow.

Dali represents the three ages of man by a series of double images seen through openings in a curved brick wall extending across the painting. These three double images are each composed of a figure, or figures, set in the familiar landscape of Cadaqués and Port Lligat. The face of the adolescent in the centre, for example, is made up of the figures of the young Dali and his beloved nurse Lucia looking out over the Bay of Cadaqués and the cliffs beyond.

Dali's Catalan roots were never far from his thoughts especially in the late 1930s and 1940s, which was a period of upheaval and self-imposed exile for him. Indeed, when he painted *The Three Ages* it would be almost a decade before Dali returned to his true spiritual home at Port Lligat.

CREATED

France

MEDIUM

Oil on canvas

PERIOD

Surrealist/Classic transition

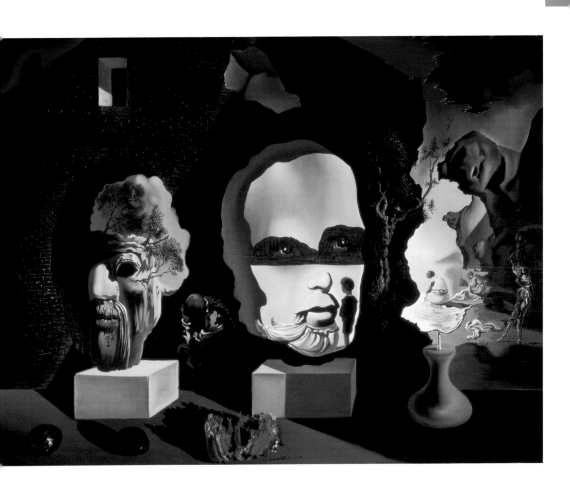

Slave Market with the Disappearing Bust of Voltaire, 1940

Many of Dali's works from his Surrealist period are based around a double or multi image where the viewer looks at what appears to be one thing and then sees it as something else entirely. This idea of things appearing to be something else completely unrelated was a central part of Dali's theory of paranoid-critical perception.

Whereas in some works the double image is of secondary importance, in *Slave Market . . .* the central image is the slave market itself, part of which can be seen as the bust of Voltaire. Gala, naked to the waist, sits at a table draped in red cloth and contemplates the scene in front of her. On the one hand it shows a group of people enclosed in a ruined arch surrounded by slaves and beggars. Viewed another way, the three main characters to the left of the group, and an opening in the arch, form the head of the eighteenth-century French philosopher, satirist and writer Voltaire (1694–1778). The head is resting on a stone stand, which is also a broken vase on Gala's table.

The head is modelled on a bust of Voltaire produced by the French sculptor Jean Antoine Houdon (1741–1828).

MEDIUM

Oil on canvas

PERIOD

Surrealist

RELATED WORK

Jean Antoine Houdon, *Voltaire*, 1781

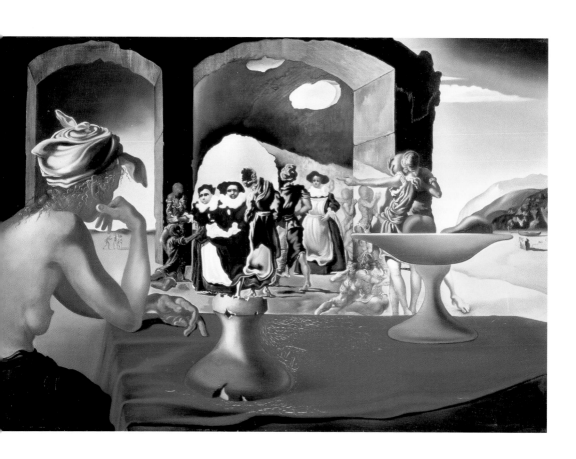

Dance of the Flower Maidens, 1942

At the end of 1941, a major retrospective of Dali's work opened at the Museum of Modern Art in New York. The exhibition sparked a number of lucrative commissions for Dali, including jewellery and advertisements.

Dali produced this design for a large porcelain plate in 1942 for Louis E. Hellman, who was president of the Castleton China Company based in New York. The finished plate was exhibited at the B. Altman and Co. department store in New York in 1942, and in Chicago the following year.

The design for the plate comprises a Classical theme of ionic columns in the foreground, and behind that, Corinthian columns and doorways with pediments. The four female dancing figures have heads made from flowers, an image that Dali first explored in 1937 in *Untitled – Woman with a Flower Head* (see page 42).

Dali deliberately chooses an unusually low viewpoint for this image, creating a 'fish-eye' perspective that is perfectly suited to a circular plate. The birds in the centre form a face, a device that Dali uses in several images around this time.

CREATED

America

MEDIUM

Watercolour over pencil on thin board

PERIOD

Classic

RELATED WORK

Andrea Mantegna, *Roundel with Putti and Ladies Looking Down*, 1465–74

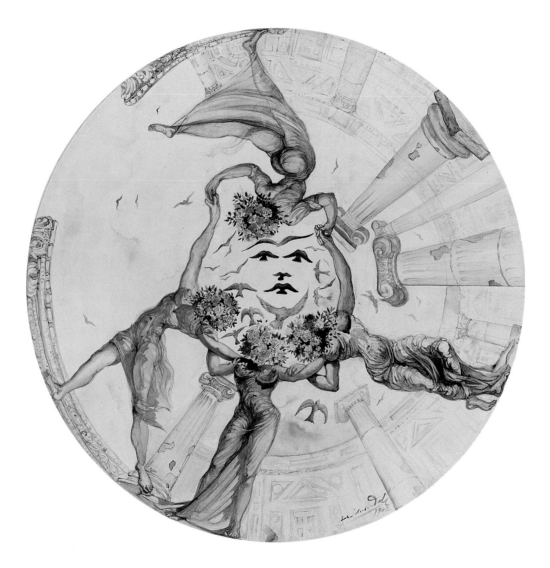

Llamas Laman
(The Flames, They Call), 1954

In this image, Dali revisits several of his earlier themes: the burning giraffes, the enormous plain with the distant figures, and the horse turning to stone seen in *Geological Evolution* (1933, see page 202). In the case of the giraffes depicted here, it is only the cracking of the 'stone' that suggests the dappled patterning of a normal giraffe, since these giraffes have coats that appear, disconcertingly, to be made of human flesh. The creatures are depicted smouldering from within, steam escapes from around their hooves and their legs glow like embers.

As in *Parade of Cavaliers* (1942, see page 264), the giraffes form a guard of honour, through which the distant mother and child will pass. These figures almost certainly represent the young Dali with his mother, who by now would have become a fading memory.

Another typically Dalinian feature of this painting is the double image on the right-hand side. This time, however, the image is rather subtle and easy to overlook. The dark archway forms the woman's glossy hair, the face of the man seated on the giraffe's back forms her eye, and his shadow on the giraffe's neck forms her nose and lips.

MEDIUM

Oil on canvas

PERIOD

Nuclear Mystic, but Surrealist subject

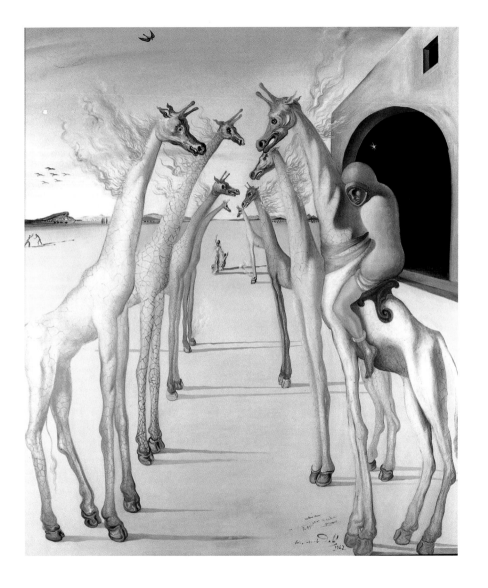

Nu dans la Plaine de Rosas
('Naked in the Plain of Rosas'), 1942

Dalí produced this design for the second mural panel in Helena Rubinstein's dining room (the first panel is *Paysage Fantastique*, see page 190). In this design a reclining nude overlooks the vast coastal plain of Rosas. In the finished version, however, the nude is absent, and the focal point becomes the double image of a Madonna-like figure, her head formed by a flock of birds, and a ghostly foot and sandal visible on the sandy plain.

The depiction of architecture on the right includes three oval cartouches. The top one contains a key, a Freudian phallic symbol and reference to repressed desires. On the preparatory design, shown here, the other two cartouches are empty, but in the finished work the second oval contains an ant, Dali's symbol of decay, and the bottom one has a Classical portrait bust.

Helena Rubinstein's luxurious apartment on Park Avenue, New York, was enormous, comprising twenty-six rooms spread over three floors linked by circular staircases. Miss Rubinstein, who owned the apartment for 30 years, gave herself the title 'Princess Gourielli'. Dalí described her character as being that of, 'an unyielding corset'.

MEDIUM

Oil on canvas

PERIOD

Classic

RELATED WORK

René Magritte, *Le Génération Spontanée*, 1937

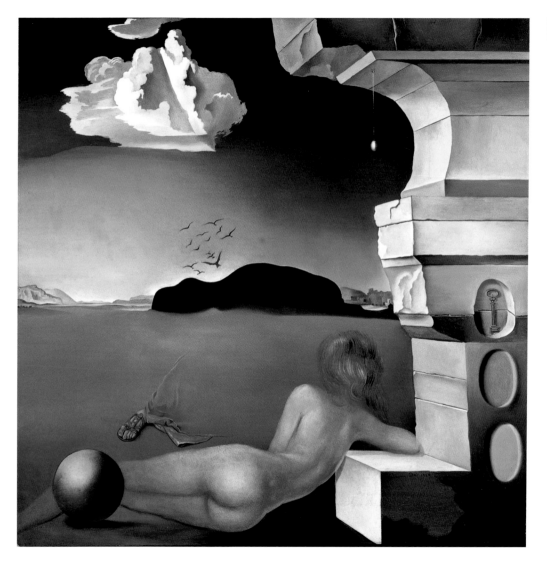

My Wife Nude Contemplating Her Own Flesh Becoming Stairs, Three Vertebrae of a Column, Sky and Architecture, 1945

Dali often commented on how attractive he found Gala's back. He claimed his initial infatuation for her came from the sight of her back, which he compared to, 'the serene perfection of the Renaissance'.

Appropriately it was the Classical style of the Renaissance painters to which Dali turned when he painted this particular portrait of Gala sitting contemplating an anthropomorphic version of herself. To accentuate the Classical pose, Dali paints the bust of a Greco-Roman man on the column next to her. The inclusion of a Classical head appears in the metaphysical paintings of Giorgio de Chirico (1888–1978) whose work Dali greatly admired. Next to Gala is a dandelion, a symbol of transience that is reinforced by the struggle of its roots to find a home in the rock. Dali contrasts the voluptuous curves of the human Gala with the mechanical soulless image of her anthropomorphic double. In the centre of the pavilion that Gala's skeletal frame encloses is the minute figure of a man, presumably Dali, gazing at what surrounds him.

In 1960 Dali repeated the image of the seated Gala almost exactly in the painting *Gala Nude Seen From Behind*.

MEDIUM

Oil on panel

PERIOD

Classic

RELATED WORK

René Magritte, *La Race Blanche*, 1937

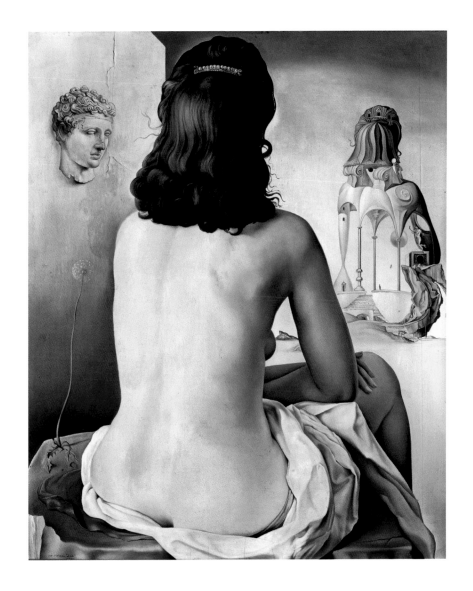

Intra-atomic Equilibrium of a Swan's Feather, 1947

In a press conference that Dali held after meeting Pope Pius XII in 1949, Dali stated that he wanted to, 'guide modern painting back into the great medieval and Renaissance traditions'. Although Dali wanted a return to the techniques of the Renaissance, he clearly felt that the subject matter should reflect the advances in particle theory and nuclear physics that had emerged in the previous decade.

Intra-atomic Equilibrium of a Swan's Feather combines Renaissance technique and nuclear theory in one canvas. Against a background in which the construction lines have been retained, creating the suggestion of the illusion of pictorial space, ten articles float free of gravity. Groups of articles seem to have a connection with each other while others do not. A finely sculptured hand, reminiscent of the hand of Michelangelo's (1475–1564) *David* reaches for the pen and inkwell below it. The swan's head, the bird's leg tied with string and the feather are connected. The empty snail shell is a popular symbol in Dutch vanitas still lifes of the seventeenth century, suggesting life's impermanence.

Together these apparently unconnected groups of objects form an 'atomic' still life painted in the Classical style.

MEDIUM

Oil on canvas

RELATED WORK

René Magritte, *La Jeunesse Illustrée*, 1936–37

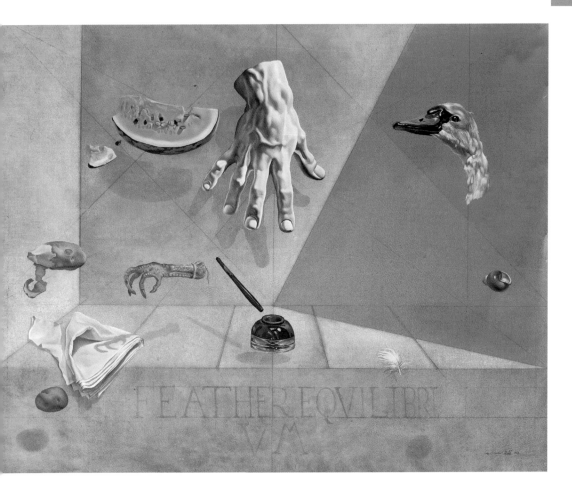

Atomic Leda, 1949

At the end of the 1940s Dali's interest in Classical themes and the style of the old masters was becoming increasingly bound up with his growing interest in atomic theory. He was particularly fascinated by the idea that seemingly solid matter was in fact made up of particles in a constant state of flux.

Atomic Leda combines the Classical Greek myth of Leda and the Swan and an 'atomic' view of the world symbolized by objects hovering in the air, mimicking their constituent atoms that never touch. Dali even paints the sea suspended above the earth. In the myth, Leda, the wife of the king of Sparta, is ravaged by Zeus, the supreme ruler of the gods, who appears disguised as a swan. Dali had a profound knowledge of Greek and Roman mythology. He compared his relationship with Gala, represented in this work as Leda, with the complex, amoral and often incestuous relationships between the gods and mortals.

The French writer and critic Jean Louis Ferrier devoted a whole book, *Leda Atomica – Anatomie d 'un Chef d'Oeuvre* to this one Dali painting.

MEDIUM

Oil on canvas

PERIOD

Classic

RELATED WORK

Jean Thierry, *Leda and the Swan*, 1717

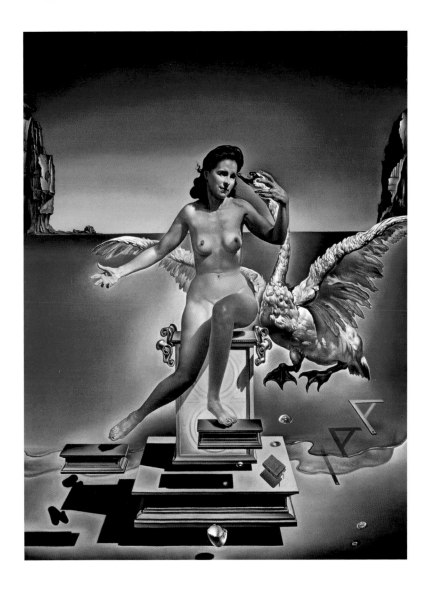

Portrait of Gala With Rhinocerotic Attributes, 1954

In a number of paintings that Dali produced during his Nuclear Mystic period, he transformed parts of the image into rhinoceros-horn shapes. Examples include *Raphaelesque Head, Exploding* (1951), *Assumpta Corpusclaria Lapislazulina* (1952, see page 242) and *Paranoiac-Critical Painting of Vermeer's 'Lacemaker'* (1955). In the image shown here, Gala's neck and upper chest, and some of the coastal rocks, appear to be constructed from floating horns, the spaces between referencing the fact that in particle physics individual atoms do not touch.

Dali was fixated with the natural occurrence of the logarithmic spiral, which dictates the curve of the rhinoceros horn and occurs elsewhere in nature, including in the growth pattern of seeds on the head of a sunflower, which form clockwise and anticlockwise logarithmic spirals: see *L'Ascension de Christ* (1958, see page 238) and *The Virgin of Guadalupe* (1959). Likewise, the logarithmic spiral occurs in the growth pattern of certain seashells, and also in the shape of the arms of spiral galaxies.

Dali clearly used a photograph to produce Gala's portrait, as it has a snapshot-like quality. In addition, by this time she was nearly sixty, and this appears to be the portrait of a rather younger woman.

MEDIUM

Oil on canvas

PERIOD

Nuclear Mystic

RELATED WORK

Pablo Picasso, *Portrait of Madame HP*, 1952

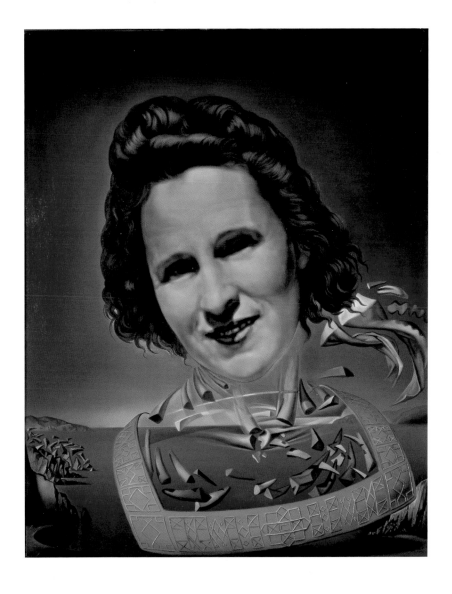

Gala Contemplating the Mediterranean Sea Which at Eighteen Metres Becomes the Portrait of Abraham Lincoln, 1973

The second half of the twentieth century saw rapid advances in the ways that images could be created and reproduced. Dali, continually fascinated by the way things appeared and were seen, took every opportunity to experiment with these developments. Benday dots, expanded half-tone dots, stereoscopic images and even holograms were all used by Dali to explore different ways of seeing.

In 1973, an article by Leon Harman in *Scientific American* demonstrated just how little information was needed to produce a recognizable face. He did this by generating a 'coarse scale' pixilated image of Abraham Lincoln that, although little more than a sequence of monochromatic squares, could still be seen as Lincoln. Dali takes Harman's original pixilated image, reproduces it in colour and, within the cruciform shape of Lincoln's face, adds images of the nude Gala, Christ crucified, patterned motifs and a collage of smaller, more recognizable versions of Harmon's image.

In this very large painting, measuring 4.5 m by 3.5 m (15 ft by 11 ft), Dali brings together such disparate themes as religion, sex, advances in technology, the nature of authority, civil war, his enduring affection for American culture and, crucially, what the viewer brings to a reading of an image.

MEDIUM

Oil on photographic paper

PERIOD

Late

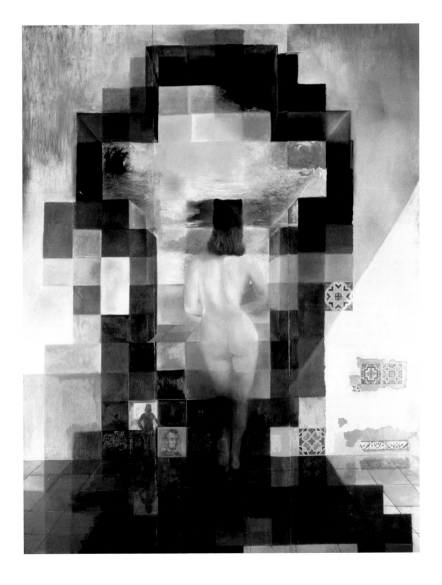

Galatea of the Spheres, 1952

One of the most celebrated images from Dali's Nuclear Mystic period, *Galatea of the Spheres*, depicts Gala looking down pensively, in a modest, Madonna-like pose. The portrait is composed of a series of spheres that continue towards a vanishing point, creating a powerful illusion of perspective. Some of the spheres are moving, suggesting the forms of Gala's hair, collarbone and neck. Other spheres have been 'painted' with the elements that make up her face, such as the ears, hair and lips. The eyebrows are depicted as separate floating elements.

The spheres relate to Dali's interest in divine proportions. Pythagoras and later philosophers believed that the spacing of the planets conformed to the same ratios as governed harmonious musical intervals. It was, therefore, thought the planets must make perfectly harmonious sounds as they passed through space, although these could not be heard on earth.

Dali said this painting of Gala as Galatea, the sea nymph, embodied the 'unity of the universe' and 'the music of the spheres, to which the sirens are dancing'.

MEDIUM

Oil on canvas

PERIOD

Nuclear Mystic

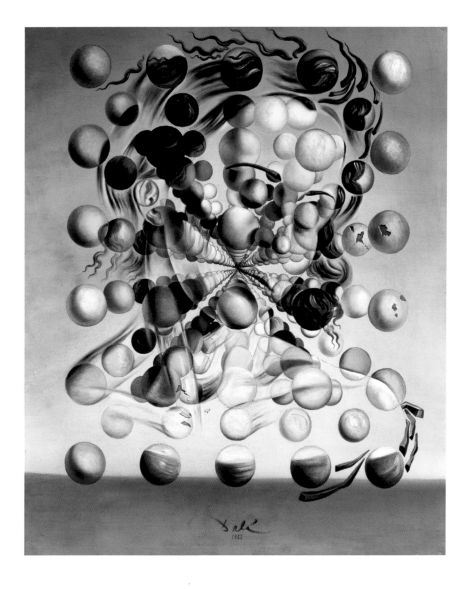

La Rose, 1958

Throughout the history of western art, flowers have been the carriers of symbolic meaning. Madonna lilies, for example, have long been associated with purity and are therefore an attribute of the Virgin Mary. Red roses, on the other hand, are associated with love and passion. For Dali, roses were specifically associated with female sexuality. For Dali the presence of thorns on this otherwise beautiful and appealing flower represented his fear of women and, by extension, sexually transmitted diseases.

In this painting, an enormous rose hovers in the sky like an unidentified flying object (UFO). Two tiny figures witness this bizarre apparition, emphasizing the disparity of scale. A drop of water on one of the petals looks like blood, linking it to a painting produced by Dali nearly thirty years earlier, in 1930. The painting, *Bleeding Roses*, depicts a naked woman, her abdomen formed of four large roses, oozing blood, a reference to menstruation and its link with female sexuality.

Earlier in his career, 1936–37, Dali produced a series of paintings in which women's heads became balls of flowers, including *Untitled – Woman with a Flower Head* (see page 42).

MEDIUM

Oil on canvas

PERIOD

Late

RELATED WORK

René Magritte, *Le Tombeau des Lutteurs*, 1960

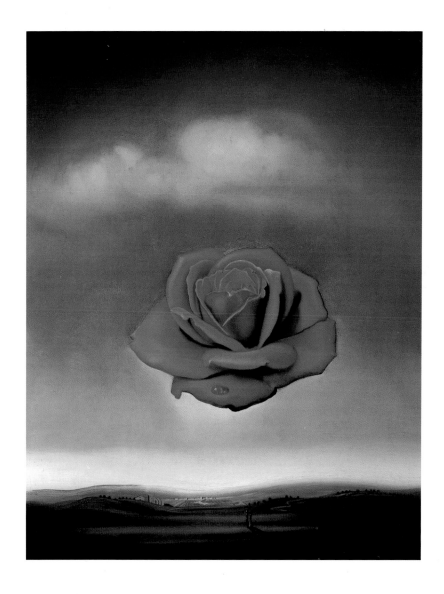

Les Oeillets aux Clefs ('Carnations with Keys'), 1967

This painting depicts a bizarre juxtaposition of two apparently unconnected objects: flowers and keys. Throughout his career Dali liked the surreal effect that could be obtained by this sort of combination, a classic example being his pairing of a lobster with a telephone in *Téléphone-Homard* (1936, see page 38).

Influenced by Freud's theories, Dali saw keys as phallic, since they are inserted into keyholes. Some of the keys project from the centre of the blooms like extended stamen, the male sexual parts of a flower.

By contrast, Dali saw flowers as feminine. The word carnation comes from the Latin for flesh, since the first carnations were flesh pink. Here, therefore, we have a combination soft flesh and unyielding phallic keys. Dali's carnations are not, however, pink but blood red, and relate to his earlier images of red roses: *Bleeding Roses* (1930) and *La Rose* (1958, see page 352). In *Les Oeillets aux Clefs*, some of the keys are smaller and red, and appear to be dripping, blood-like, from the outer petals of the flower heads.

MEDIUM

Mixed media on paper

PERIOD

Late

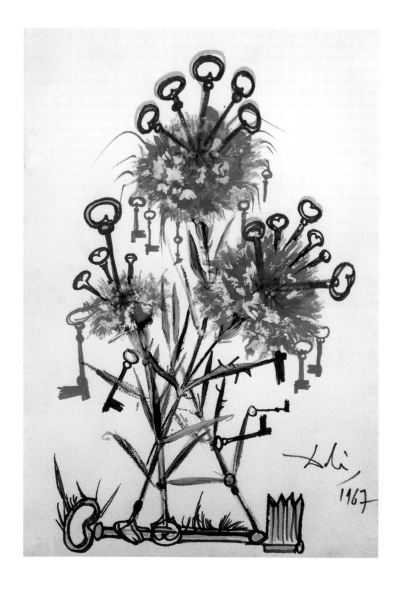

Six Dessins de Cartes à Jouer: 'Le Joker' ('Six Drawings of Playing Cards: 'The Joker''), 1967

Le Joker is one of six designs for playing cards that Dalí is thought to have produced in 1967. The figure of the joker, or jester, is one that appears in Dalí's earlier watercolours of Italian scenes and is a character that appealed to the joker in Dalí himself. The joker is the outsider in the pack: he owes no allegiance to any particular suit.

At first glance, the figure here appears similar to a conventional representation of the joker, but Dalí, while following the conventions of traditional playing-card design, has included many of his favourite motifs in this striking image. The joker with his air of morbid humour often relates to death and Dalí acknowledges this with the skull, elongated into a phallic shape, which is supported by a crutch, the symbol of impotence, emerging from a drawer in the joker's chest, a Freudian symbol of hidden desires.

At first it can be hard to make out the joker's pose. In fact he is standing on his hands with his feet in the air, his head facing left with a tulip in his mouth.

MEDIUM

Watercolour

PERIOD

Late

Papillons et Raisins
('Butterflies and Grapes'), 1974

At first glance, it is hard to make out what is going on in this image. In fact it comprises a caricature-style drawing of the profile of a face, executed in soluble pen, which has then been dampened to create a streaky effect. Dali has added rusty-brown paint on the nose, mouth and chin, which has blurred, making the image hard to read.

The profile does not really look like a self-portrait of Dali, but the way he depicts the eye, with its long lashes, is very similar to his soft self-portraits in *The Great Masturbator* (1929, see page 100) and *The Persistence of Memory* (1931, see page 314). The calligraphic squiggles at bottom of the page suggest a Don Quixote-like ruff, typical of seventeenth-century Spanish dress, around the neck of the figure.

Contrasting with the 'accidental' quality of the blurred paint and ink, the collaged elements, consisting of butterflies and bunches of grapes, appear sharp and precise. Grapes, which appear as a motif on numerous occasions in Dali's work, form the hair of the figure.

MEDIUM

Gouache and photo collage on stiff paper

PERIOD

Late

RELATED WORK

Max Ernst, *The Ace of Spades*, 1924

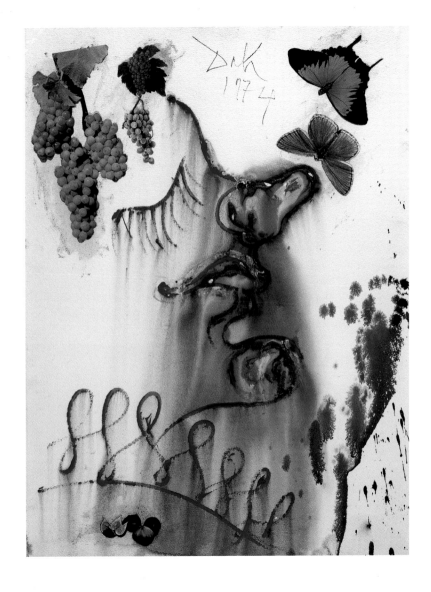

Design for a Record Cover, 1969

Dali designed this striking LP cover for an album by Haitian jazz singer, Jho Archer, who was living in Paris. The design is constructed from collaged elements, and the singer's mouth appears on the flame-like shape appearing from the top of the television and on the front panel of the gramophone, visible on the television screen. Dali has reduced the singer just to a mouth, representing his voice, for which he is famous, rather than showing his full face.

The speakers of the gramophone are formed from lilies, one of which is supported by Dali's trademark crutch. Even in 1969, this type of record player, a phonogram, would have appeared old-fashioned, but its use on the HMV record label meant it would have been seen as an iconic symbol (and still is today) – an instantly recognizable sign of a record player.

Dali also uses cut-out butterflies in the design, something he had done before, in *Design for the Costume for 'The Woman of the Future'* (1953, see page 122) and *Paysage Surréaliste* (1958, see page 200). Dali's signature, in the bottom right-hand corner, becomes part of the design.

CREATED

France

MEDIUM

Collage on paper

PERIOD

Late

Dawn, Noon, Sunset and Twilight, 1979

Throughout his life Dali was obsessed by *The Angelus* (1858), a work by the French Realist painter, Jean Francois Millet (1814–1875). Dali wrote extensively about this painting and, remarkably, in 1933 he predicted hidden elements of the picture that were only revealed by x-rays much later.

In earlier interpretations of Millet's painting, *Atavism at Twilight* (1933–34) and *Archaeological Reminiscence of Millet's Angelus* (1935), Dali included both the male and female characters from the original work. However, in *Dawn, Noon, Sunset and Twilight*, which he painted at the age of 79 in 1979, only the female form remains, repeated five times. Dali considered that the woman's shape was reminiscent of the praying mantis, the female of which eats the male after mating. We might infer that the humble woman who seems to be adopting the attitude of prayer has in fact consumed her male partner.

The Pointillist effect Dali uses is evocative of the works of the French Post-Impressionist Georges Seurat (1858–1891), and the contrasting points of colour suggest light at different times of the day.

MEDIUM

Oil on panel

PERIOD

Late

Objet Surréaliste a Fonctionnement Symbolique ('Surrealist Object Functioning Symbolically'), 1975

In the early 1930s Dali updated the concept of the *objet trouvé*. He wanted these assemblages to become 'symbolically functioning' and 'erotically charged'. He proposed that this should be achieved by using objects in the assemblages that would arouse hidden desires rather than merely be aesthetically pleasing.

Dali himself described the work as: 'A woman's shoe, inside which a glass of warm milk has been placed in the centre of a soft paste in the colour of excrement. The mechanism consists of the dipping in the milk of the sugar lump, on which there is a drawing of a shoe, so that the dissolving of the sugar, and consequently the image of the shoe, may be observed. Several accessories (pubic hair glued to a sugar lump, an erotic little photograph) complete the object, which is accompanied by a box of spare sugar lumps and a special spoon for stirring lead pellets inside the shoe.'

The original 1932 version of this work has not survived, but was recreated by Max Clarac Serou in 1975 in a limited edition of eight signed by Dali.

MEDIUM

Assemblage with a shoe, white marble, photographs, a glass containing wax, a gibbet, a matchbox, hair and a wooden scraper

PERIOD

Surrealist

RELATED WORK

Meret Oppenheim, *My Nurse*, 1936

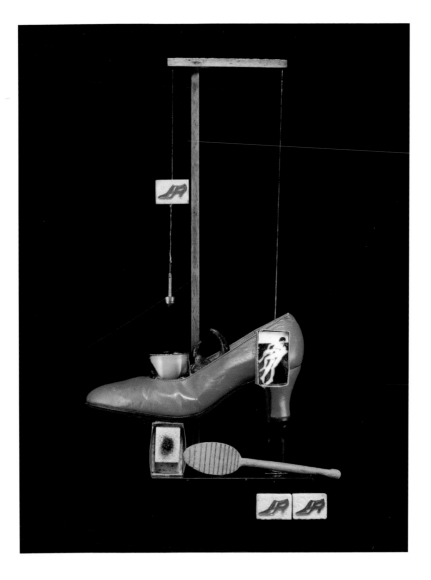

Six-piece set of cutlery, 1957

Dali was always happy to take on commissions to design decorative objects such as jewellery, plates and, here, cutlery. This extraordinary six-piece table setting designed by Dali consists of a table knife and fork, a desert knife, fork and spoon, and a teaspoon. The designs are based on organic forms and have a strong Art Nouveau quality to them. Dali was particularly taken by the Art Nouveau architecture of Antonio Gaudi (1852–1926), who came from the Catalan capital Barcelona.

The organic forms that Dali employs here include snail shells for the ends of the handles of four of the six items, and acorns, oak leaves and bark for the remaining two. The cutlery is made from silver-gilt, solid silver that has been gold plated. The bowls of the spoons are enamelled, mainly in purple, to suggest elaborate flower petals.

Undoubtedly the irregular shapes of the handles, fork tines and the bowls of the spoons seriously diminish their usefulness. However, for the sort of client who would be attracted by such items, practicality would presumably be of little importance.

MEDIUM

Silver-gilt

PERIOD

Late

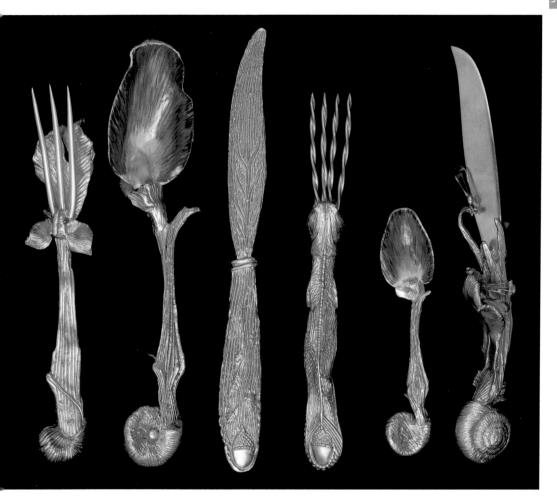

Hommage à Terpsichore (La Danse), 1984

Throughout the later period of his life Dali conceived many bronzes, which he had cast. Some of these pieces, such as *Profil du Temps* (1984, see page 292), were simply three-dimensional realizations of images from his paintings, others, like *Hommage à Terpsichore*, were original works.

Hommage à Terpsichore is one of a range of bronzes cast in the 1980s by various European foundries under Dali's supervision. Terpsichore, the muse of the dance, is represented by two figures moving in space. Although they differ in form, the figures mirror each other's movements. The left-hand image is Classical, representing grace and fluidity, and has a patina that suggests these qualities. The other figure is androgynous and almost robotic. It has a female form yet also what appear to be male genitals. The highly polished gold finish accentuates its Cubist form and the tendrils growing from its calves and head refer to the plant forms in Dali's Surrealist portraits of the 1930s.

Hommage à Terpsichore suggests the tension that exists between the natural grace of the Classical style and the more chaotic style of the Modern.

MEDIUM

Bronze

PERIOD

Late

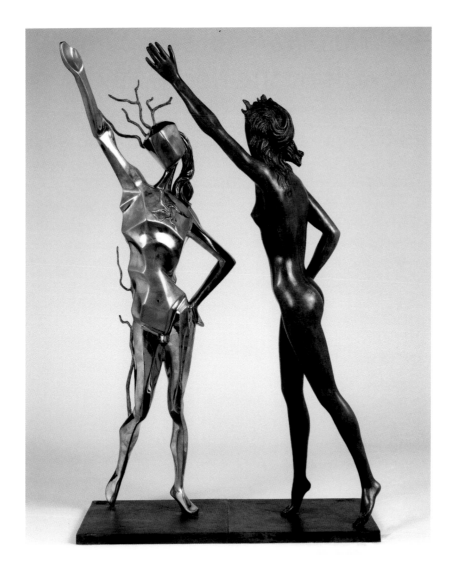

Venus à la Giraffe (Base of Venus Figure with Giraffe Neck), 1973

Venus à la Giraffe is not an original subject in the way that *Hommage à Terpsicore* (1984, see page 372) is. Neither is it simply an image from a previous work given three-dimensional form like *Profil du Temp* (1984, see page 292).

This sculpture borrows some of Dalí's more common motifs and combines them in a work that is somewhat less than the sum of its parts. The main inspiration for the piece is *Flaming Giraffe* (1935, see page 136). Dalí combines the eponymous giraffe with the body of *Venus de Milo with Drawers* (1936, see page 214), giving her the skin of the giraffe, and extending her neck to form a phallic shape with a disconcertingly childlike face on top. A further borrowed motif is the extended phallic object, in this case a drawer, supported by a crutch.

There is no doubt that much of Dalí's output at this time was produced for little more than commercial motives. The silvered-bronze sculpture of *Venus à la Giraffe* has much of the confused feeling of just such a work.

MEDIUM

Silver-patinated bronze

PERIOD

Late

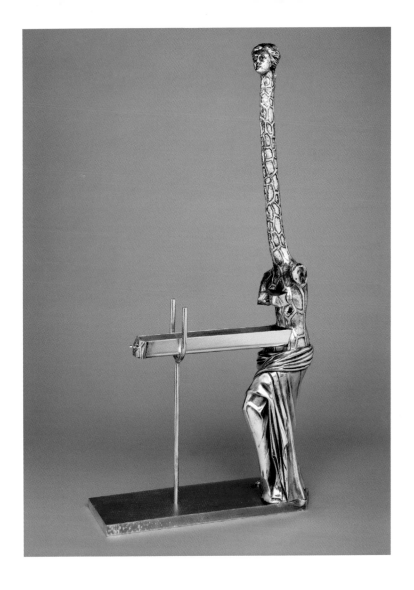

The Eye of Time brooch, 1949

The Eye of Time is an exquisite piece that originally formed part of the fabulous collection of Dali-designed jewels owned by the American millionaire Cummins Catherwood. Dali was intimately involved with the production of each individual piece, preparing the detailed drawings, choosing the individual gems and closely overseeing the work of the silversmiths and goldsmiths responsible for the finished artefacts.

Dali's jewellery often made reference to symbols from his paintings. The jewel entitled *The Persistence of Memory* (1949), for example, is the representation in gold and diamonds of a soft watch from the 1931 painting of the same name (see page 314). The design of *The Eye of Time* is unmistakeably the work of Dali, reminding the viewer of the unforgettable image in Dali and Luis Buñuel's 1929 film *Un Chien Andalou*. At the centre of the eye is a wonderfully intricate clock movement set in a rim of platinum, diamonds and uncut rubies.

The Owen Cheatham Foundation acquired Cummins Catherwood's collection of Dali jewellery in 1958 and lent it out to charitable organizations that were able to raise money by exhibiting this breathtaking set of unique jewels to the public.

CREATED

America

MEDIUM

Platinum, rubies and diamonds, Movado model 50SP clock movement

PERIOD

Classic

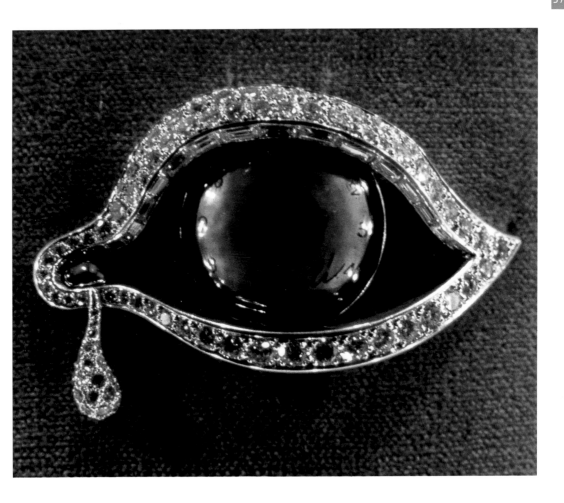

Author Biographies

Elizabeth Keevill and Kevin Eyres (authors)

Elizabeth Keevill trained as a printmaker and textile designer at Camberwell School of Arts and Crafts in London and at ENSAD in Paris. She is a writer, journalist and broadcaster specializing in the arts and lectures at Kingston University. Kevin Eyres qualified as an arts teacher at the UEA. He has a master's degree in European cultural policy and writes extensively on modern art and media related topics.

Michael Robinson (foreword)

Michael Robinson is a freelance lecturer and writer on British art and design history. Originally an art dealer with his own provincial gallery in Sussex, he entered academic life by way of a career change, having gained a first class honours and Masters degree at Kingston University. He is currently working on his doctorate, a study of early modernist period British dealers. He continues to lecture on British and French art of the Modern period.

Picture Credits: Prelims and Introductory Matter

Further Reading

Ades, D., *Dali*, Thames &
 Hudson Ltd, 1995

Bennett, L., *The Life and Work
 of Salvador Dali*, Heinemann
 Library, 2005

*Dali Jewels: A Collection of the
 Gala-Salvador Dali Foundation*,
 Umberto Allemandi, 1999

Dali, S., *Dali on Modern Art: The
 Cuckolds of Antiquated Modern
 Art*, SOS Free Stock, 1996

Dali, S., *50 Secrets of Magic
 Craftsmanship*, Dover
 Publications, 1992

Dali, S., *Hidden Faces*, Peter Owen,
 2001

Dali, S. & Chevalier, H. M. (trans.),
 The Secret Life of Salvador Dali,
 Alkin Books, 1993

Dali, S. & Halsman, P., *Dali's
 Mustache*, Flammarion, 1994

Dali, S. & Howard, R. (trans.),
 Salvador Dali, Macmillan, 1976

Dali, S. & Parinaud, A., *Maniac
 Eyeball: The Unspeakable
 Confessions of Salvador Dali*,
 Creation Books, 2004

Descharnes, R., *Dali: The Work, The
 Man*, Harry N. Abrams, Inc., 1997

Descharnes, R. & Neret, G., *Dali: The
 Paintings*, Taschen, 2001

Gibson, I., *The Shameful Life of
 Salvador Dali*, Faber & Faber, 1998

Goff, R., *Salvador Dali*, Harry N.
 Abrams, Inc., 1998

Kachur, L., *Displaying the Marvellous:
 Marcel Duchamp, Salvador Dali
 and Surrealist Exhibition
 Installations*, The MIT Press, 2003

Lear, A., *Persistence of Memory: A
 Personal Biography of Salvador
 Dali*, National P Books, 1987

Masters, C., *Dali*, Phaidon Press,
 1995

McGirk, T., *Wicked Lady: Salvador
 Dali's Muse*, Headline Book
 Publishing Ltd, 1990

Scheibler, R., *Dali: Genius, Obsession
 and Lust*, Prestel Publishing Ltd,
 1999

Wenzel, A., *The Mad, Mad, Mad,
 Mad World of Salvador Dali*,
 Prestel Publishing Ltd, 2003

Index by Work

General Index